SOFA
NEW YORK
SCULPTURE OBJECTS
& FUNCTIONAL ART

**The Eighth Annual International Exposition
of Sculpture Objects & Functional Art**

June 2-5, 2005

Seventh Regiment Armory
Park Avenue & 67th Street

A project of Expressions of Culture-NY, Inc.

John Rose
Incantation, 2005
poplar, 78 x 20 x 18
represented by Bentley Projects
photo: John De Cindis

All dimensions in the catalog
are in inches (h x w x d)
unless otherwise noted

Library of Congress – in Publication Data

SOFA NEW YORK 2005
The Eighth Annual International
Exposition of Sculpture
Objects & Functional Art

ISBN 0-9713714-4-X
2005923926

Published in 2005 by Expressions of Culture-NY, Inc., Chicago, Illinois

Graphic Design by Design-360° Incorporated, Chicago, Illinois
Printed by Pressroom Printer & Designer, Hong Kong

SOFA
NEW YORK
SCULPTURE OBJECTS
& FUNCTIONAL ART

Expressions of Culture-NY, Inc.

4401 North Ravenswood, Suite 301
Chicago, IL 60640
voice 773.506.8860
fax 773.506.8892
sofaexpo.com

Mark Lyman, president

Anne Meszko

Julie Oimoen

Kate Jordan

Jennifer Haybach

Greg Worthington

Barbara Smythe-Jones

Patrick Seda

Bridget Trost

Conte

SOFA
NEW YORK
SCULPTURE OBJECTS
& FUNCTIONAL ART

6 Acknowledgements

12 Lecture Series

14 Essays

Vision & Voice: The Nanette L. Laitman Documentation Project
Mija Riedel and Liza Kirwin

Rose Slivka as Prophet
Jack Lenor Larsen

Symphony of Shards: Rick Dillingham's Legacy
Garth Clark

Jerome and Simona Chazen: The Pursuit of Excellence
David Revere McFadden

Perspective on Danish Studio Glass– the Nineties Generation
Jørgen Schou-Christensen

The Museum of Fine Arts Houston; Helen Williams Drutt Collection—Building a Collection: A Passionate Journey
Helen W. Drutt English

44 Exhibitor Information

164 Resources

202 Advertisements

208 Index of Exhibitors

214 Index of Artists

Welcome to SOFA NEW YORK 2005!

We are once again delighted to welcome premium international galleries and dealers to SOFA NEW YORK. In thinking about the broad spectrum of high quality artworks they represent—geographically wide and historically deep—weare struck by their common trait of fine craftsmanship—the proud, signature mark of the artist's hand. This apogee of technical skill is not an end in itself, but rather a means for artistic expression. In this regard, the artworks at SOFA are doubly rich, in materials and process, as well as meaning.

We are very pleased that Opening Night will benefit the Museum of Arts & Design for the eighth straight year, and officially kick off the Fourth Annual Contemporary Decorative Arts Week: *Bringing Art to Life,* a city-wide celebration of New York's vibrant contemporary arts and design scene. MAD's leadership role in promoting the value of materials and craftsmanship in contemporary arts is unparalleled. Many thanks to Holly Hotchner and the Museum's dedicated Board of Governors, and to Opening Night Gala Co-Chairs, Sandra B. Grotta and Jack Lenor Larsen, for their continuing support.

Two Special Exhibits at SOFA NEW YORK this year are perfect examples of artworks that bridge the decorative and fine arts. Olga de Amaral, the Columbian textile master, has created a unique art form which challenges narrow critical categorization, combining elements of fiber art, painting and sculpture. Many thanks to Charlotte Kornstein and Thea Burger of Bellas Artes/Thea Burger, in cooperation with the Museum of Arts & Design, for organizing the Special Exhibit, *ESTELAS.*

The Museum of Fine Arts, Houston's acclaimed decorative arts department has been acquiring and exhibiting ceramics, fiber, furniture and woodwork, glass, jewelry and metalwork since 1976. MFAH's Special Exhibit at SOFA NEW YORK presents select highlights from its collection, including works from the newly acquired Helen Williams Drutt Collection, internationally recognized for its depth and quality, with some 57 artists from 17 countries represented. Many thanks to Cindi Strauss, Curator, Modern and Contemporary Arts and Design at MFAH, and Helen Drutt for organizing *A New Vision: Collecting at the Museum of Fine Arts, Houston.*

Key speakers and topics in the SOFA NEW YORK 2005 Lecture Series will explore signature craftsmanship in the creation of a work of art. We are especially excited about a lecture on the Nanette L. Laitman Documentation Project for Craft and Decorative Arts in America, an important program of The Archives of American Art, Smithsonian Institution. A five-year project, the Archives will record and transcribe 100 oral history interviews with key figures in our field. The grant will also support a major campaign to collect the papers of prominent artists working in clay, glass, fiber, metal and wood. Many thanks to the individuals and organizations who have contributed to the Lecture Series.

We also wish to thank the many collector and museum groups attending SOFA NEW YORK; and last but not least, the very fine galleries and dealers, which are the reason for us coming together. We hope you will enjoy the unique synergy of the human hand and mind in the artworks at SOFA.

Mark Lyman, President, Expressions of Culture, Inc.

Anne Meszko, Director of Advertising and Educational Programming

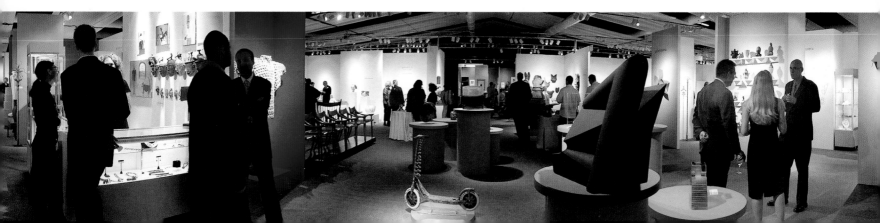

Expressions of Culture-NY, Inc. would like to thank the following individuals and organizations:

Participating galleries, artists, speakers and organizations

Aaron Anderson

Art Jewelry Forum

Sam Bailey

The Bard Graduate Center for Studies in the Decorative Arts, Design & Culture

David Barnes

John Bruno

Desiree Bucks

Thea Burger

Julian Chu

Citadel Security Agency

Garth Clark

Carolyn Cohen

Ernest Coscia

Keith Couser

Design-360°

Dietl International

Floyd Dillman

Anne Dowhie

Lenny Dowhie

Jeff Drabant

Helen W. Drutt English

Empire Safe Company

D. Scott Evans

Sean Fermoyle

Matthew Fiorello

Don Friedlich

Anne Merete Grønlund

Sandy & Lou Grotta

John Hamilton

Lauren Hartman

Evan Haughey

Heckler Electric Company

Scott Hodes

Holly Hotchner

Scott Jacobson

Howard Jones

Patrick Keefe

John Keene

Liza Kirwin

Jessica Klein

Charlotte Kornstein

Ryan Kouris

Jane Kozlow

Nanette L. Laitman

Stephanie Lang

Jack Lenor Larsen

Levin & Associates

David Ling

Matt Lipinski

LongHouse Reserve

Ellie Lyman

Nate Lyman

Michael Macigewski

Jeanne Malkin

David McFadden

Meadows Wye Cardinal

Desmond Moneypenny

Marjorie Mortensen

Bill Murphy

Nancy Murphy

Museum of Arts & Design

Museum of Fine Arts, Houston

Larry Mushinske

Ann Nathan

Walter Nathan

Robert Panarella

Bonnie Poon

Pressroom Printer & Designer

Mija Riedel

Bruce Robbins

Jennifer Scanlan

The Seventh Regiment Armory

Monique Snyder

Society of North American Goldsmiths

Cindi Strauss

Scott Swenson & Staff

TASTE

Barbara Tober

Matko Tomicic

Israel Vines

Christina Root Worthington

Don Zanone

Myrna Zuckerman

photo: David Barnes

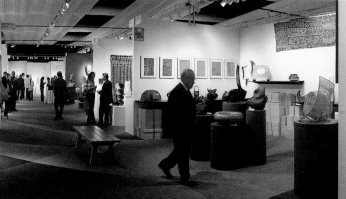

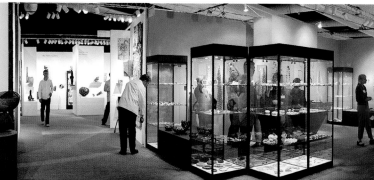

On behalf of the Board of Governors and staff of the Museum of Arts & Design, I extend a warm welcome to the 8th annual International Exposition of Sculpture Objects and Functional Art- SOFA NEW YORK 2005. Once again this year over 50 prestigious art dealers from around the world present work by the most significant established and emerging artists today. MAD has partnered with SOFA since its inception in New York in 1998. We are grateful to Mark Lyman and Expressions of Culture Inc. for their dedicated support for the field and for our Museum.

The Museum is delighted to present the work of Olga de Amaral. Ms. de Amaral, a native of Columbia, is internationally acclaimed for her innovative and inspiring works. Her exceptional talent and unparalleled skill has resulted in a distinctive style which fully merges art, craft, and design.

Concurrent with SOFA, the museum's primary galleries are dedicated to *Dual Vision* an exhibition of highlights of the Chazen collection. The Chazen's dual vision as collectors has been an inspiration to many. Simona and Jerry's first in depth introduction to craft was in the 1960's through the Collectors Circle of the then American Craft Museum. The educational travel group gave an opportunity to meet collectors and Artists with whom they formed lasting friendships. Many of their circle of Artists and Friends who have shared this passion will be visiting New York SOFA. The Chazens are passionate collectors of glass, ceramics, painting, and sculpture. Selections from their collection are shown at the Museum as they are in their home—a seamless integration of all the arts. From the beginning they have been courageous pioneers and generous patrons, and have always been advocates for new talent and new art forms.

I urge you to come to the Museum to enjoy Dual Vision and appreciate the quality and diversity of what Jerry and Simona have collected. The exhibition marks a generous gift of their glass and ceramics to the Museum of Arts & Design, and they will once again been seen in the Museum's new home at Two Columbus Circle. *Dual Vision* is an exciting preview of the collections that will delight and inspire new generations of collectors, students and young artists, and I believe you, too, will be inspired by the breadth and depth of the Chazen collection.

2005 will be a pivotal year for the Museum as we work toward our move into our new home. I am grateful for the support you have shown us and the artists we represent with your participation in SOFA NEW YORK.

Holly Hotchner
Director

Lecture Series

ectures

Lecture Series

sponsored by SOFA NEW YORK 2005

SOFA NEW YORK 2005
Lecture Schedule

Lectures are in the Tiffany
Room and are included
with daily admission unless
noted otherwise.

Thursday
June 2

Noon – 1 pm
**When Is A Collection
More Than A Collection?**
There is an ironic contradiction
in defining what it means to
collect: on one hand, the
collector is assembling and
preserving a body of works
for posterity, yet the objects
so gathered continue to
evolve in their meanings over
the lifetime of the collector
and beyond. It might be
suggested that collecting is
a variant form of writing one's
autobiography. This talk will
look at the layers of meaning
embedded in any collection,
with specific reference to the
collection formed by Jerry
and Simona Chazen. **David
Revere McFadden**, chief
curator, Museum of Arts
& Design, NYC

1 – 2 pm
**Readings from Rose
Slivka's Five Decades of
Writings Instigating the
Metamorphosis of Craft**
From functional artisanry to
personal art expression… In
1950 Peter Voulkos proclaimed,
"Let us not make teacups!
Rather, let us be studio
artists!" More than anyone
else, Rose made this happen.
Come hear readings from
her prophetic writings, as
persuasive as when written.
Moderated by **Jack Lenor
Larsen**, president, LongHouse
Reserve, East Hampton, NY

2 – 3:30 pm
**Vision & Voice: The
Nanette L. Laitman
Documentation Project**
A panel discussion about
the Nanette L. Laitman
Documentation Project for
Craft and Decorative Arts at
the Smithsonian's Archives
of American Art, a five-year
project to produce 100 oral
history interviews and to col-
lect the papers of prominent
artists in the United States
working in clay, wood, fiber,
metal, and glass.

Liza Kirwin, curator of manu-
scripts and **Mija Riedel**, west
coast field researcher, Nanette
L. Laitman Documentation
Project, Archives of American
Art, Smithsonian Institution;
Helen W. Drutt English,
author, founder/director of
Helen Drutt: Philadelphia,

curatorial consultant; **William
P. Daley**, ceramic artist
and Professor Emeritus of
the University of the Arts
in Philadelphia; **Tacey
Rosolowski**, writer and
independent scholar; **Robert
Ebendorf**, jeweler and **Carole
Grotnes Belk** Distinguished
Professor, East Carolina
University School of Art,
Greenville, North Carolina

3:30 – 4:30 pm
Drawn to the Edge
Artist **Norma Minkowitz** will
discuss her psychologically
complex sculptures and how
they evolved from the solid
forms of the 1970's, to the
web-like structures of today.
She will discuss her recent
book, *Portfolio Collection:
Norma Minkowitz,* and how
the text brings new dimension
to the interpretation of her
work. Minkowitz is repre-
sented by Bellas Artes/Thea
Burger, New York & Santa Fe

Friday
June 3

10:15 am – Noon
Calling It Craft
Design expert **Lily Kane** will examine how the current lexicon of art and craft in the United States has been shaped by the role of craft in the decorative arts of the 20th century, and consider what "calling it craft" means in the 21st century marketplace. Kane is gallery director at R 20th Century in NYC. The introductory lecture is followed by a tour of selected objects on view at SOFA. This program has been organized by The Bard Graduate Center for Studies in the Decorative Arts, Design, and Culture to complement the exhibition *Cherished Possessions: A New England Legacy.*

Noon – 1 pm
Once upon a Teapot
In her illustrated lecture, artist **Red Weldon Sandlin** presents a mid-career survey of her figural works in ceramics, autobiographical narratives combined with tales from children's literature in a sculptural framework referencing the teapot form. Weldon Sandlin is represented by Ferrin Gallery, Lenox MA

1 – 2 pm
Building a Collection
The **Helen Williams Drutt** Collection of modern and contemporary jewelry has been part of the permanent holdings of The Museum of Fine Arts, Houston since 2002. Its formation during the mid-1960's and its transition from the private sector to a public institution will be explored by its eponymous originator. Helen W. Drutt English, founder/director, Helen Drutt: Philadelphia and curatorial consultant

2 – 3 pm
Noam Elyashiv:
The Harmony of Line
Israeli-American artist **Noam Elyashiv** will speak about her seductive and minimalist work in metal from the past ten years, focusing on her recent series, *Portraits*. Elyashiv is represented by Sienna Gallery, Lenox MA. *Presented by the Art Jewelry Forum*

3 – 4 pm
Zen and the Art of
Wood Construction
Move from England to Hong Kong. Absorption of Asian culture. Move to USA. Development of work into 3-D. Realization of Zen in my wood constructions. Influence of scientific material. Artist/speaker **John Rose** is represented by Bentley Projects, Phoenix

4 – 5 pm
Czech Glass 2005:
Trends and Events
An illustrated outline of topical trends and events in the Czech studio glass scene, including new, unknown masterpieces and emerging artists. **Dr. Sylva Petrova**, Professor in Glass, University of Sunderland, U.K. *Presented by the Czech Center, NY*

Saturday
June 4

11 am – Noon
Echoes of the Ocean:
The Ceramic Art of
Sakiyama Takayuki
Through slides of his work, the artist will discuss how his forms are influenced by his natural surroundings in Izu, Japan. **Sakiyama Takayuki** was just awarded the prestigious Emperor's Cup (top award) at the 2005 Nihon Togei Ten (2005 Japan Ceramics Exhibition). He is represented by Joan B. Mirviss Ltd., NYC

1 – 2 pm
Collecting Craft: A New
Vision at The Museum
of Fine Arts, Houston
An illustrated discussion of the development of the craft collections at the MFAH, speaking about criteria and the museum's commitment to placing the work in context with other media, while celebrating its roots. **Cindi Strauss,** curator, modern and contemporary decorative arts and design, The Museum of Fine Arts, Houston

2:30 – 3:30 pm
Aesthetics of Silver Thread
Artist **Jung Sil Hong** discusses jjoum-ipsa: the traditional Korean damascene technique of inlaying metal in steel, as utilized in her works of art. Hong is a professor at Wonkwang University in South Korea and is represented by Gallery Gainro, Seoul. *Presented by the Society of North American Goldsmiths*

SOFA 2005

Essays

Vision & Voice: The Nanette L. Laitman
Documentation Project
Mija Riedel and Liza Kirwin

Rose Slivka as Prophet
Jack Lenor Larsen

Symphony of Shards:
Rick Dillingham's Legacy
Garth Clark

Jerome and Simona Chazen:
The Pursuit of Excellence
David Revere McFadden

Perspective on Danish Studio Glass–
the Nineties Generation
Jørgen Schou-Christensen

The Museum of Fine Arts Houston;
Helen Williams Drutt Collection—Building
a Collection: A Passionate Journey
Helen W. Drutt English

Essays

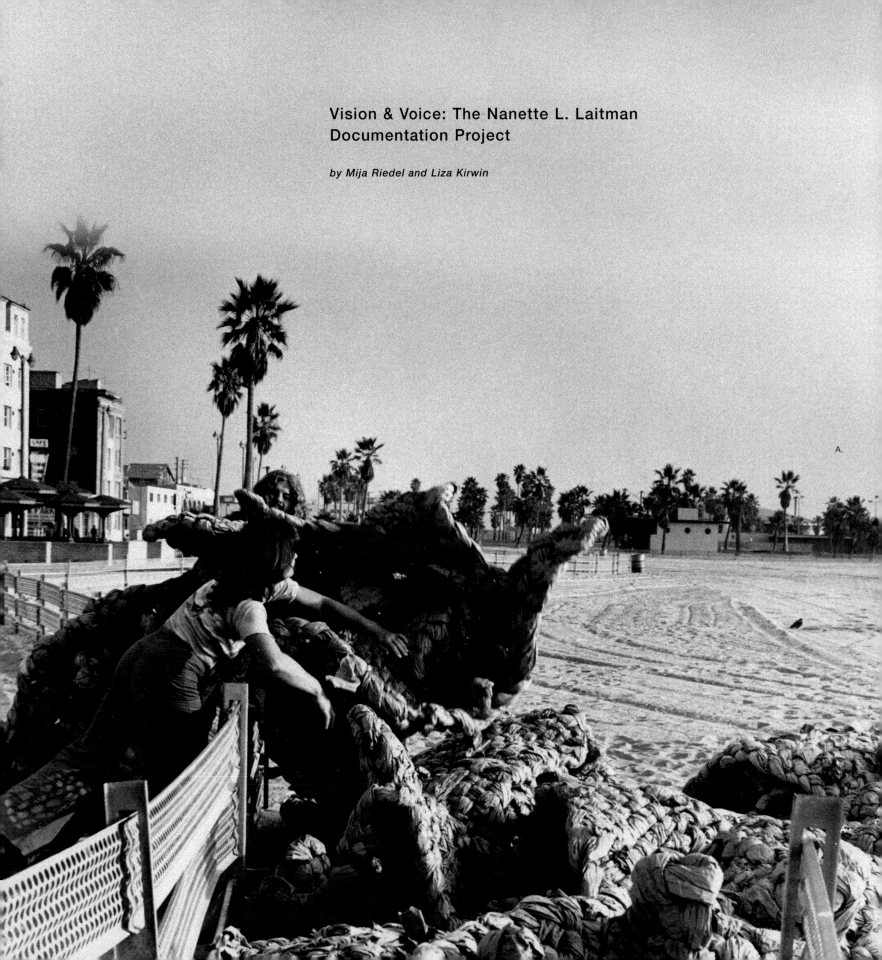

Vision & Voice: The Nanette L. Laitman
Documentation Project

by Mija Riedel and Liza Kirwin

A.

C.

Heikki Seppä Sketchbook
Heikki Seppä papers
1944-1996

D.

Dominic Di Mare
Sketchbook, undated
Dominic Di Mare papers
1950-2002

a Al-Hilali
ch Occurrence
ongues, 1975
door fiber installation
ce Beach
a Al-Hilali papers
0-1995

oh Bacerra
tch of Shoji Hamada at
amada Workshop at the
versity of Southern California,
tember 1963
oh Bacerra papers
9-2003

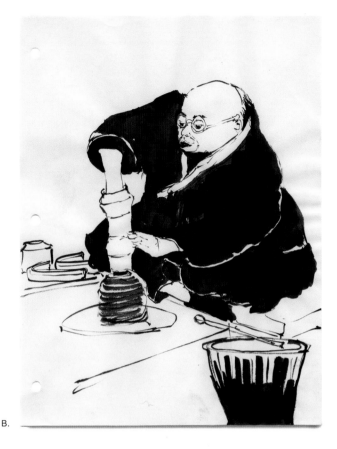

B.

C.

D.

"I just *got* to tell you this story," said Fritz Driesbach to Suzanne Frantz, during their lengthy interview for the Archives of American Art's Nanette L. Laitman Documentation Project. It was 1964 and Dreisbach had only been blowing glass for two months when he sought out artist and glass technologist Dominick Labino to ask for a formula. "There was this old guy," said Dreisbach, "not old, but there's this white haired—gray haired fellow with a moustache mowing the yard in overalls. And I could see the house and I could see a shop way down at the end…it looked like it could be a barn rather than a studio or a laboratory.

And so I asked the guy that was mowing the yard where I could find Nick Labino—Dominick Labino— Mr. Labino, I think I may have said. And he said, 'Yeah, I'm Nick. Are you Fritz?' And he made me welcome right from that very, very moment. And so we went out to the shop and we looked at things, and he did give me the formula."[1]

Driesbach's firsthand account of meeting Dominick Labino and the early origins of the "Labino-style furnace,"[2] is just one of the thousands of stories documenting the events that are fundamental to the history of American art. These expansive recollections, as well as the personal papers of many craft artists are now preserved at the Smithsonian's Archives of American Art and available to researchers, thanks to the vision and generosity of Nanette L. Laitman.

The Smithsonian's Archives of American Art is the world's largest single source of original letters, diaries, financial records, unpublished writings, sketchbooks, scrapbooks, and photographs created by artists, critics, collectors, art dealers, and societies—the raw material for scholarship in American art. In 2000, Nanette L. Laitman gave the Archives a grant to fund an important archival endeavor: the Nanette L. Laitman Documentation Project for Craft and Decorative Arts in America, a five-year initiative to record and transcribe one hundred in-depth interviews of prominent artists working in clay, glass, fiber, metal, and wood, and to collect their personal papers. Through the accumulation of separate but related collections, the Archives now holds unparalleled primary sources for the study of American craft, placed squarely in the context of the history of the visual arts. Mrs. Laitman's vision is responsible for this rich and growing new group of research materials, which will allow curators, scholars, authors, and

students to further explore both the development and historical context of craft in America.

The oral history interviews, many of which are available online, are the more visible component of this project. The best examples provide a sense of detail, inflection, and character not found in written records. Each interview is recorded digitally in multiple sessions and is at least three hours long. The transcripts are edited in consultation with interviewer and interviewee. All the interviews start with a common set of questions that serve as a point of departure for individual lines of inquiry. Built around such topics as the artist's educational background, working methods, technical interests and innovations, and issues of patronage and influence, the interviews also touch on experiences and preoccupations that emerge across media—for example, apprenticeships, teaching, criticism, and sources of inspiration.

Under the auspices of the Laitman project, the Archives has also gathered more than forty collections of personal papers and gallery records including those of Neda Al-Hilali, Ralph Bacerra, Clayton Bailey, Garry Knox Bennett, William P. Daley, Margaret De Patta, Dominic Di Mare, Arline M. Fisch, Trude Guermonprez, Otto and Vivika Heino, Lloyd E. Herman, L. Brent Kington, Gyöngy Laky, Jack Lenor Larsen, Marvin Lipofsky, John Marshall, James Melchert, Paul and Elmerina Parkman, Antonio Prieto, Merry Renk, Heikki Seppä, Kay Sekimachi, Mary Shaffer, Jean and Hilbert Sosin, Robert Sperry, Bob Stocksdale, and J. Fred Woell, as well as the records of the Candy Store Gallery, Dorothy Weiss Gallery, Fendrick Gallery, the Gallery at Workbench, and Joanne Rapp Gallery/The Hand and the Spirit. These collections illuminate further the depth, breadth, and evolution of American craft, and illustrate clearly that the diversity of the field is not served by narrow or rigid definitions.

These primary sources lay the foundation for a more nuanced interpretation of craft. They reveal the variety of objects, paintings, sculpture, cultural traditions, and schools of thought that have influenced these artists and their work. Craft is a spectrum. It includes a range of media and a range of forms—from utilitarian vessels, to idea-based works, to conceptual and environmental installations. Borders in craft are porous and frequently in flux. Innovation and experimentation both define the field and make it difficult to define.

E.

So 6 more miles of breakless driving to Santa Fe. Beautiful fire works in sky on way down. & Policeman. Nothing open in Santa Fe. Parked car at Hotel. We dressed and went out for a drink. Walked through Plaza, coffee and to bed. They seem to have only Vanilla ice cream in New Mexico.

Huge Bowl at least 3 ft. width.

If the pot was cracked Indians used rawhide to hold it together → was useful to store cornmeal

F.

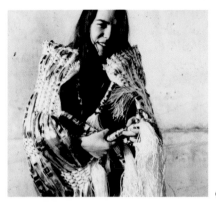

G.

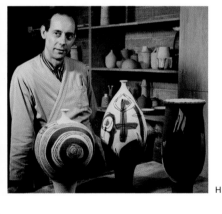

H.

E.
Ralph Bacerra
Diary of a driving trip from
Los Angeles to Hopkinton,
New Hampshire with Vivika Heino,
1959 July 1 - September 5
Ralph Bacerra papers
1959-2003

F.
Dominic Di Mare at the
Macomber loom, 1965
photo: Studio Beeson
Dominic Di Mare papers
1950-2002

G.
Gyöngy Laky at UC
Berkeley, ca. 1971
photo: Lou Schneider
Gyöngy Laky papers
1912-2004

H.
Antonio Prieto in his
workshop, undated
photo: Robert John Wright
Antonio Prieto papers
1947-1967

As a group, these materials suggest that to understand more fully the twists and turns of artistic influence and intention, we need to apprehend each artist's aesthetic in his or her own language. James Melchert, artist, Professor Emeritus at the University of California, Berkeley, and the former director of the Visual Arts Program at the National Endowment for the Arts, proposed studying the field with particular attention to mutable borders. "Somewhere there needs to be a space given to the area between categories, where the edges aren't defined—which is the most interesting to me, when the art/craft categories don't apply."[3]

In their interviews, Ralph Bacerra speaks of the influence of Persian manuscripts, Japanese prints, and M. C. Escher's interlocking shapes on his patterned ceramics, and Norma Minkowitz looked to Albrecht Dürer for inspiration. She said, "I adored Albrecht Dürer and the fine pen and ink cross hatching of his linear works and his woodcuts." When she makes her fiber pieces, she explains, "I'm actually drawing three dimensionally with the line."[4]

A 1979 exhibition of Alberto Burri's "cracked paintings" impacted Robert Sperry's ideas about content and technique, while referencing memories of nature from his own childhood. Burri "was working with plain fields of cracked materials both white and black. These were exactly like the mud which eventually dried up after the spring runoff sloughs had evaporated... I began to think of the technique which in clay would allow me to express the ideas about energy and impact and interaction which were more and more on my mind."[5]

Many of these artists cited nature as an influence on their work. Dominic Di Mare's father was a commercial fisherman and Di Mare spent much of his childhood at sea, watching the water's surface for signs of fish below. The fishing rituals of his childhood—the exacting crafting of nets, the repetitive casting and retrieving of fishing lines, and the rhythm of the waves—surface in his poetic constructions of wood and horsehair. They're also apparent in his sketchbook explorations of layers, transparency, pattern, and porous borders.

Borders—physical, metaphorical and international—are traversed repeatedly in the course of the Laitman interviews and papers. Frances Senska acknowledges the techniques and attitudes of potters in Cameroon, Africa, where she spent her childhood, for her overall theory of ceramics—from the value of digging one's own clay to symbolic

decorative brushwork. When Gyöngy Laky, at twenty-nine, founded the Fiberworks Center for the Textile Arts in Berkeley, she already had lived in Budapest, Vienna, Ohio, Oklahoma, California, Paris, Canada, and India. She later wrote, "What made the textile arts movement of the 70s in Northern California distinctive was that the richness of ethnic diversity, interest in other cultures and other traditions was mixed right in with contemporary art explorations and endless experimentation."[6]

While experimentation was a cornerstone of this extraordinarily creative era, new art forms rarely were embraced outright. In 1991, James Melchert wrote to fellow artist and professor Tony Hepburn regarding his first encounter with the work of Peter Voulkos at the Chicago Art Institute in 1957: "I walked in, took one look around and got out. Nothing had upset me before like those parched white wares that he had sent. I remember thinking that somebody in California would do that. The work revolted me and kept on irritating until a year and a few months later, I went off to Montana to sign up for a summer course that he was teaching. I didn't know how else to deal with it."[7]

Among Laky's papers are the notes for a lecture in which she remarked, "Robert Hughes once posed the question, 'How can one prepare for the unexpected?' I believe that is what artists do all their lives. Embrace difference and search for change. Undo the order... Look for things that do not go together."[8]

Ron Nagle cites the paintings of Giorgio Morandi as a catalyst for Nagle's own, long-running series of cups. "A lot of ceramic people are very much influenced by Morandi, I think because of the way he rendered or represented dumb kind of objects... the pot was just a vehicle for something else... when you look at a Morandi painting, it's not about a vase; it's about a feeling."[9] Nagle appreciated that Morandi "took a very simple format which he basically developed and just kept honing it down until it got more and more and more to the essence."[10]

While the idea of working in series emerges as a common means of exploration, experimentation, and problem solving, the artists work from different precepts. For J. Fred Woell, the greatest value of producing a series is the "serendipity element"—by allowing chance to enter into how he put things together, the process itself generates new ideas and surprising results.[11] Whereas Walter Nottingham works in series to limit his choices in a kind of

I.

J.

"structured freedom," that is, the greater you limit yourself the greater the creativity.[12] Robert Ebendorf talks about his series of pectoral crosses as a means of articulation: "After twenty-seven different crosses, from gold and pearls to sticks and stones, the work had a presence. So I find that working in a series brings about that kind of odor or that kind of voice."[13]

Often, a shift in intent or a new topic of inquiry necessitates a shift in material. Numerous artists interviewed for the Laitman Project worked with different media over the course of their careers. Robert Sperry made ceramic sculptures and awarding winning documentaries; his "papers" contain thirty-nine reels of film. Ron Nagle wrote music. Clayton Bailey made burping ceramic mugs, life-sized metal robots, and ceramic fossils for the faux archeological expeditions of the fictitious Dr. Gladstone, who bore an uncanny resemblance to Bailey, and specialized in the little-studied "pre-credulous" era. Certain artists managed to create a spectrum—from useful to conceptual—in the span of their own careers.

One significant feature of the papers the Archives has collected in the Laitman project is their documentation of impermanent works that lasted only for a month, a weekend, or less. John Roloff's kiln sculptures are a prime example of the conceptual installations that lie at the opposite end of the craft spectrum from utilitarian objects. Roloff's work focuses on the interaction between humankind and nature, art and science, and the passing of time, both literally and metaphorically. His research collection contains videotapes of installations and events, some of which occurred in a single evening more than a decade ago.

Neda Al-Hilali installed site-specific constructions in a dozen locations from West Coast to East. The photographs of these pieces—*Cassiopeia's Court* at Scripps College, *Beach Occurrence of Tongues* in Venice, California, *Feathers* at New York's Artpark—are among the only records of their existence. Sketches can take impermanence a dimension further, allowing us to see ideas and designs that never cleared the drawing board. Al-Hilali's proposal for a colorful snake rising up from the earth, looping through the air, disappearing back under the ground and surfacing repeatedly around a Los Angeles sculpture park exists only as a series of collaged photographs.[14]

Much of metalsmith John Marshall's work was commissioned by private clients. One of the few public records of these sculptures is the photographs and original renderings included in Marshall's papers. Such drawings allow a rare glimpse of the visual mind at work—composing, assembling, and reconfiguring. Heikki Seppä's journals illustrate the continual dialog between concepts and skills. Seppä advocated inventive techniques and the exhaustive examination of form as methods for evolving silver into an expressive medium; one of the more specific pages in his sketchbooks clarifies the requisite lines of a dripless tea spout. Margaret De Patta's sketches illustrate the artist's ongoing exploration of structure and open forms. Kay Sekimachi's and Neda Al-Hilali's papers include graphs of complex woven patterns.

Clayton Bailey's ceramic evidence of the "pre-credulous" era existed long enough to be phtographed and reported by Dr. Gladstone. Were it not for rare copies of *The Unnatural Enquirer*, a four-page tabloid found among Bailey's papers, Gladstone's contributions to science might have disappeared altogether.

Bailey's more and less serious approaches to making art exemplify the playful investigations that figure prominently in numerous artists' teaching philosophies. William P. Daley relishes the idea of teaching as experimentation. He noted, "I think in some ways the connection between information and formation and transformation is at the core of what education's about... I'm always absolutely amazed by what students do when they give themselves to suspending their disbelief, and practice openly enough so that they can enter a domain where they are not worried about outcome."[15]

Many teachers found working in the studio along side their students an essential part of the learning experience. Art Carpenter insisted that his work pay for itself. His studio became his classroom. "I became a teacher by precept," he said. "That was my method of teaching. I went ahead and worked on whatever I was working on and let other people work alongside or just watch. And there was absolutely no formal organization."[16]

Others like Ralph Bacerra found it difficult to teach and work at the same time. "I couldn't really work in the studio during class/school time," he noted. "It was difficult because my head was not there... Now that I have all this time and no students, no school, it's probably the best time of my life right now."[17]

Dorothy Gill Barnes realized that her best teaching was not in the classroom, but was out in the field

K.
Trude: The All American Girl,
comic strip,undated
Trude Guermonprez papers
1929-1986

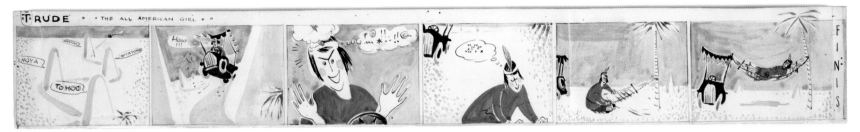

K.

where she could show students how to properly harvest their materials—bark, vines, twigs, grasses and the like. "I knew from the start that if they didn't have the material experience that [students] weren't going to catch on to what we were talking about."[18]

James Melchert wrote, "Bob Irwin used to talk so eloquently about art making as a means for acquiring new knowledge. Essentially, he argued that, unless we think that we already know everything that can be known, we had better attend to what we have yet to discover and understand. As you'll see in his paper, Ed Levine [Professor of Visual Arts and Director, Visual Arts Program at MIT] goes into how science and art are complementary and gain complementary insights from research. I think that if we can justify spending federal funds on scientific research, we're equally justified in supporting aesthetic research."[19]

Historically, new art forms rarely receive a warm reception. Artists often depend on patrons, grants and residencies to support their work. Philanthropy, often flowing from individuals, continues to play a significant role in the American art world. In her testimony before a Congressional subcommittee twenty-five years ago, Gyöngy Laky described the kind of vision behind such generosity: "Support for the arts and for artists encourages a continuing regeneration and reformulation of meaning and symbols. When the arts flourish and when a society enthusiastically supports the arts, we have the possibility to constantly refresh our existence. We must not hesitate to make the essential investment."[20] In this particular case, we are indebted and grateful to Nanette L. Laitman for her contribution.

Mija Riedel is the West Coast field researcher for the Nanette L. Laitman Documentation Project, Archives of American Art, Smithsonian Institution.

Liza Kirwin is the curator of manuscripts at the Archives of American Art, Smithsonian Institution.

Published in conjunction with the SOFA NEW YORK 2005 lecture *Vision & Voice: The Nanette L. Laitman Documentation Project.*

[1]Interview of Fritz Driesbach conducted by Suzanne Frantz, 21-22 April 2004.

[2]Ibid.

[3]"Notes for craft essay." James Melchert papers.

[4]Interview of Norma Minkowitz conducted by Patricia Malarcher, 17 September and 16 November 2001.

[5]Robert Sperry journal, undated. Robert Sperry papers.

[6]"Raising the Current" lecture notes, San Jose, February 1996. Gyöngy Laky papers.

[7]Letter from James Melchert to Tony Hepburn, 19 December 1991 (fax transmission). James Melchert papers.

[8]"Geometry of Form and Sculptural Constructions," lecture notes for Art/Math at University of California, Berkeley, 5 August 1998. Gyöngy Laky papers.

[9]Interview of Ron Nagle conducted by Bill Berkson, 8-9 July 2003.

[10]Ibid.

[11]Interview of J. Fred Woell conducted by Donna Gold, 6 and 11 June 2001 and 9 January 2002.

[12]Interview of Walter Nottingham conducted by Carol Owen, 14, 15, and 18 July 2002.

[13]Interview of Robert Ebendorf conducted by Tacey Rosolowski, 16-18 April 2004.

[14]Proposal for Barnsdall Park, The Reappearance of the Snake. Neda Al-Hilali papers.

[15]Interview of William P. Daley conducted by Helen Drutt English, 7 August and 2 December 2004.

[16]Interview of Arthur Espenet Carpenter conducted by Kathleen Hanna, 20 June and 4 September 2001.

[17]Interview of Ralph Bacerra conducted by Frank Lloyd, 12 and 19 April 2004.

[18]Interview of Dorothy Gill Barnes conducted by Joanne Cubbs, 2 and 7 May 2003.

[19]Letter from James Melchert to Bill Barrett, Association of Independent Colleges of Art and Design (fax transmission), 8 March 1995. James Melchert papers.

[20]Gyöngy Laky typescript of testimony before the Congressional Subcommittee on Postsecondary Education, 16 February 1980. Gyönky Laky papers.

All materials cited are part of the Nanette L. Laitman Documentation Project for Craft and Decorative Arts, Archives of American Art, Smithsonian Institution. To view completed transcripts online visit the Archives' website at *www.aaa.si.edu.* The authors wish to thank Darcy Tell, Joan Lord, and Erin Corley for their assistance with the preparation of this essay.

Time has a way of overwhelming the functional values of an object that outlives the men who made and used it, with the power of its own objective presence—that life-invested quality of being that transcends and energizes. When this happens, such objects are forever honored for their own sakes—they are art.

Rose Slivka, "The Persistent Object"
The Crafts of the Modern World
Horizon Press, New York, 1968

Rose Slivka as Prophet

by Jack Lenor Larsen

Author, editor and critic, Rose Slivka was the most penetrating of writers to document the contemporary Craft Movement. She was also so simpatico with the makers and mediums that her descriptions parallel often the forms she described. Slivka's concerns, delved deeply, always probing to discover Why? Although she became in later years a poet with haunting perceptions, her profound contribution is as a farsighted prophet, until now unrecognized.

Not prepossessing except for penetrating eyes and a gift for listening and recording, this diminutive redhead recognized before others the very core, the soul of contemporary craft. Even those of us there at mid-century, those who built the Craft Council and its museum didn't understand craft as she did. Calling ourselves Designer Craftsmen to separate from traditionalists, we saw craft as an aspect of Modern Design, and so, pared down, functional, expressing materials and method. To us, 'Ornament' was *out;* "Architectural" the ultimate compliment.

Rose, married to a sculptor in the West Village, knew as friends the explosive Abstract Expressionists. When, like them, potter Peter Voulkos proclaimed in 1950, "Let us not make teacups! Rather let us work as studio artists," she knew full well where he was coming from and going. She would go there, too. So would *Craft Horizons*, as the Council's magazine was then called, become an art magazine. Single handedly, blind to both opposition and indifference, Rose pulled us into art and away from functional concerns. Slowly, the focus of exhibitions changed as new/old media such as glass, paper, iron, felt, and basketry suggested works dimensional and sculptural – often in large scale. When our weaving gave way to a host of off-loom structures, Slivka was at the front lines to abet the conflagration as Surface Design swept in like a tornado.

When the Council founder, Mrs. Vanderbuilt Webb, focused her attention on the World Craft Council, Slivka's sphere also widened. So did her readers, as American creativity shook up craftmakers globally. *Craft Horizons* also brought us such news as gargantuan sculpture that Europeans crafted in fiber for public spaces, that is, Art Fabrics. Slivka then printed the International Tapestry – Bienalle at Lausanne as "the Greatest Craft Shows on Earth." They were! But Art shows, in craft media. Rose won her long campaign to consider the craft mainstream as art.

Although she left us without a bow or curtain call, her words are as true today as when written.

Jack Lenor Larsen, president, LongHouse Reserve.

Expressions of Culture, Inc. pays tribute to Rose Slivka for her ground-breaking role in founding the critical discourse on the essential nature of the pure object.

Symphony of Shards
Rick Dillingham's Legacy

By Garth Clark

A.

I recently spent a year spent examining ceramics in the Southwest from the Pueblo Grande and Four Corners areas working on a project for Europe, Free Spriti the New Native American Potter. My research unearthed more than just shards by Indian potters. It also revealed to me how the legacy of a past master, Rick Dillingham (1952-1994) has fared. Dillingham was not just an artist but one of the most respected and knowledgeable dealers in Indian pottery. He was a good scholar as well and his 1974 book *Seven Families in Pueblo Pottery* (re-issued and updated in 1994 to fourteen families) sold over 80,000 copies and became a standard text for the field.

His name came up everywhere, with grudging admiration from fellow dealers and unstinting praise from native artists. The grudging side of the admiration had to do with the fact that one would not describe Dillingham as "easy." He was informed, highly competitive, passionate and just a tad arrogant, a volatile mix. The Indian potters remembered him warmly and without reserve. (No pun intended.) In his dealing, trading, and art making he treated these potters not just with the respect they deserved but with a sensitivity to their cultural differences. There was never a hint of Anglo paternalism and that was appreciated.

They also admired his work even though it drew from their legacy, albeit indirectly, normally a touchy issue on the Pueblos. In some ways I think that they also envied him. Dillingham had freedoms they did not enjoy as artists. The Indian

market is strictly proscribed by the tastes of a conservative, ageing marketplace. Any potter wanting to sell has to accept the rules. The cardinal one was refinement, pushing surface finesse to the point of perfection, rarely a virtue in art. Indeed it is not just amongst the Native American collectors that we find this approach. The mainstream American market also worships at this temple. But at least in Dillingham's case the market was broad enough to accommodate him as well.

This reverence for Dillingham got me to go through my papers on him and I came across a piece I wrote about him in 1993, the year before he died of AIDS. It still rang true and in a way served as a metaphor for the battle of the Indian potters to escape the yoke of the revival pottery movement, now in its 125th year:

Many ceramists search for perfection in an unblemished wholeness or unity of form: clays without impurities, glazes that are even and well-behaved, firings that produce pots without cracks. Many collectors enjoy much the same taste. They shy away from as much as a hair-line crack on an otherwise dramatically beautiful vase. Perhaps they do not want to be reminded of the fragility of costly man-made objects or maybe they are trying to avoid confronting their own mortality.

Rick Dillingham's pots stand as a rebuke to the urge for perfection and a commentary on our fragile impermanence. However, in common with

the pierced burial pots of the Mimbres, they also have an optimism seeing loss as an essential part of a life-giving cycle of birth, death and resurrection. Dillingham begins by creating a flawless vessel which he then tenderly and carefully destroys only to reassemble the fragments and retrieve the shape but with the raw scars of life's experience evident on the fissured surface. The implications of this process are multifarious but the bottom line is that the critic or collector is being invited to take seriously and revere what is essentially a broken pot.

This presentation of "damaged goods" is as evocative as it is challenging. We have all experienced reassembled pots in museums when looking at the wares of Pre-Columbian, Greek, Roman and other ancient cultures. In this hushed and academic environment the damage takes on a romantic, archeological aura. We know that the hand of the scholar and the restorer have lovingly collaborated to bring the object back to life. The care that has gone into this process of reconstruction further instructs us that the object is worthy of the cost and labor of preservation and so heightens its status to that of cultural treasure.

B.

A.
Rick Dillingham
Large Bowl, *1989*
earthenware
14.75 x 18.5
photo: Anthony Cunha

B.
Gas Cans, *1982*
glazed stoneware
with metallic leaf
various sizes
photo: Mark Freeman

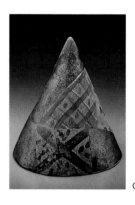

C.

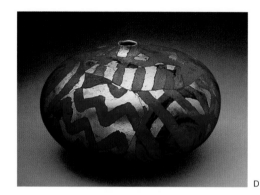

C.
Cone, *1984*
glazed stoneware
with metallic leaf
14 x 12 x 12
photo: John White

D.
Large Globe, *1987*
honey colored stoneware
with gold
11 x 16
photo: Mark Freeman

D.

The vessels by Dillingham also evoke this preciousness of context to some degree and this gives them a mystery, drama and potency. Conceptually, his pots become part of a lineage of worthy ceramic forms that have been retrieved from death. However Dillingham's work, seductive as it is, is not always received positively and particularly not by those coming upon it for the first time. Some find the act of breaking and then rebuilding to be profoundly disturbing, an infuriatingly arrogant gesture that is less creative than confrontational. Certainly arrogance is one of the colors in Dillingham's emotional palette and he enjoys challenging the status quo. But his arrogance is neither irrational nor destructive, it is a calculated act designed to take one's breath away and in the stasis of that momentary vacuum challenges one to look at the art of the potter in a new and exciting way.

Dillingham directs one to *first* acknowledge the vessel's parts before one can appreciate it as a whole. This is a radical step for it completely reverses the process by which we have traditionally looked at pots. For this reason his work has had considerable influence in encouraging today's increasingly deconstructive approach to the vessel. However, Dillingham's genius does not exist solely within the notion of reconstructing pots. The idea, innovative as it is, could easily have become tired and pointless. It is just a starting point and so his pot can only be as interesting as the journey that follows.

He achieves this interest through his unique skill as a painter on a three dimensional "canvas." Dillingham has an eye for unconventional composition that approaches the style, freedom and energy of assemblage. Each shard has its own character and identity, sometimes painted to overlap into other shards and sometimes to stand alone. Each relates to other shards (and not necessarily those that are directly adjacent) in ways that are cunning and subtle while at the same time responding to the overall architecture of the pot. This symphony of painted shards, a masterfully directed merging of textures, shapes, colors (from earthy orange slips to hedonistic gold leaf) is Dillingham's real gift and more than twenty years since he decided to smash his first pot, and bring it freshly to life.

Garth Clark
©1993-2005

Garth Clark is a widely published ceramic arts historian, critic and dealer. He was this year's recipient of the prestigious Mather Award, the College Art Association's highest award for art criticism.

Published in conjunction with Garth Clark Gallery's exhibition in SOFA NEW YORK 2005

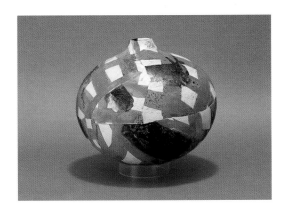

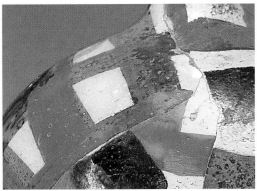

E.

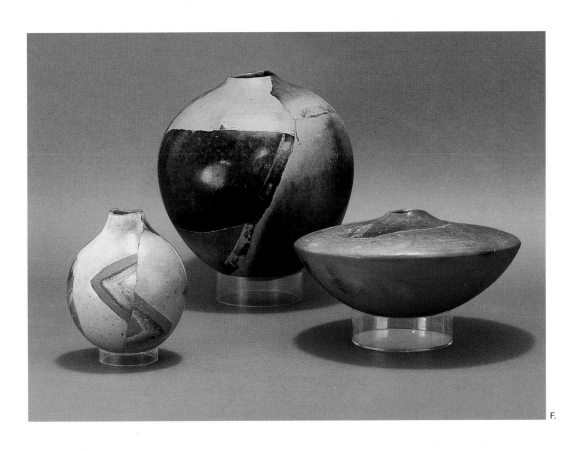

F.

E.
Globe Form, *1980*
raku
10d
photo: Mark Freeman

F.
Untitled Vessels, 1978
earthenware
various sizes
photo: Mark Freeman

Jerome and Simona Chazen: The Pursuit of Excellence

David Revere McFadden

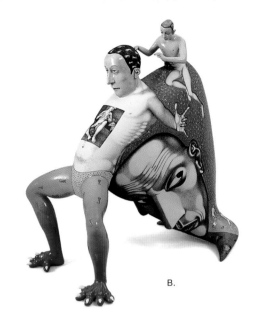

A.
Louise Nevelson
Mirror Shadow XXXXV, *1987*
wood, paint
46 x 33 x 3
photo: David Behl

B.
Sergei Isupov
To Keep in Touch, *2000*
porcelain
18 x 16.5 x 10
photo: David Behl

B.

The Museum of Arts & Design is proud to announce the donation of a stellar group of objects in glass, ceramics, and metalwork from The Simona and Jerome Chazen Collection. This gift will be a foundation collection for the Museum when it moves into its new home at Two Columbus Circle in 2007. This summer nearly one hundred works from the Chazen collection—paintings and sculpture as well as glass and clay—will be on view at the Museum of Arts & Design in a special exhibition entitled Dual Vision, The Simona and Jerome Chazen Collection. *This article is adapted from the catalogue for the exhibition.*

The extraordinary collection assembled by Simona and Jerome Chazen over the past four decades is an eloquent record of the life passion of two individuals, each with their own vision and definition of art, but also of a partnership in which these two visions are united in a coherent and significant way. To fully appreciate the Chazen collection, it is essential to see their objects—paintings, drawings, and sculpture in glass, clay, and metal—as a seamless and continuous spectrum of the arts. Painting lives comfortably with other mediums, and, in the Chazen's own residences, each work is thoughtfully and carefully placed so that it interacts with neighboring objects and the overall architectural environment. Works are distributed between the Chazens' gracious Frank Lloyd Wright–inspired home on the Hudson River, and their aerie with 360-degree views of the city from the top of a Manhattan apartment building. Both settings, rural and urban, have been filled with objects that express their vision.

My collecting interests began when I was young, but my passions were baseball cards and jazz records. This was back in the days

when early 78 rpm discs could be found at second-hand stores. I have given up baseball cards, but my love of jazz will never end. My interest in the visual arts came later. Then, when circumstances allowed me to collect important contemporary art, I discovered glass. Our first purchases were from a craft gallery that featured glass by Orient and Flume and vases by Donald Carlson. Very shortly afterward, we purchased a large globe by Robert Palusky. I was hooked. – Jerome Chazen

The Chazen collection includes art from around the world, primarily pieces by artists who are still living and working today. There are objects of tremendous elegance and refinement by such artists as Steven Weinberg and Lino Tagliapietra. Other works are compelling for their spiritual and psychological presence; Flora Mace and Joey Kirkpatrick's *Vision with Likeness*, one of their most memorable works in blown glass, is comprised of two ghost-like figures eternally linked to each other. Powerful and large-scale sculpture includes Stanislav Libenský and Jaroslava Brychtová's *Cross Head*, an imposing presence in glowing cast glass. Some are provocatively humorous; Donald Lipski's *Pilchuck #90–21*, made of sheet glass slumped into a recycled French fry basket comes to mind, as does Janusz Walentynowicz's unforgettable *Yellow Twelve Pack*, a dozen rolls of glass toilet paper that glow as if lit from within.

What is it that gives the Chazen collection its unity? What links works in such diverse mediums to each other and to the collectors' visions? There are many themes that weave the Chazen collections into a seamless tapestry of visual, emotional, and intellectual explorations. In this collection, the paintings of Robert Motherwell and Gerhard Richter live side

by side with glass by William Morris, Mary Shaffer, and Hank Murta Adams, and with sculpture by Louise Nevelson and Jim Dine. The Chazen collection invites us to create links and bridges among the works and in so doing to express our own vision of art, but it also asks us to join the collectors on the personal journey of looking, discussing, comparing, and contrasting.

Do we always agree on what we choose for the collection? Not always, but certainly a lot of the time. Our individual points of view, as well as our shared vision, are part of the character of the collection. We do have one rule that vetoes a purchase: if the other person absolutely hates it, we don't buy it. – Simona Chazen

Simona Chazen is a clinical social worker. Jerry Chazen is a business entrepreneur whose success has depended on his awareness of subtle changes in public taste. It is not surprising that a substantial number of works collected by the couple address perennial changes in states of being, both physical and psychological.

The work of the recently deceased sculptor Viola Frey is represented in the Chazen collection by two works, including an imposing (over seven-foot-high) figure, *Reflective Woman II*. Frey's *Reflective Woman* stands expectantly, as though waiting for someone familiar. At the same time, the almost hierarchical posture and face suggest hesitation and even alienation. Frey captured these intense emotions in outsized figures that self-consciously refer to eighteenth-century traditions of delicately painted porcelain figurines and their nineteenth- and twentieth-century kitsch descendants—knickknacks. This creates a powerful tension between the evocations of historical standards of value and

the evocations of historical standards of value and beauty and our modern appreciation of the confrontational potential of art.

> **In looking over the collections it is interesting to note that we are not usually collectors of vessels. While we can appreciate the value of the decorative arts in our daily lives, we are drawn to strong figural work or powerful abstractions, and little in between. – S. Chazen**

British sculptor Sir Anthony Caro is well known for his abstract and geometric constructions in metal, but he also produces more organic and figural works, particularly in clay, intentionally disregarding artificial hierarchies and barriers that have been used to separate ceramics from the larger field of sculpture in general. Caro's *Mister* belongs to a series of works that explore the timeless presence of the figure. The standing male figure is presented as a fragment of the body, lopped off at the knees and neck. The references to classical Greek male nudes are clear; Caro has long been inspired by ancient history, myths, and literature. At the same time, a strong sense of person emanates from the fragment. We do not have any face and minimal references to specific body parts to help us understand who the figure might represent (it is, indeed, an anonymous "mister"); however, the posture and body language are eloquent in their evocation of this strong, confident, and determined individual. The emotional and spiritual content of the figure is evoked with grandeur even in these fragments.

> **How would I define beauty? For me something beautiful is a delight to the eye, and that includes grotesque beauty as well. I have always thought the human body was very beautiful, and that might explain our lifelong interest in works that celebrate the body. This is not only true for our paintings, but also for our sculpture. – S. Chazen**

Sergei Isupov's *To Keep in Touch* is filled with a physical and emotional tension portrayed in the writhing and contorted forms; the result can be read by the viewer as either a dream or a nightmare, or a curious amalgamation of both. While Isupov's work is dynamically three-dimensional, the Calibanesque character of his figures is reiterated in the accomplished drawing on the porcelain surfaces. His background as a printmaker becomes apparent in these fine-lined images in which every intimate detail of a body or face is recorded. The intensity of

Isupov's faces is echoed in another haunting work in the Chazen collection: a painting by American artist John Wilde entitled *Work Reconsidered #2. A Portrait of Jesper Dribble*. This is a spellbinding and unsettling glimpse of the artist analyzing himself in a canvas mirror. We are drawn to the figure, but at the same time the oval frame reminds us that we can never truly enter the artist's private world.

The process of change and evolution is inevitable in our lives, but also in inanimate objects. Through works of art, we are able to "see" time as well as timelessness, which may be a factor influencing the sense of engagement, contemplation, and pleasure that emanates from a collection, whether displayed in private or public. Thoughtful collectors also realize that the works they have judiciously assembled are revelatory of another kind of time—that which the artist has invested in creating the object, and that embedded in the process of collecting. "Time," wrote the Argentinean author Jorge Luis Borges, "is the substance of which I am made. Time is a river that carries me along, but I am the river; it is a tiger that devours me, but I am the tiger; it is a fire that consumes me, but I am the fire."[1] Time carries meaning only when we realize that we are time itself.

> **What is it that so appeals to me about glass? I have always found color to be seductive. I think this feeling comes through in our paintings and ceramics as well. But, as a medium, glass alone has that magical quality of color that is brought to life with light. – J. Chazen**

Some artists in the Chazen collection catch time in a stop-motion gesture—a unique moment like waves on the surface of water that are now preserved in tangible form. Glass is particularly adept at capturing this quality, and it is not surprising that many artists use this material to create visual metaphors of time and memory. Daniel Clayman's *Ripple* situates a vibrating demi-egg of translucent glass inside a bronze container, the shape suggesting a dried seed pod at the end of autumn—broken open, seeds dispersed, and now filled with the icy reminder of winter and the passing away of the corporeal. Mary Shaffer's *Hanging Series Water— White #3* connotes the fluid inconsistency of water in motion, but also the rippling effect of wind on a transparent cloth. Like Clayman, Shaffer brings the qualities of glass and metal into play in an unexpected way. Shaffer's work also carries a subliminal message about the finality and inescapability of change; in this work, Schaffer's glass passages are

trapped in an intractable wire mesh. Shaffer's work is haunting and mysterious, transforming discarded metal fragments such as this piece of mesh, forgotten rusty tools (often used in other work by this artist), and humble slumped or cast transparent glass into emotion-charged touchstones for memory and fantasy.

> **I am always asked, "What is your favorite work of art?" My answer is, "I don't know if I can answer that because I love all my children." We have never sold anything and have discarded very little we have bought in the last twenty-five years. One of the most important, and the most challenging, questions is: which objects are our favorites. I don't even know if I can answer that because there is nothing in our collection that I do not love. – S. Chazen**

In their collection, the Chazens have written a memorable autobiography through the objects they live with. They have also contributed significantly to the larger story of why art is made, and why it is loved, preserved, and transmitted from one generation to another. The audience invited to read both histories—of collectors and a collection—has expanded geometrically with the Chazens' decision to make their collection a gift to the Museum of Arts & Design and to the world at large.

> **We have works by more than 200 artists in glass, ceramic and other mediums. They were all carefully chosen for their artistic excellence, and we love them all. I wish we could mention every artist by name. Ultimately we are only stewards of these objects. The art will go on after us. In the meantime, it has been a labor of love for Simona and for me. – J. Chazen**

> **What is the future for our collection? Our children will have some of it, but we hope that many of our beloved works will give pleasure to future generations who come to the Museum of Arts & Design collection. – S. Chazen**

David Revere McFadden is Chief Curator, Museum of Arts & Design.

Published in conjunction with the exhibition *Dual Vision, The Simona and Jerome Chazen Collection* on view at the Museum of Arts & Design May 26 – September 11, 2005.

[1] From "A New Refutation of Time," in *Labyrinth: Selected Stories & Other Writings*. Donald A. Yates and James E. Irby, editors. (New York: New Directions Books, 1962, 1964): p. 234.

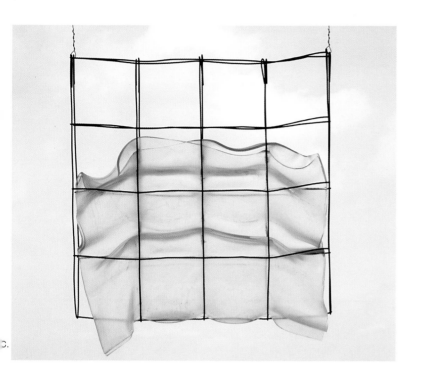

C.

D.

E.

F.

C.
Mary Shaffer
Hanging Series Water-
White #3, *1991*
slumped glass, wire
24 x 24 x 5
photo: David Behl

D.
Hank Murta Adams
Flagman, *1988*
cut glass, metal
32 x 22 x 10
photo: David Behl

E..
William Morris
Raft, *1988*
hand-blown and
sculpted glass
photo: Rob Vinnedge

F.
Daniel Clayman
Ripple, *1999*
glass, metal
11.5 x 24 x 18.5
photo: David Behl

Perspective on Danish Studio Glass—
the Nineties Generation

Jørgen Schou-Christensen

A.

This article looks at the most distinctive group of Danish glass artists—born in the 60s and 70s and mastering their craft up through the 80s. 2003 represented a milestone year for Danish glass art: for the first time ever an art museum—Holstebro Kunstmuseum—gave over all its space to an exhibition of studio glass.

By 1990, the studio glass movement had spread and was thriving throughout northern and western Europe, America, Japan and Australia. The general level of skill in handling the material is now most impressive. Glass art has become a very professional and serious business, but it may also have lost some of the primitive charm of early studio glass—although perhaps not so much in Denmark as elsewhere.

Denmark has proved an excellent place for anyone wishing to keep well abreast of developments in studio glass and to have a finger on the pulse of the international scene. For this we have to thank the highly influential centre at Ebeltoft and a whole succession of exhibitions held there and in museums and galleries throughout Denmark, including the thriving specialist gallery, Galleri Grønlund, Copenhagen, and the Danish Museum of Decorative Art.

Danish studio glass has always been primarily concerned with functional forms, although there has always been some incidence of the freely sculptural, even among those artists who stick mainly to functional forms. And here we are not just talking about Arts and Crafts pieces, although many of the innumerable glass workshops in Denmark today earn their bread and butter by producing commercial glass designs: quality pieces for the home, along with the occasional, less felicitous, souvenir. Some workshops seem to have the ability to cover the whole spectrum of glassmaking, while only a handful concentrate solely on free artistic creativity.

The eight artists profiled in this essay reflect something of the diversity to be found in modern Danish glass and can—over and above their age differences and different educational backgrounds—be distinguished one from another by the techniques they employ.

A.
Micha Maria Karlslund
White Rubber Ring, *2001*
glass
10h

B.
Lene Bødker
Vessel, *2003*
glass
17d

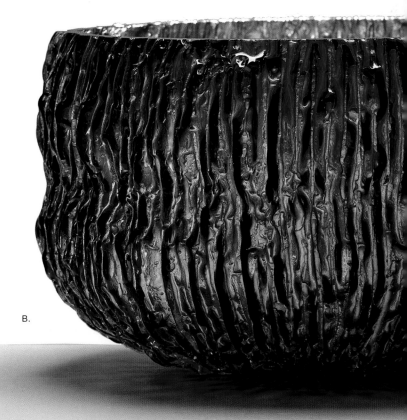

B.

C.
Stig Persson
Gateway, *1999*
glass, metal
75' x 25'

D.
Lene Bødker
Moonlit Night Sky, *2004*
glass, metal
48 x 24 x 2

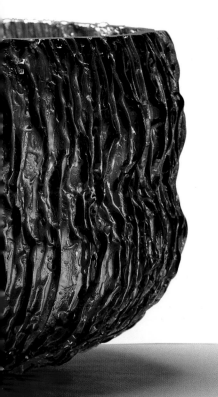

Lene Bødker, born 1958, and Stig Persson, born 1960, graduated from the Danish Design School/ Institute of Design Craft only one year apart (in 1992 and 1993). The two soon made their mark at more or less the same exhibitions, with dense, weighty works in cast glass. In both cases, these were monumental pieces that had the appearance of boxes or sealed containers of various shapes and forms.

The early boxes or caskets of both evolved into block-like, house-like sculptures that Persson himself referred to as "houses" or "towers", and which were at times almost monumental in character. In Persson's work these led to a large installation, *Gateway*, consisting of 48 spears of light, each one several metres tall. Lene Bødker's block sculptures took a rather different direction; even though they are, as a rule, very architectonic, they often referenced nature.

Stig Persson has been working more and more with functional forms: bowls, dishes and vases— chunky, thick-sided pieces, which nonetheless have a strangely ethereal air about them. One series, *Japanese Dishes*, features pieces with almost vertical sides. How Persson manages to produce such sharp angles with such thick glass is an effective mystery.

In 2000, Stig Persson was awarded the Copenhagen Polytechnic's Silver Medal (the top award of its kind, first presented in 1879), for a circular dish with an inlaid center square in a contrasting color.

In recent years, Lene Bødker has taken the working of the surface structure of glass still further. She has been known to take a hammer and chisel to the glass, but for her, the finishing process is just as liable to involve grinding, polishing and patina-tion. While living and working in the US in 1999, she developed a new technique by which the glass is blown up into forms—large bowls or vessels, for example—endowed with a texture full of detail.

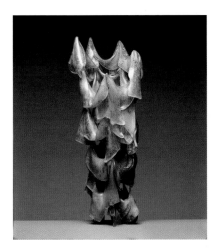

E.
Pipaluk Lake
Floridea III, *2003*
glass
19h

F.
Pipaluk Lake
Crinoidea I, *2003*
glass
16.5h

G.
Micha Maria Karlslund
Black box, *2001*
glass, metal
8h

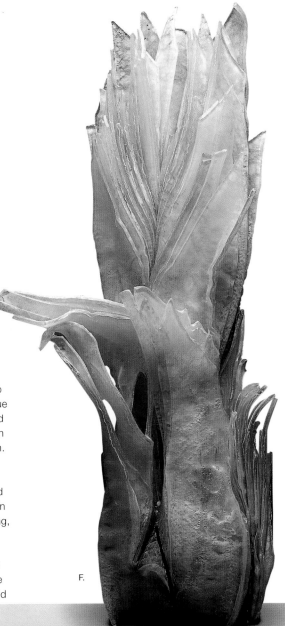

F.

The actual process of creating the mold in which the glass is cast or blown is a complex one, involving many different stages. The basic form may be a model in clay that is translated, via a plaster model, into a number of identical models in wax, each of which is then worked up into a final, individual one-off piece. This technique would appear to offer greater artistic freedom and for Lene Bødker, it has borne fruit in a succession of brilliant glass pieces usually functional in form.

Pipaluk Lake, born 1962, takes a quite different approach to glass. She began by studying wood carving at a school in Norway, receiving her main training at the School of Arts and Crafts in Kolding, Jutland. She supplemented this with study in the US and Sweden, and finally in 1992, at the Copenhagen Polytechnic's Institute for Precious Metals. By then she was already making a name for herself on the international scene, and had held a splendid solo exhibition in Copenhagen.

Pipaluk Lake works mainly with a technique known as *slumping*. Lake almost always has metal integrated into the glass. When heated during the slumping process, the metal produces oxides that color the glass, an effect which can be enhanced by adding different acids, salts and organic substances to the glass and metal. Few artists have explored this technique as thoroughly as Pipaluk Lake. This exceptional artist can take boring old window glass and geometric forms cut from glass and metal, and subject them to a process that results in a highly organic kind of deformation, reminiscent of natural underwater forms.

Two different workshops, each run by an artist couple, can be said to form the brackets of the Nineties Generation: Steffen Dam, born 1961, and Micha Maria Karlslund, born 1963, set up a workshop together in Århus in 1990, moving in 2000 to Handrup near Ebeltoft. Tobias Møhl, born 1970, and Trine Drivsholm, born 1970, opened their workshop down by Ebeltoft harbour in the summer of 1998.

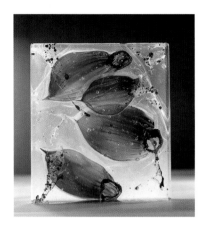

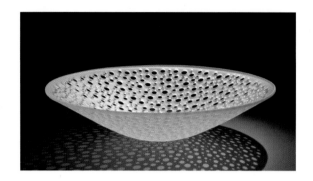

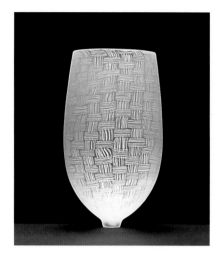

H.
Steffen Dam
Blue Fossil, *2004*
glass
9.5 x 9 x 1

I.
Steffen Dam
Clear Perforated Bowl, *2005*
glass
18d

J.
Tobias Møhl
Glassweaver, *2003*
glass
17h

K.
Tobias Møhl
Black Net, *2003*
glass
9.5h

Micha Maria Karlslund came to glassmaking by a somewhat unconventional route. She did not study at a proper school of glass, as is normally the case. Instead she served an apprenticeship of sorts, with Steffen Dam, and at Ebeltoft Glas with Finn Lynggaard and Tchai Munch. Steffen Dam, on the other hand, began by training as a toolmaker, but went on to learn the art of working with glass the hard way, through tireless experimentation with the finer points of technique and craftsmanship, and an obvious determination to settle for nothing less than perfection.

Although Micha Maria Karlslund was to all intents and purposes, a pupil of Steffen Dam's, it is probably fair to say that she was the first to win recognition. In her earliest exhibition in Copenhagen in 1993, she made a big impression with compound sandblasted glass pieces. Later came fanciful houses that in turn evolved into all manner of boxes, in what was often a sophisticated play on natural forms, seed pods and the like. These themes were developed in exhibitions with such names as *Blown Boxes, Life's Signs,*

An Odd Little Exhibition. As their titles imply, these tended to involve little humorous touches.

In the summer of 2003, Micha Maria Karlslund held her largest exhibition to date, *The Heavens Below Us* at the Glass Museum, Ebeltoft. In this she experimented in various ways with the relationship between glass and space, but she also presented the minuscule entities that made up a hundred strange, and yet not unappealing creatures. Within just a few years, Micha Maria Karlslund has forsaken her initial area of interest functional forms—almost completely.

Functional forms are, however, very much her partner Steffen Dam's domain, even if he does occasionally amuse himself with his *Fossils*—jelly fish and fish encased in flat glass blocks—prime examples of what a master glassmaker can create, and equally as beautiful as illustrations in an antiquarian book.

Steffen Dam's consummate skill is also evident in the scores of exquisitely formed carafes to which he applies a whole range of glassmaking's finest decora-

tive techniques. But best and most original of all, are his platters, bowls and vases, often executed in a lovely bluish glass, or in combinations of clear (white) and blue glass, with holes bored in the glass. Here one finds form and decoration in perfect harmony, classically Italian in inspiration. In terms of consummate craftsmanship, there is nothing to match the matte surface treatment seen, for example, on his *Peacock Eye*.

The somewhat younger sector of the Nineties Generation has produced, perhaps an even more brilliant glassmaker or glassblower in Tobias Møhl. And that, indeed, is what he trained as, working at Holmegaard Glass until 1992. Since then he has regularly attended master classes at Pilchuck Glass School and Haystack Mountain School of Crafts in the US—classes led by Lino Tagliapietra, the Venetian maestro and possibly the finest glassblower in the world. Tobias Møhl now ranks as one of Tagliapietra's favorite assistants. Møhl has mastered most of the traditional Venetian glassmaking techniques, for example, the incredibly tricky reticello or lace technique. Slowly but surely he is progressing

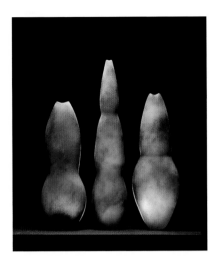

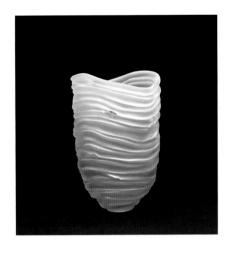

L.
Trine Drivsholm
Three Green Jars, *2003*
glass
various sizes

M.
Marianne Buus
Trail, *2003*
glass
6.5h

N.
Marianne Buus
Cut Series, *2003*
glass
8h

K.

from technical excellence to a somewhat unusual and very exciting style of modern design, but one which is still firmly rooted in the functional form.

Møhl's partner, Trine Drivsholm, was first introduced to glass in England. From 1996 to 1998, she studied at the School of Arts and Crafts in Kolding, Jutland. Since then Drivsholm has attended a number of master classes at Pilchuck Glass School, Haystack Mountain School of Crafts, and the Creative Glass Center in Scotland.

Trine Drivsholm first became known for plates with motifs fused onto the glass by means of a special technique. In 1998, Drivsholm was awarded the Copenhagen Polytechnic's Silver Medal for one of these plates. But what she is best known for now are her series of organically formed vases: positively plantlike pieces with matte or distinctively coarse surface textures. Her colors are exquisite, especially her greenish hues, and the effect, when several vases are grouped close together, is particularly elegant and delicate. And it certainly highlights the subtle variations in form.

Marianne Buus, born 1967, studied mainly in England, with intermittent student placements at Transjö Hyttan and Kosta Glasbruk in Småland, Sweden. She took her MA from the Royal College of Art in London in 1997. She has worked as a designer, and is a guest lecturer at the Glass & Ceramics School on the island of Bornholm. At exhibitions in recent years, her *Trails*—lovely, fluid glass forms constructed in rings or spirals—have generated a lot of interest.

Remarkable breadth and quality are the keynotes of the works produced by this close-knit younger generation of Danish glass artists. Most of the eight artists are already well-established, mature, but scintillatingly creative. Danish glass art is currently enjoying a quiet renaissance, and is gradually gaining quite a reputation for itself both at home and abroad.

Jørgen Schou-Christensen is a curator at The Danish Museum of Art & Design in Copenhagen.

Published in conjunction with the exhibition of Galleri Grønlund, Copenhagen in SOFA NEW YORK 2005.

The Museum of Fine Arts, Houston;
Helen Williams Drutt Collection
Building a Collection: A Passionate Journey

Helen Williams Drutt English

A.

B.

"An awareness of time is a profoundly individual experience. That in the course of his life every person sooner or later finds himself in the position of Robinson Crusoe, carving notches and... crossing them out... and these notches are a profoundly solitary activity isolating the individual and forcing him toward an understanding... of the autonomy of his existence in the world," as Joseph Brodsky, the Russian poet once wrote. One of my notches has carved a segment in the history of modern and contemporary crafts through the formation of a collection. At what point in one's life does the notion occur of placing privately owned objects into a permanent place in the public forum?

If, indeed, the desire to "hold" history through the acquisition of works is primary, then eventually it is necessary for those objects to be secured in an institution that will regard them with the highest artistic integrity. It is important to make certain that forty years of commitment to the field will not be dispersed at auction. It is also important that my lifework not become a responsibility for my children; it constituted my passion, not theirs. Responding to the interest communicated by Peter C. Marzio, Director of the Museum of Fine Arts, Houston, (MFAH), in 2002, made it possible for me to secure a repository that would allow the works to enter into a comprehensive, permanent museum collection, and, in so doing, be incorporated into a diversity of exhibitions. This was the ultimate dream for one whose work was challenged by dissolving the boundaries between the fine and applied arts. In addition, the responsibility to each artist who supported my passion for the field was fulfilled by the MFAH in its desire to document and preserve the works in a scholarly fashion, as well as ensuring their legacy.

• • •

The resurgence of the modern craft movement after World War II signaled great changes in the field of contemporary jewelry. Although exhibitions exploring new movements in the fine arts were part of the early 1960s, information heralding avant-garde concepts–and approaches diametrically opposed to the prevalent ideas of ornamentation— were rarely part of this public forum. Two major exhibitions occurred in Europe: In 1961, the "International Exhibition of Modern Jewelry: 1890-1961" was held in London, and three years later, "Internationale Ausstellung: Schmuck" was held in Darmstadt, Germany. These exhibitions proved to be the catalysts for collections in Europe to develop. Throughout the world, however, works still awaited discovery and artists awaited recognition.

• • •

In 1964, I was the proud owner of a gold-plated circle pin, acquired around 1948, and my grandmother's cameo brooch, laced in platinum and diamonds, which was given to her by my father in 1918. It was inconceivable to me that four decades later, I would be surrounded by the treasures of my time. My interest in decorative embellishments for the body lay dormant until I was thirty-five. A third acquisition in 1955, was a replica of Queen Shubad's gold-leaf necklace. I wore it with pride! A decade later, I discovered that the prototype had been made by Olaf Skoogfors for the University of Pennsylvania Museum.

In 1965, during a visit to Stanley Lechtzin's studio, a brooch that was near completion caught my eye. The electroformed object was an abstract form that incorporated the aesthetic qualities of painting and sculpture, and it stirred me passionately. At the same time, Olaf Skoogfors and I were engaging in

lengthy and stimulating conversations about nature, music, industrialism, socialism, and constructivism, evoked by his pins and pendants. Both Skoogfors and Lechtzin lived and taught in Philadelphia. Initially, one reason for owning the work was to promote my newly born interest in the craft movement. It was logical that no one could carry a vessel or chair into a meeting, yet wearing a brooch was no different from being a living billboard. Jewelry acted as a catalyst for questions and queries from museum directors, curators, acquaintances, students, even strangers. A golden triangle was formed—artist, object, observer–bound together by pioneering galleries, visionary institutions, artists, and patrons. And the memories of that time are numerous. I remember delivering an impromptu lecture to a charwoman in a train station as she tried to grasp the lyrical complexities of an Albert Paley brooch. Another time, I was an unannounced guest lecturer on a flight from Philadelphia to Detroit because I was wearing an electroformed torque by Lechtzin. The recognition of their works stimulated continuous debate and inquiry. It was important for the works to have a walking educator.

• • •

A.
Gijs Bakker
Botticelli Project *Neckpiece, 1990*
1990
PVC, print, gilded brass, 18k gold
The Museum of Fine Arts, Houston;
Helen Williams Drutt Collection
photo: Thomas R. DuBrock

B.
Beyond Ornament: Selections from
the Helen Williams Drutt Collection
The Museum of Fine Arts, Houston
August 16, 2003 through July 5, 2004
photo: Thomas R. DuBrock

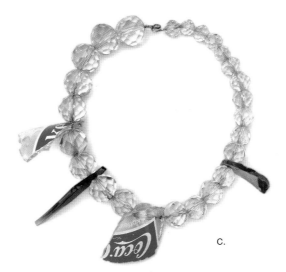

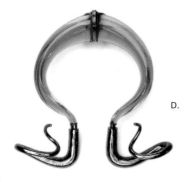

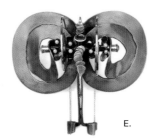

C.

D.

E.

The founding of the Philadelphia Council of Professional Craftsmen (PCPC), in 1967, and the development of the first syllabus for a modern craft history course, in 1973, at the Philadelphia College of Art (now University of the Arts) were important factors that led to the establishment of the Helen Drutt Gallery, in Philadelphia, in 1973-74. These events placed me in contact with artists and significant works that until then had evoked little public response. During this time, panels, lectures, and exhibitions were organized, including the first David Watkins—Wendy Ramshaw show to be held in America, in Philadelphia (1973). With continuing independent research, these activities dominated my existence and ignited the acquisition spark. I was encouraged to consider acquisitions as essential to the operating budget of the gallery as the utilities and services necessary to sustain it.

● ● ●

In the beginning, the formation of the Helen Williams Drutt (HWD) collection was not intentional, nor was it a primary concern. Objects were disappearing from exhibitions held at universities, colleges, and nonprofit institutions, and were not being documented properly. Museums were not seriously collecting jewelry, and there was no forum for private collectors. The lack of support made me realize that collecting to "hold" history was becoming essential. My instinct for the recognition of major works was strong.

Today, the MFAH: HWD collection reflects the activities that were central to my life in Philadelphia and to the travel that the mounting interest in the craft movement ultimately necessitated. Some of the first acquisitions were Stanley Lechtzin, Bruce Metcalf, Eleanor Moty, Albert Paley, the Pencil Brothers (Ken Cory and Les LePere), Olaf Skoogfors, and Fred Woell. When Claus Bury came to this country to lecture in the fall of 1973, he was my houseguest, which resulted in another acquisition for the collection. My knowledge of his work initially came through his documentation in the catalogue *Gold + Silber, Schmuck + Gerät: Von Albrecht Dürer bis zur Gegenwart,* which accompanied the exhibition in Nuremberg, Germany, in 1971. This publication was a seminal force in my introduction to European work.

C.
Bernhard Schobinger
Scherben vom Moritzplatz
Berlin Necklace, 1983-1984
antique crystal beads, splinters of television bulbs, German Coca-Cola bottle, silver, steel wire
The Museum of Fine Arts, Houston; Helen Williams Drutt Collection, gift of Gail and Louis K. Adler in honor or Fayez Sarofim
photo: Thomas R. DuBrock

D.
Stanley Lechtzin
Torque 22-D Neckpiece, 1971
sterling silver, polyester resin
The Museum of Fine Arts, Houston; Helen Williams Drutt Collection
photo: Thomas R. DuBrock

E.
Albert Paley
Double Fibula Brooch, 1968
gold, silver, bronze, pearls, moonstone, Madagascar labradorite
The Museum of Fine Arts, Houston; Helen Williams Drutt Collection, gift of Mr. and Mrs. John W. Mecom, Jr., by exchange
photo: Thomas R. DuBrock

F.
Peter Chang
Bracelet, 1991
acrylic, gold leaf, resin, PVS
The Museum of Fine Arts, Houston; Helen Williams Drutt Collection
photo: Thomas R. DuBrock

G.
Tone Vigeland
Neckpiece, 1981
steel, silver, 14k and 18k gold
12.5 x 12.5
The Museum of Fine Arts, Houston; Helen Williams Drutt Collection, gift of the Susan Vaughan Foundation
photo: Hans-Jorgen Abel

Works by avant-garde European artists, removed from the traditional concept of jewelry, compelled me to make purchases from abroad—in particular, a Gerd Rothman bracelet, in 1973, from London's Electrum Gallery. My relationship with the late Emmy van Leersum and Gijs Bakker began during their American lecture tour in 1974; as a result, I began to visit the Netherlands. As the friendship grew, it led to a deeper understanding of their work as well as a commitment on my part to preserve their, and many other international artists' history in an American collection.

• • •

In 1980, the World Crafts Council meeting in Vienna, created a dynamic forum for international crafts, heralded by "Schmuck International." It was there that I first met its organizer Peter Skubic, as well as Bruno Martinazzi, Fritz Maierhofer, and Inge Asenbaum, who was the founder-director of Galerie Au Graben and a major collector. The many encounters with Martinazzi in the decade that followed eventually led to the introduction of his work to the American audience. Chance meetings with other artists provided an introduction to a range of previously unknown individuals and works. One of the most rewarding was with Breon O'Casey, at the Irish Historical Society, New York, in the fall of 1981.

Serendipity and sheer pursuit on my part played an important role in the acquisition of work. Peter Chang, for instance, entered my life quite accidentally; we met in the Frankfurt train station en route to "Ornamenta I," at the Schmuckmuseum, in Pforzheim, Germany. It was there that I also bonded with Manfred Bischoff and developed a deeper friendship with Georg Dobler. During that decade, invitations to lecture and perform research brought me to Israel in 1983 and to Australia in 1992, broadening the scope of the collection as well as the exhibition schedule in the gallery. As the collection traveled throughout Europe and the United States, opportunities to incorporate works by artists not represented by the gallery presented themselves. The late 1990s saw renewed interest in America's Northwest. In addition to the works of Merrily Tompkins and the Pencil Brothers, the holdings were increased to include Ron Ho, Kiff Slemmons, Ramona Solberg, Don Tompkins, and Nancy Worden.

• • •

The notion that a collection existed did not occur until I was invited by Paul Smith to participate in an exhibition entitled "The Collector," at the Museum of Contemporary Crafts, New York (now Museum of Arts and Design), in 1974. In 1984, however, the HWD collection formally began its exhibition schedule with an invitation from the Montreal Musée des Arts Décoratifs, and continued to tour Europe and the United States through 1995. After it entered the permanent collection of the MFAH in 2002, selections were exhibited in "Beyond Ornament," 2003-4. A comprehensive exhibition of the collection, "Ornament as Art: Avant-Garde Jewelry from the Museum of Fine Arts, Houston's Helen Williams Drutt Collection," will be organized by Cindi Strauss, Curator of Modern and Contemporary Decorative Arts and Design at the MFAH, and shown in February 2007, accompanied by a definitive catalogue. This journey has been augmented by lecturing, visiting studios, conducting oral histories, and organizing exhibitions, as well as attending events that always expand the dialogue.

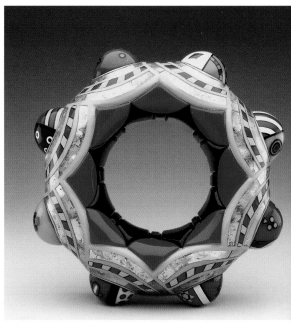

F.

• • •

Traditionally, it is the role of the art historian and critic to recognize and preserve the work of their age, but the independent observer, free from poltics and board restrictions, also affords the artist freedom from oblivion. Our museums, therefore, are filled with objects from collectors whose spirit of adventure and passion has documented the taste of their time and held the reins of history.

• • •

Luis Buñuel, in his autobiography, talks about memory—that life without memory is no life at all, that the hidden treasures we have buried in our mind are waiting to be recalled. Possessing the physical pieces reinforces that transition from our memory into language and into history. It's like Hemingway's initial impressions of Paris: "The images stay with you your entire life, like a movable feast." For us, it is a visual feast that forms one segment of the international history of jewelry. Other collections may embrace a different selection of artists and works, also central to the field, that reflect the activities of their collectors and the artists connected with them. Different cities, different artists, and different stimuli—they all form another chapter in the chronicles of twentieth and twenty-first century art.

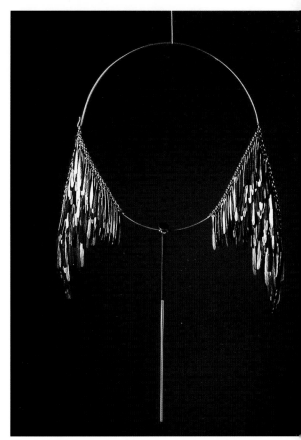

G.

H.
William P. Daley
Manhattan Canyon Wall, 1971
stoneware
73 x 112 x 14
The Museum of Fine Arts,
Houston; Gift of Marlin
Miller Jr. and Helen Williams
Drutt English
photo: Thomas R. DuBrock

I.
Robin Kranitzky and
Kim Overstreet
Starmaker Brooch #1626, 1993
nickel silver, acrylic, brass, paper,
egg shell, postcard fragments,
found objects, Mylar, balsa
The Museum of Fine Arts,
Houston; Helen Williams
Drutt Collection
photo: Thomas R. DuBrock

J.
Manfred Bischoff
Rene Descartes Ring, 1971
mirrored glass, coral, gold,
copper alloy
73 x 112 x 14
The Museum of Fine Arts,
Houston; Helen Williams
Drutt Collection
photo: Thomas R. DuBrock

K.
Bruno Martinazzi
Aquila Brooch, 1990
20k gold, marble; fabricated,
unique
1.25 x 1.25 x .5
The Museum of Fine Arts,
Houston; Helen Williams
Drutt Collection
photo: Jack Ramsdale

H.

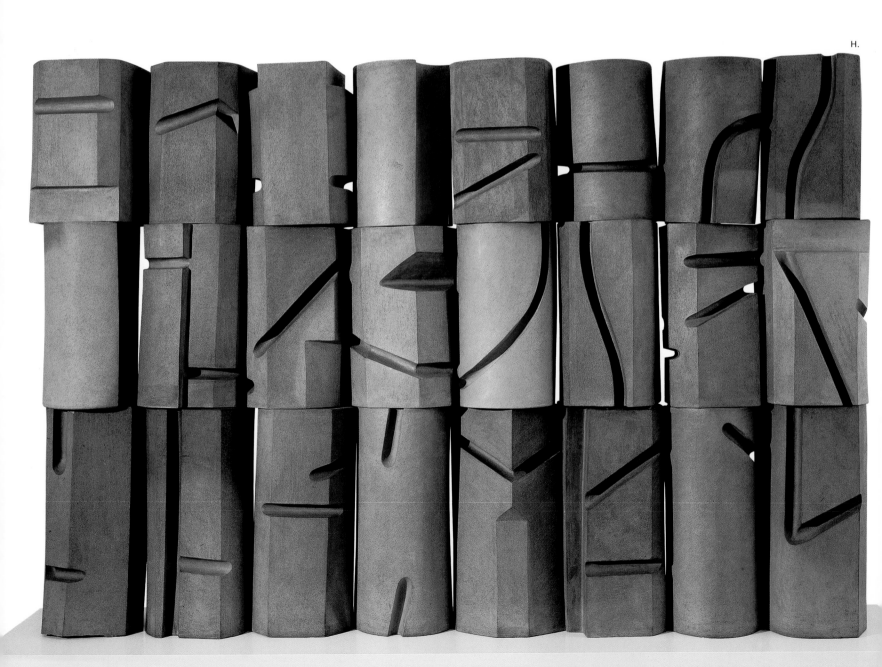

I.

J.

K.

The MFAH: HWD collection documents my experiences and relationships of the past forty years. It is not meant to be an inclusive history. The premise for the acquisition of a work was based on a dialogue with the artist. Rarely did objects enter the collection from people with whom there was no contact. More than six hundred fifty works of art were drawn from seventeen countries within five continents. The collection includes pieces by established artists and by artists little known at the time of acquisition who have since achieved international renown. Some have moved into other fields of contemporary art, industrial design, and architecture, and some died prematurely from illness—Toni Goessler-Snyder, Tony Papp, and Olaf Skoogfors. Their history is bound in the objects. Among the internationally recognized artists are Gijs Bakker, Claus Bury, Peter Chang, Georg Dobler, Yasuki Hiramatsu, Hermann Jünger, Stanley Lechtzin, Bruno Martinazzi, Breon O'Casey, Albert Paley, Wendy Ramshaw, Gerd Rothmann, Emmy van Leersum, Tone Vigeland, and David Watkins.

• • •

How do people come together? How does the international dialogue begin to expand? Among the important events that occurred in 1970 were the World Crafts Council meeting, in Dublin, and the first meeting of the Society of North American Goldsmiths (SNAG), in St. Paul, Minnesota. Thirty-five years later, I realize how important those meetings were. Contact among the patrons, artists, and museum professionals gave rise to a historical exchange of information—and the birth of collections. Today, some of the professional events that continue to expand the dialogue are the SNAG conferences in the United States, Schmuck in Munich, and art fairs such as SOFA NEW YORK, SOFA CHICAGO, and Collect in London.

Seeing and discovering transforms the act of acquisition into the greater notion of caretaking and securing the history for the artist. This concept defines the Museum of Fine Arts, Houston's Helen Williams Drutt Collection and reinforces its journey from the private sector into the public domain. Although its residence and ownership have changed, the desire to continue expanding the collection has not diminished. In recent months, great consideration has been given to increasing its historical base as well as to fulfilling my mandate from the museum to search for collateral material and consult with the department of Modern and Contemporary Decorative Arts and Design.

The MFAH has made a major commitment to our field. In so doing, it has lent credibility and integrity to works that previously struggled for recognition. Their legacy has been secured, and my work has been confirmed by a major institution. It's been a great journey!

Helen W. Drutt English has been a resource to scholars and institutions in the field of Modern and Contemporary Crafts for over thirty-five years. Founder/Director of the Helen Drutt: Philadelphia (1973/4 – 2002) she has also organized seminal exhibitions which include *Poetics of Clay: An International Perspective* (2001), and *Brooching it Diplomatically: a Tribute to Madeleine K. Albright* (1998), both traveled internationally. Co-author with Peter Dormer of *Jewelry of Our Time*, she has contributed essays to numerous publications.

Portions of this essay are excerpted from the introduction to *Jewelry of Our Time*, Thames and Hudson Ltd, London, 1995.

Exhibitions of the Helen Williams Drutt Collection, listed under a short form of the titles given by the exhibiting bodies:

A Movable Feast 1964-1994, Museum voor Moderne Kunst, Ostend, 1995; Stedelijk Museum, Amsterdam, 1994/1995

Schmuck Unserer Zeit 1964-1994, Museum Bellerive, Zurich, 1994

Contemporary Jewelry 1964-1993: Selected Works, HWD Collection, The Arkansas Arts Center, Little Rock, AK, 1993

Korun Kieli (The Language of Jewelry) 1964-1992, Röhsska Konstslöjdmuseet, Gothenburg, 1992/93; Taideteollisuusmuseo, Helsinki, 1992

Modern Jewelry 1964-1984, Philadelphia Museum of Art, PA, 1986/1987; Cleveland Institute of Art, OH, 1986; Honolulu Academy of Arts, HI, 1986; Montreal Musée des Arts Décoratifs, 1984/1985

Published in conjunction with the SOFA NEW YORK 2005 special exhibit *A New Vision: Collecting at the Museum of Fine Arts, Houston* presented by the Museum of Fine Arts, Houston and Helen Drutt: Philadelphia and lectures Building a Collection: A Passionate Journey by Helen W. Drutt English and A New Vision: Collecting at the Museum of Fine Arts, Houston by Cindi Strauss.

• • •

A New Vision: Collecting at the Museum of Fine Arts, Houston

A New Vision: Collecting at the Museum of Fine Arts, Houston will feature select highlights from the MFAH's decorative arts collection including works by the Norwegian artist Tone Vigeland from the newly acquired Helen Williams Drutt Collection of modern and contemporary jewelry. Also included in the presentation will be a monumental ceramic installation entitled *Manhattan Canyon Wall* (1971) by the American artist William Daley and one of Wendell Castle's trompe l'oeil mahogany sculptures, *Coat Rack with Trench Coat* (1978), among other pieces.

The MFAH's decorative arts department was founded in 1976 and has been collecting craft since that time. In the past decade, the museum has reaffirmed its commitment to this area by actively acquiring and exhibiting ceramics, fiber, furniture and woodwork, glass, jewelry, and metalwork. The special exhibition reflects the museum's aim to collect globally in all media by both acknowledged masters and emerging artists alike.
-Cindi Strauss, Curator, Modern & Contemporary Decorative Arts and Design, Museum of Fine Arts, Houston.

hibitors

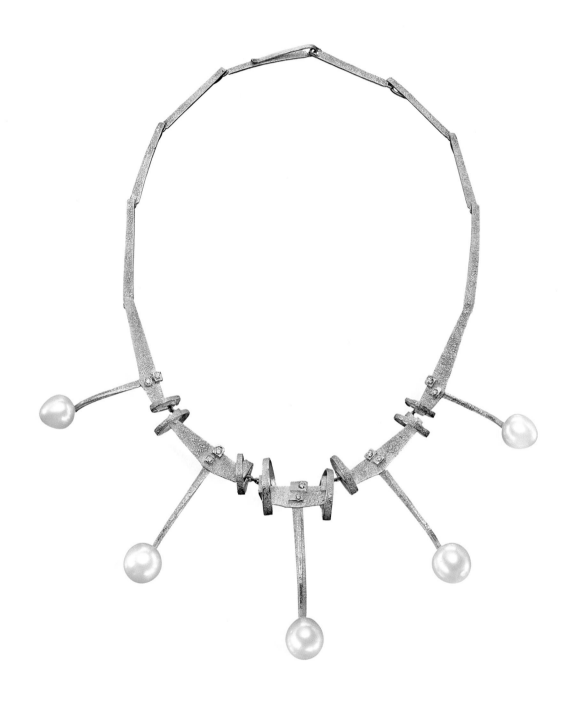

Marco Borghesi, **Winter in Venice necklace,** *2004*
18k yellow gold, South Sea pearls, diamond
photo: Arnold Katz

Aaron Faber Gallery

Thirty years of personalizing jewelry design and style; Special SOFA NEW YORK Presentation: Artist and Collector

Staff: Edward Faber; Patricia Kiley Faber; Felice Salmon; Erika Rosenbaum; Jackie Wax; Jerri Wellisch; Sabrina Danuff; Ji-Hae

666 Fifth Avenue
New York, NY 10103
voice 212.586.8411
fax 212.582.0205
info@aaronfaber.com
aaronfaber.com

Representing:
Glenda Arentzen
Margaret Barnaby
Marco Borghesi
Wilhelm Buchert
Ute Buge-Buchert
Claude Chavent
Françoise Chavent
Lina Fanourakis
Christine Hafermalz-
 Wheeler
Melissa Huff
Sydney Lynch
Enric Majoral
Bernd Munsteiner
Jutta Munsteiner
Tom Munsteiner
Tod Pardon
Linda Kindler Priest
Marianna Sammartino
Susan Kasson Sloan
Noriko Sugawara
Jeff Wise
Susan Wise
Michael Zobel

Wilhelm Buchert, **Brooch,** *2004*
20k yellow gold, 0.48ct yellow sapphire, 0.31ct diamond, 2 x 2

Lina Fanourakis, **Flower brooch**
24k, 22k, 18k yellow gold, 18k pink gold, 3.25 x 3.5

*Artist and Collector: Studio artists highlight their newest work
with a favorite piece from another jewelery artist*

Clara Ines Arana / Giselle Kolb
Glenda Arentzen / Earl Pardon
Whitney Boin / Barbara Heinrich
Harlan Butt / Ingrid Psuty
Valerie Jo Coulson / Anya Kristin Beeler
Lina Fanourakis / Françoise and Claude Chavent
Melissa Huff / Sarah Perkins
Jeannie Hwang / Curtis Arima
Janis Kerman / Barbara Heath
Steven Kretchmer / Michael Bondanza
Micki Lippe / Jennifer Howard-Kicinski
Christine Mackellar / Luci Heskett-Brem
Jan Mandel / Jay Song
Eleanor Moty / Yuyen Cheng
Harold O'Connor / Wilhelm Tasso Mattar
Tod Pardon / Sharon Church
Gayle Saunders / Robin Quigley
George Sawyer / Judith Kinghorn
Sam Shaw / Pat Flynn
Susan Sloan / Robert Ebendorf
Yumi Ueno / Tod Pardon
Alexandra Watkins / Margot di Cono

Glenda Arentzen, **Box bracelet**
*24k yellow gold, 14k yellow, white and pink golds, .75 x 7
photo: Arnold Katz*

Chris Hill, **Rhythm Shift**
welded steel, acrylic paint, 48 x 72

Ann Nathan Gallery

Established and emerging contemporary realist painters, artist-made steel furniture, famed ceramic and bronze sculptures, visionaries and selective African art
Staff: Ann Nathan; Victor Armendariz; Sarah Coffey; John Welter

212 West Superior Street
Chicago, IL 60610
voice 312.664.6622
fax 312.664.9392
nathangall@aol.com
annnathangallery.com

Jim Rose, **Quilt Cupboard**
welded blue steel, found colored panels, 74 x 52 x 21

Representing:
Mary Borgman
Gordon Chandler
Cristina Cordova
Gerard Ferrari
Krista Grecco
Michael Gross
Chris Hill
Jesus Curia Perez
Jim Rose
John Tuccillo
Jerilyn Virden

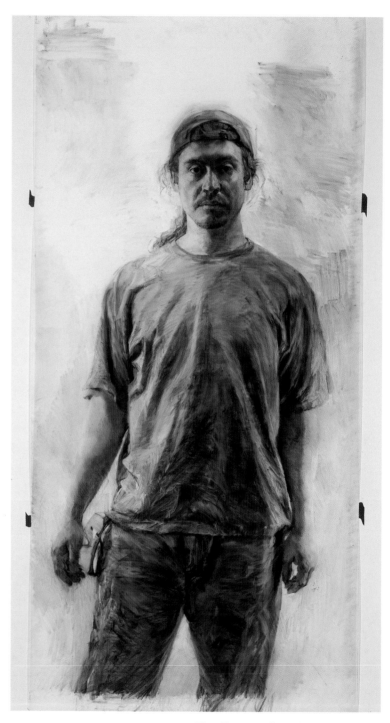

Mary Borgman, **Portrait of Jose Manuel**
charcoal on Mylar, 82 x 42

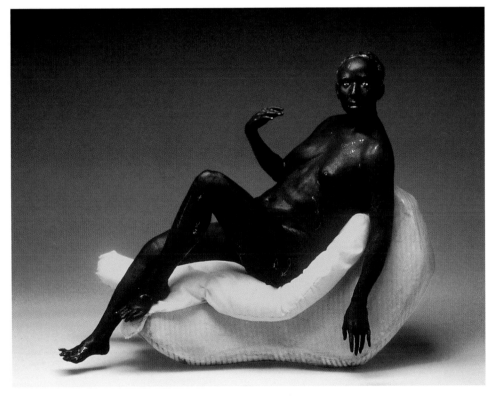

Cristina Cordova, **Ana en Reposo**
ceramic, mixed media, 22 x 18 x 8

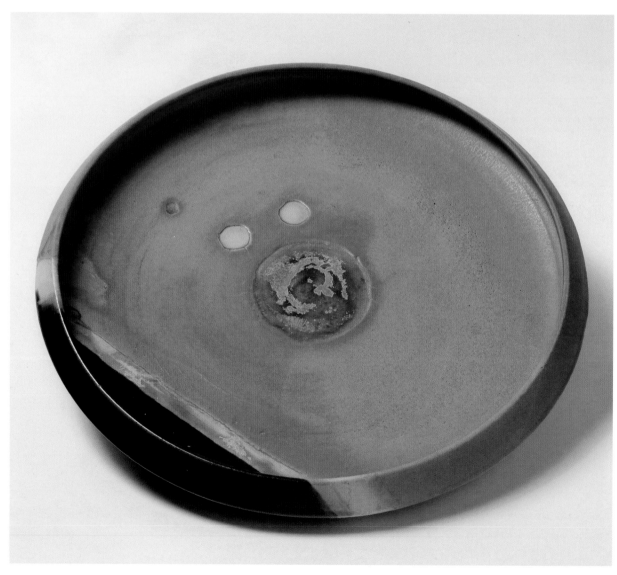

Simone Racz, **Universe I,** *2000*
stoneware, 15d

Artempresa

International contemporary art, with special emphasis in Latin American expressions
Staff: Maria Elena Kravetz, director; Raul Nisman; Matias Alvarez, assistant

San Jeronimo 448
Cordoba 5000
Argentina
voice 54.351.422.1290
fax 54.351.427.1776
artempresa@arnet.com.ar
artempresagallery.org

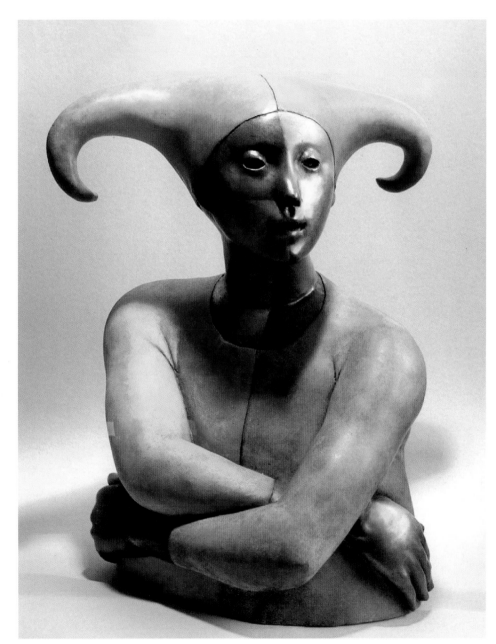

Elias Toro, **Arlequin**, *2004*
bronze, 224 x 206 x 10

Representing:
Faba
Elizabeth Gavotti
Nora Kimelman
Celia Marco del Pont
Cristina Nuñez
Silvia Parmentier
Simone Racz
Margarita Selva
Maria Alejandra Tolosa
Elias Toro
Feyona Van Stom

Yoichi Ohira, **Ricordo delle vetrate di Parigi Vase**, *2004*
hand-blown glass canes with murrine, granular, and powder inserts; faceted surface, 7.75 x 7.5
photo: F. Ferruzzi

Barry Friedman Ltd.

Contemporary decorative arts, including glass, cutting-edge furniture, ceramics, wood and metal
Staff: Barry Friedman; Carole Hochman, director; Marc Benda, director; Erika Brandt; Lisa Jensen; Spencer Tsai

32 East 67th Street
New York, NY 10021
voice 212.794.8950
fax 212.794.8889
contact@barryfriedmanltd.com
barryfriedmanltd.com

Ron Arad, **Spanish Made**, *1990*
polished and patinated steel
photo: Graeme Montgomery

Representing:
Ron Arad
Giles Bettison
Jaroslava Brychtová
Václav Cigler
Tessa Clegg
Laura de Santillana
Ingrid Donat
Droog
Erwin Eisch
Michael Glancy
William Hunter
Stanislav Libenský
Massimo Micheluzzi
Joel Philip Myers
Yoichi Ohira
František Vízner
Toots Zynsky

Olga de Amaral, **Umbra 33 Roja,** *2003*
fiber, gesso, acrylic, 68.5 x 39.5

Bellas Artes/Thea Burger

Staff: Thea Burger; Charlotte Kornstein

653 Canyon Road
Santa Fe, NM 87501
voice 505.983.2745
fax 505.983.1271
bc@bellasartesgallery.com
bellasartesgallery.com

39 Fifth Avenue, Suite 3B
New York, NY 10003
voice 802.234.6663
fax 802.234.6903
burgerthea@aol.com

Representing:
Olga de Amaral
Richard DeVore
Ruth Duckworth
Shihoko Fukumoto
Shoichi Ida
Robert Kushner
Norma Minkowitz
Judy Pfaff

Olga de Amaral, **Umbra 34,** *2003*
fiber, gold leaf, acrylic, 32 x 78.5

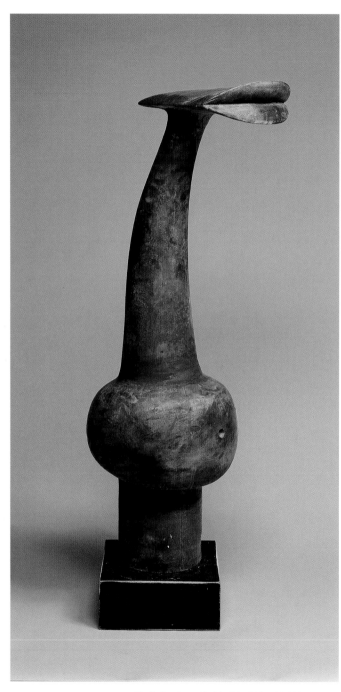

Ruth Duckworth, **Untitled No. 692900,** *2000*
stoneware, 47 x 16 x 15
photo: James Prinz

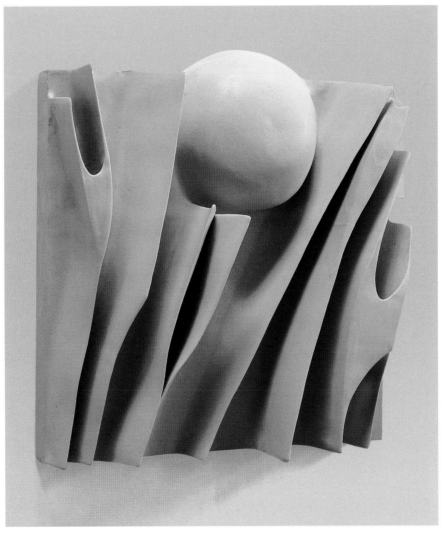

Ruth Duckworth, **Untitled No. 7541201,** *2001*
porcelain
photo: James Prinz

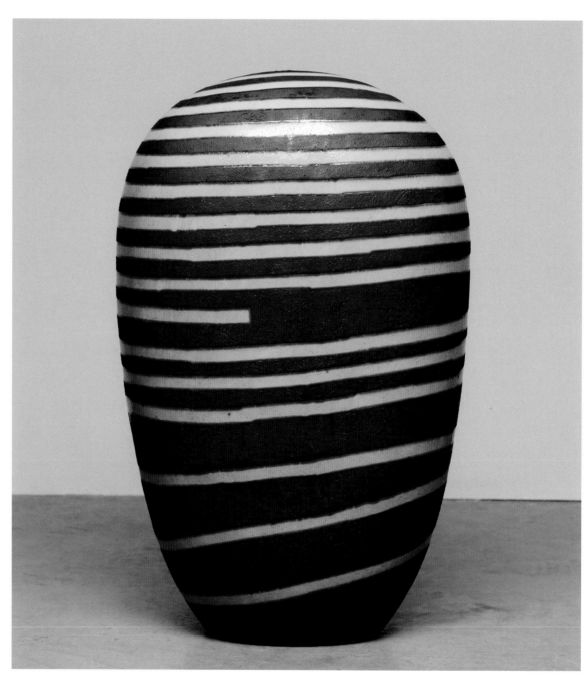

Jun Kaneko, **Untitled Dango,** *2004*
hand-built glazed ceramic, 31.5 x 19.25 x 12
photo: Dirk Bakker

Bentley Projects

Contemporary sculpture, painting, works on paper, and fine craft
Staff: Betsy Rosenmiller; Michael Costello; Daryl Childs; Glen Lineberry

215 East Grant Street
Phoenix, AZ 85004
voice 602.340.9200
fax 775.206.9140
information@bentleygallery.com
bentleyprojects.com

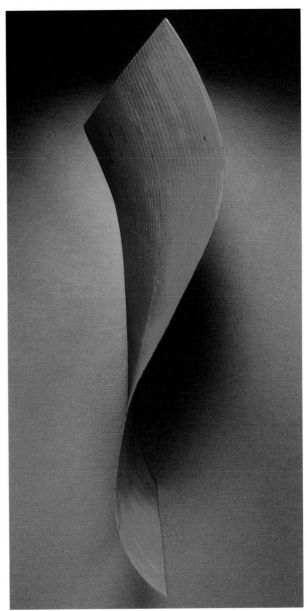

Representing:
Jeremy Briddell
Woods Davy
Jeff Dick
Keitaro Fujii
Jun Kaneko
Matt Moulthrop
Philip Moulthrop
John Nelson
Shigeru Oyatani
Nancy Sansom Reynolds
John Rose
Carrie Seid
Bobby Silverman
Tom Tuberty
Cybèle Young

Nancy Sansom Reynolds, **Red Fall,** *2005*
laminated wood, 45 x 14

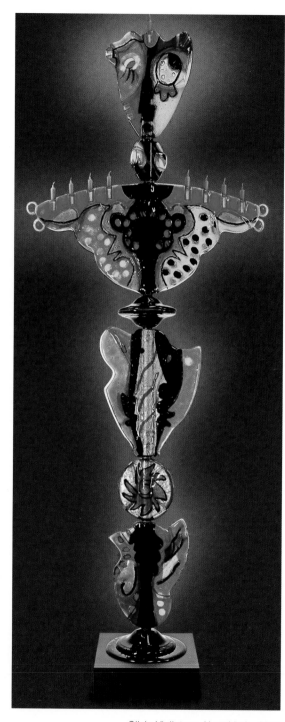

Silvio Vigliaturo, **Hanukkah,** *2004*
fusion glass, 94 x 37 x 18
photo: F. Ferruzzi

Berengo Fine Arts

Contemporary art and glass art
Staff: Adriano Berengo, director; Hans van Enckevort, fair manager

Kortestraat 7
Arnhem 6811 EN
The Netherlands
voice 31.26.370.2114
voice 31.61.707.4402
fax 31.26.370.3362
berengo@hetnet.nl

Berengo Collection
Calle Larga San Marco
412/413
Venice 30124
Italy

Glass Studio & Gallery
Fondamenta Vetrai 109/A
Murano, Venice 30141, Italy
voice 39.041.739453
voice 39.041.5276364
fax 39.041.527.6588
adberen@berengo.com
berengo.com

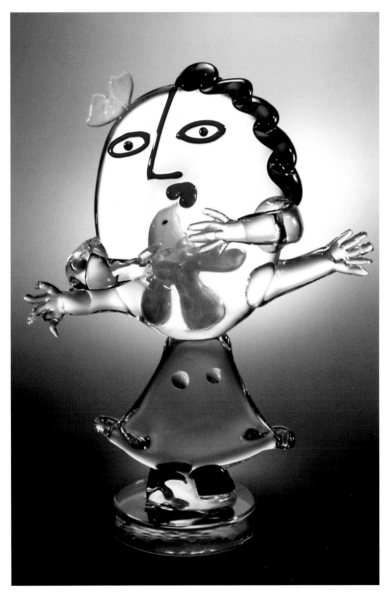

Representing:
Luigi Benzoni
Dusciana Bravura
Pino Castagna
James Coignard
Marya Kazoun
Kiki Kogelnik
Irene Rezzonico
Juan Ripollés
Shan Shan Sheng
Silvio Vigliaturo

Juan Ripollés, **Beso de la Paz**, *2004*
Murano glass, 22 x 21 x 9
photo: F. Ferruzzi

Jin-Sook So, **Constructions (Pojagi inspirations work),** *2000*
steel mesh, electroplated silver, gold, paint, steel thread, 14.5 x 14.5 x 2.25 each
photo: Tom Grotta

browngrotta arts

Focusing on art textiles and fiber sculpture for 18 years
Staff: Rhonda Brown and Tom Grotta, co-curators; Roberta Condos, associate

Wilton, CT
voice 203.834.0623
fax 203.762.5981
art@browngrotta.com
browngrotta.com

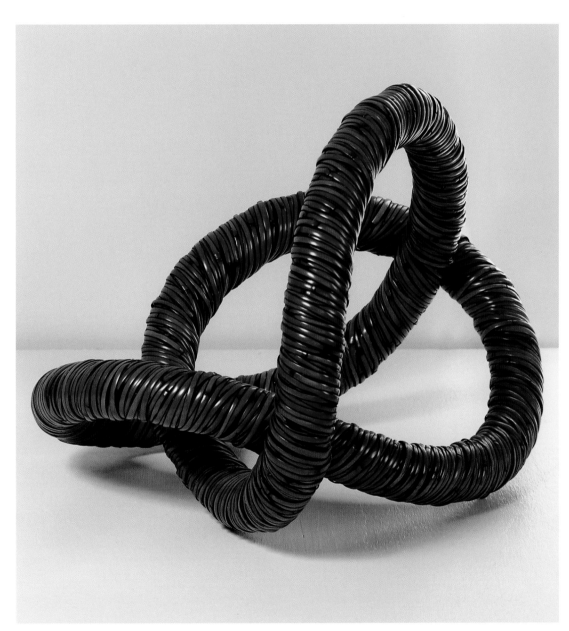

Jiro Yonezawa, Mu, 2003
bamboo, 17.5 x 21.5 x 21.5
photo: Tom Grotta

Representing:

Adela Akers	Gyöngy Laky
Dona Anderson	Inge Lindqvist
Jeanine Anderson	Åse Ljones
Marijke Arp	Astrid Løvaas
Jane Balsgaard	Dawn MacNutt
Jo Barker	Ruth Malinowski
Dorothy Gill Barnes	Mary Merkel-Hess
Caroline Bartlett	Judy Mulford
Dail Behennah	Leon Niehues
Nancy Moore Bess	Keiji Nio
Birgit Birkkjaer	Simone Pheulpin
Sara Brennan	Valerie Pragnell
Jan Buckman	Ed Rossbach
Pat Campbell	Scott Rothstein
Chris Drury	Mariette Rousseau-
Lizzie Farey	Vermette
Ceca Georgieva	Debra Sachs
Mary Giles	Toshio Sekiji
Linda Green	Hisako Sekijima
Françoise Grossen	Kay Sekimachi
Norie Hatekayama	Carol Shaw-Sutton
Ane Henricksen	Hiroyuki Shindo
Maggie Henton	Karyl Sisson
Helena Hernmarck	Britt Smelvær
Sheila Hicks	Jin-Sook So
Marion Hildebrandt	Grethe Sørenson
Agneta Hobin	Kari Stiansen
Kazue Honma	Noriko Takamiya
Kate Hunt	Chiyoko Tanaka
Kristín Jónsdóttír	Hideho Tanaka
Christine Joy	Tsuroko Tanikawa
Glen Kaufman	Blair Tate
Ruth Kaufmann	Lenore Tawney
Tamiko Kawata	Jun Tomita
Anda Klancic	Deborah Valoma
Lewis Knauss	Claude Vermette
Mazakazu Kobayashi	Ulla-Maija Vikman
Naomi Kobayashi	Kristen Wagle
Nancy Koenigsberg	Wendy Wahl
Yasuhisa Kohyama	Katherine Westphal
Irina Kolesnikova	Jiro Yonezawa
Markku Kosonen	Masako Yoshida
Kyoko Kumai	

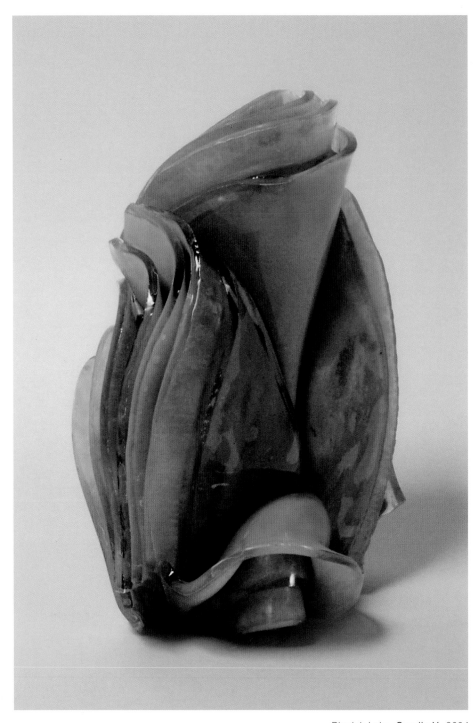

Pipaluk Lake, **Coralla V**, *2004*
slumped sheet glass, oxide, iron wire, 11 x 6

Chappell Gallery

Contemporary glass sculpture
Staff: Alice M. Chappell, director; Kathleen M. Pullan, manager

526 West 26th Street
Suite 317
New York, NY 10001
voice 212.414.2673
fax 212.414.2678
amchappell@aol.com
chappellgallery.com

Representing:
Sean Albert
Mary Ann Babula
Alex Gabriel Bernstein
Lyndsay Caleo
Stanislava Greboníčková
Eva Heyd
Kathleen Holmes
Toshio Iezumi
Yoko Kuramoto
Pipaluk Lake
Anna Matoušková
Kait Rhoads
Takeshi Sano
Youko Sano
Lada Semecká
Naomi Shioya
Ethan Stern
Sasha Zhitneva

*Alex Gabriel Bernstein, **Fault**, 2005*
cast glass, fused steel, 13 x 8 x 3
photo: Daniel Fox

*Kathleen Holmes, **Sampler**, 2005*
cast glass, fabric, buttons, metal, 16 x 10 x 9
photo: James Dee

Toshio Iezumi, **P 030303**, *2003*
carved, laminated glass, 24 x 16 x 2
photo: Toshio Iezumi

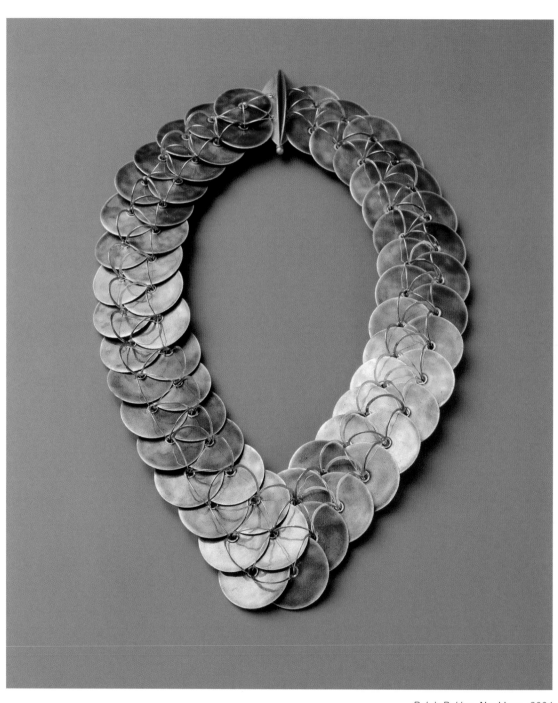

*Ralph Bakker, **Necklace**, 2004*
silver, gold, enamel
photo: Ralph Bakker

Charon Kransen Arts

Contemporary innovative jewelry from around the world
Staff: Adam Brown; Lisa Granovsky; Charon Kransen; Ciel Bannenberg

By Appointment Only
456 West 25th Street
New York, NY 10001
voice 212.627.5073
fax 212.633.9026
charon@charonkransenarts.com
charonkransenarts.com

Representing:

Efharis Alepedis	Lucia Massei
Ralph Bakker	Christine Matthias
Rike Bartels	Elisabeth McDevitt
Ela Bauer	Bruce Metcalf
Michael Becker	Miguel
Harriete Estel Berman	Naoka Nakamura
Brigitte Bezold	Evert Nijland
Liv Blavarp	Barbara Paganin
Julie Blyfield	Gundula Papesch
Antje Braeuer	Anya Pinchuk
Sebastian Buescher	Natalya Pinchuk
Anton Cepka	Kaire Rannik
Yu Chun Chen	Jackie Ryan
Giovanni Corvaja	Lucy Sarneel
Simon Cottrell	Renate Schmid
Claudia Cucchi	Claude Schmitz
Peter de Wit	Biba Schutz
Peter Frank	Marjorie Simon
Ursula Gnaedinger	Evelien Spikes
Sophie Hanagarth	Elena Spano
Valerie Hector	Claudia Stebler
Mirjam Hiller	Dorothee Striffler
Yasuki Hiramatsu	Barbara Stutman
Meiri Ishida	Hye-Young Suh
Reiko Ishiyama	Janna Syvanoja
Hiroki Iwata	Salima Thakker
Hilde Janich	Ketli Tiitsar
Mette Jensen	Terhi Tolvanen
Sergey Jivetin	Silke Trekel
Karin Johansson	Catherine Truman
Ike Juenger	Erik Urbschat
Martin Kaufmann	Flora Vagi
Ulla Kaufmann	Felieke van der Leest
Yael Krakowski	Peter Vermandere
Deborah Krupenia	Manuel Vilhena
Dongchun Lee	Karin Wagner
Peter Machata	Yasunori Watanuki
Stefano Marchetti	Annamaria Zanella

Manuel Vilhena, **Brooch**
wood, paint, gold, screws

*David Roberts, **Black Vessel**, 2004*
coil-built and raku fired ceramic, 20d
photo: Jerry Hardman-Jones

Clay

Promoting the best of British ceramics

Staff: Charles Dimont; Cheryl Dimont; Sarah Edwards

226 Main Street
Venice, CA 90291
voice 310.399.1416
fax 301.230.9203
info@clayinla.com
clayinla.com

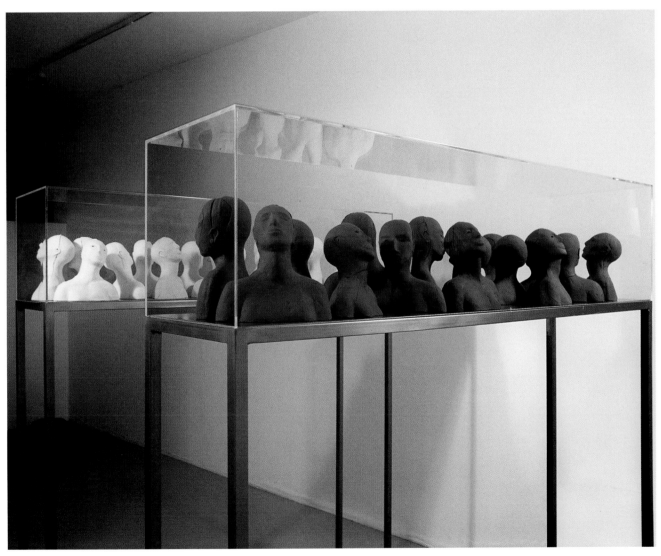

Christie Brown, **The Problem of Communication**, *2004*
ceramic, steel, acrylic, 68.5 x 59 x 13.5
photo: Kate Forrest

Representing:
Felicity Aylieff
Jane Blackman
Christie Brown
Claire Curneen
Robert Dawson
Stephen Dixon
Michael Flynn
Gabriele Koch
Frances Priest
David Roberts
Rupert Spira
Julian Stair

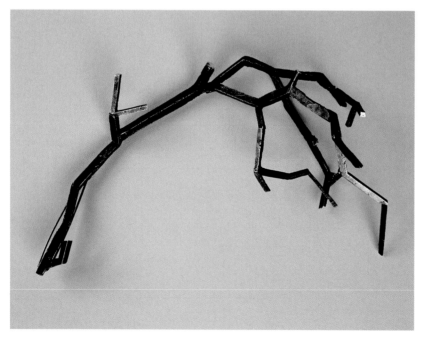

Petronella Eriksson, **Twig brooch**
oxidized sterling silver
photo: Karen Bell

The David Collection

International fine arts with a specialty in contemporary studio jewelry
Staff: Jennifer David, director; Yuki Ishi

44 Black Spring Road
Pound Ridge, NY 10576
voice 914.764.4674
fax 914.764.5274
jkdavid@optonline.net
thedavidcollection.com

Representing:
Mikiko Aoki
Sara Basch
Alexander Blank
Beate Brinkmann
Barbara Christie
Joachim Dombrowski
Valerie Dubois
Nina Ehmck
Petronella Eriksson
Kyoko Fukuchi
Tania Gallas
Gill Galloway-
 Whitehead
Ursula Gnaedinger
Michael Good
Ulrike Hamm
Michael Hamma
Masako Hayashibe
Marion Heilig
Lydia Hirte
Mari Ishikawa
Yoko Izawa
Kyung Shin Kim
Heide Kindelmann
Kostas Kyriacou
Ingrid Larssen
Wilheim Tasso Mattar
Martina Mühlfellner
Suzanne Otwell Nègre
Lena Olson
Helge Ott
Maria Phillips
Alexandra Pimental
Sabine Reichert
Julia Reymann
Kayo Saito
Mona Wallström
Beate Weiss
Hedvig Westermark

Mona Wallström, **Desert Flower neckpiece**
hematite, oxidized sterling silver, silk
photo: Karen Bell

Timothy Berg, **Ideal Pursuit,** *2005*
ceramic, mixed media, dimensions variable

Dean Project

Promoting contemporary emerging artists
Staff: Mark Dean and Jerry Inman, co-directors

25 Central Park West
Suite 5U
New York, NY 10023
voice 212.252.6840
fax 212.591.6979
info@deanproject.com
deanproject.com

Representing:
Yordi Arteaga
Timothy Berg
Karin Bos
Chad Curtis
Miky Fabrega
Sinisa Kukec
Reinaldo Sanguino

Reinaldo Sanguino, **Unspeakable Joy**, *2005*
porcelain, 12 x 12 x 9

Chad Curtis, **Untitled (Anatomy Series #2),** *2004*
unfired porcelain, earthenware encapsulated with rubber and resin, mixed media, 20 x 16 x 12

Sinisa Kukec, **Little Death SE,** *2003-05*
porcelain, mother of pearl, mixed media, dimensions variable

Jacques Vesery, **One Ocean, Different Skies,** *2004*
cherry, 23k gold leaf, oxidized silver leaf, dye, 2 x 2.5 x 3; 3 x 3.5 x 2
photo: Ronn Orenstein

del Mano Gallery

Turned and sculptured wood, fiber, teapots and jewelry
Staff: Jan Peters; Ray Leier; Kirsten Muenster

11981 San Vicente Boulevard
Los Angeles, CA 90049
voice 310.476.8508
fax 310.471.0897
gallery@delmano.com
delmano.com

Binh Pho, **Between Me and the River**, *2004*
quilted birch, acrylic paint, dye, 18 x 10
photo: David Peters

Representing:
Gianfranco Angelino
Derek Bencomo
Christian Burchard
David Carlin
David Ellsworth
Harvey Fein
J. Paul Fennell
Melvyn Firmager
Ron Fleming
Louise Hibbert
Robyn Horn
Peter Hromek
John Jordan
Ron Kent
Leon Lacoursiere
Merete Larsen
Bud Latven
Ron Layport
Alain Mailland
Bert Marsh
William Moore
Matt Moulthrop
Philip Moulthrop
David Nittman
Nikolai Ossipov
Sarah Parker-Eaton
Michael Peterson
Binh Pho
Graeme Priddle
Vaughn Richmond
Neil Scobie
Michael Shuler
Steve Sinner
Fraser Smith
Hayley Smith
Butch Smuts
Holly Tornheim
Jacques Vesery
Hans Weissflog

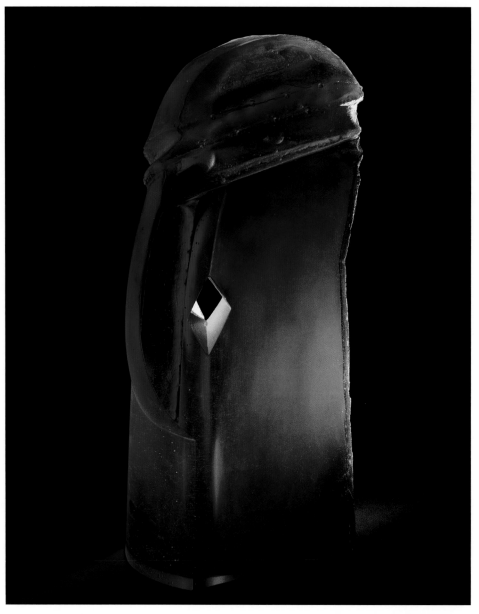

Stanislav Libenský and Jaroslava Brychtová, **Man Kurt II**, *1987*
cast glass, 24 x 9 x 8
photo: Eva Heyd

Donna Schneier Fine Arts

Modern masters in ceramics, glass, fiber, metal and wood
Staff: Donna Schneier; Leonard Goldberg; Jesse Sadia

By Appointment Only
New York, NY
voice 212.472.9175
fax 212.472.6939
dnnaschneier@mhcable.com

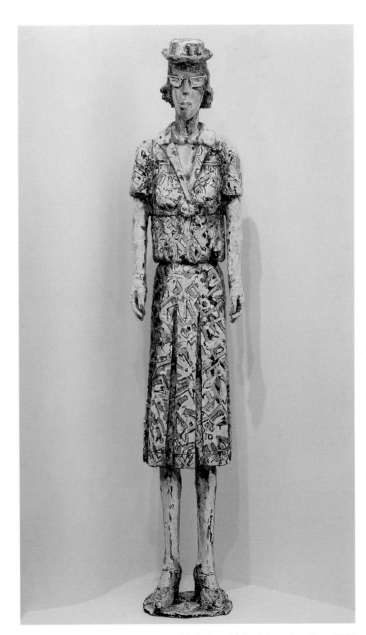

Representing:
Jaroslava Brychtová
José Chardiet
Rick Dillingham
Erwin Eisch
Viola Frey
Joey Kirkpatrick
Stanislav Libenský
Michael Lucero
Flora Mace
Mark Peiser
Flo Perkins
Stephen Rolfe Powell
June Schwarcz
Mary Shaffer
Bertil Vallien
František Vízner
Beatrice Wood
Betty Woodman

Viola Frey, **Tallest Grandmother**, *1981*
ceramic, 96 x 21 x 13

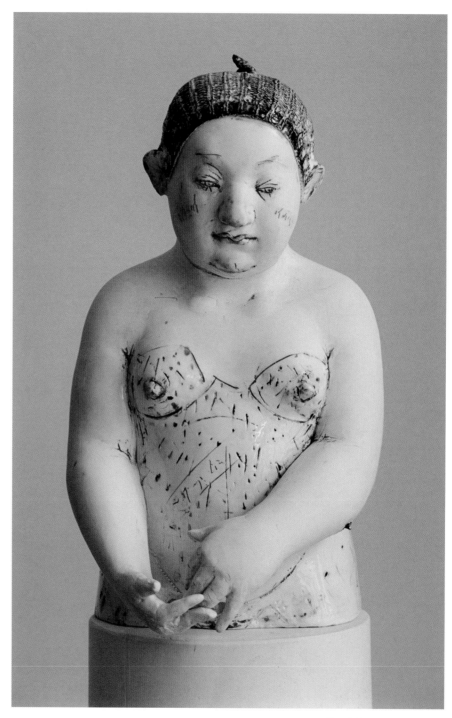

Gundi Dietz, **Frieda,** *2004*
ceramic, 15.75h
photo: Tina Dietz

Ferrin Gallery

Two and three-dimensional art, ceramic sculpture and studio pottery
Staff: Leslie Ferrin; Donald Clark; Scott Norris; Michael McCarthy; Todd Clark

69 Church Street
Lenox, MA 01240
voice 413.637.4414
fax 914.271.0047
info@ferringallery.com
ferringallery.com

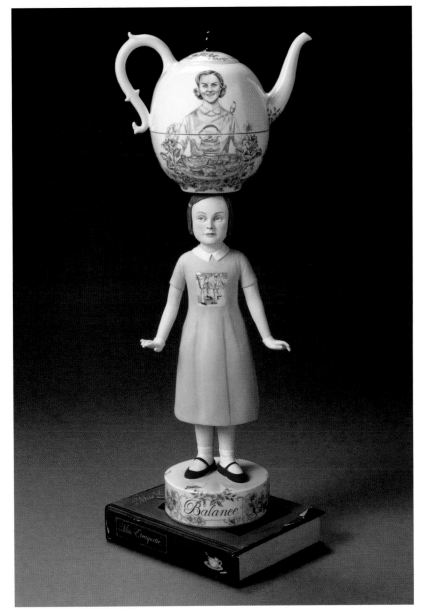

Red Weldon-Sandlin, **Miss Eteaquette**, *2004*
ceramic, wood, paint, 10 x 18.5 x 7
photo: Walter C. Kirk

Representing:
Russell Biles
Cynthia Consentino
Laura DeAngelis
Gundi Dietz
Lucy Feller
Sergei Isupov
Peter Lenzo
Karen Portaleo
Mara Superior
Red Weldon-Sandlin
Lia Zulalian

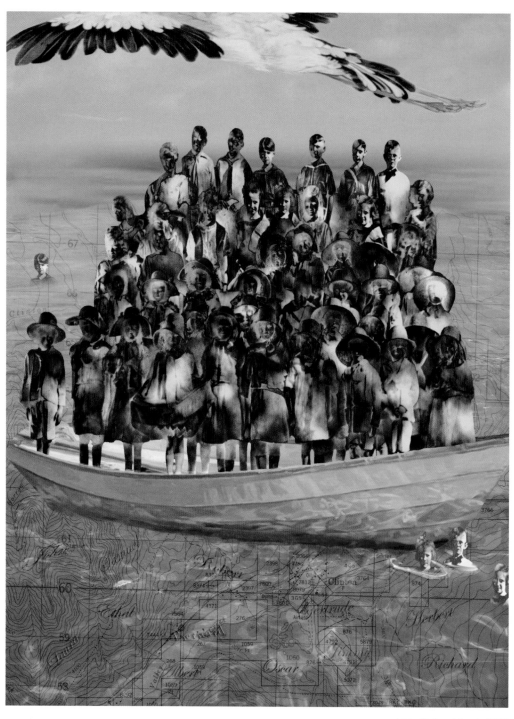

Lucy Feller, **Afloat,** *2005*
photography, 30 x 40

Lucy Feller, **Lorie**, *2004*
photography, 25 x 25

Catherine Auguste, Nux and Garric cabinet, *2003*
solid oak, walnut veneer, sycamore, tempera, varnish, 24.3 x 13.95 x 7
photo: Henri Peyre

Galerie Ateliers d'Art de France

Work by contemporary artists in a variety of media
Staff: Marie-Armelle de Bouteiller; Anne-Laure Roussille

4 Passage Roux
Paris 75017
France
voice 33.1.4401.0830
fax 33.1.4401.0835
galerie@ateliersdart.com

Representing:
Catherine Auguste
Louiselio
Christophe Nancey
Udo Zembok

Udo Zembok, **Mur,** *2005*
fused, enameled and thermoformed glass, 8.5 x 12 x 2.5

Yan Zoritchak, **Eclipse Brun**
glass, 29 x 24 x 6.5
photo: Lyon

Galerie Daniel Guidat

Contemporary glass
Staff: Daniel Guidat, director, Cannes; Albert Feix, III, director, New York

142 Rue d'Antibes
Cannes 06400
France
voice 33.4.9394.3333
fax 33.4.9394.3334
albertfeix3@earthlink.net
galeriedanielguidat.com

Yan Zoritchak, **Eclipse Mystique**
glass, 33 x 35.25 x 6
photo: Lyon

Representing:
Alain Bégou
Francis Bégou
Marisa Bégou
Gilles Chabrier
Goudji
Yan Zoritchak
Czeslaw Zuber

Peter Powning, **Crusty Branch Arch Basin,** *2004*
thrown, textured and raku-fired clay, cast bronze, 11.5 x 9.5 x 9.5
photo: Peter Powning

Galerie Elena Lee

New directions of contemporary art glass for over 29 years
Staff: Elena Lee; Joanne Guimond; Cinzia Colella; Louise Lapointe; Christian Thériault; Sylvia Lee

1460 Sherbrooke West
Suite A
Montréal, Québec H3G 1K4
Canada
voice 514.844.6009
info@galerieelenalee.com
galerieelenalee.com

Tanya Lyons, **Flower-Child**, *2005*
solid worked glass, copper, 25 x 10 x 4
photo: Tanya Lyons

Representing:
Annie Cantin
Carole Frève
John Glendinning
Kevin Lockau
Tanya Lyons
Caroline Ouellette
Peter Powning
Cathy Strokowsky

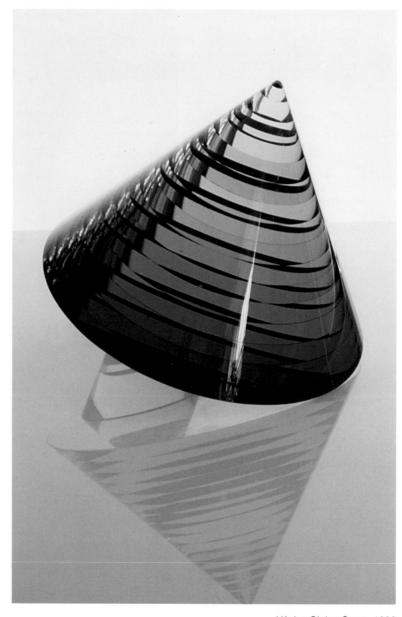

Václav Cigler, **Cone,** *1998*
flat glass, laminated and polished, 14 x 10

Galerie Pokorná

Important contemporary artists and their work, 20 – 21st century
Staff: Jitka Pokorná, director

Janský Vrsek 15
Prague 1, 11800
Czech Republic
420.222.518635
fax 420.222.518635
office@galeriepokorna.cz
galeriepokorna.cz

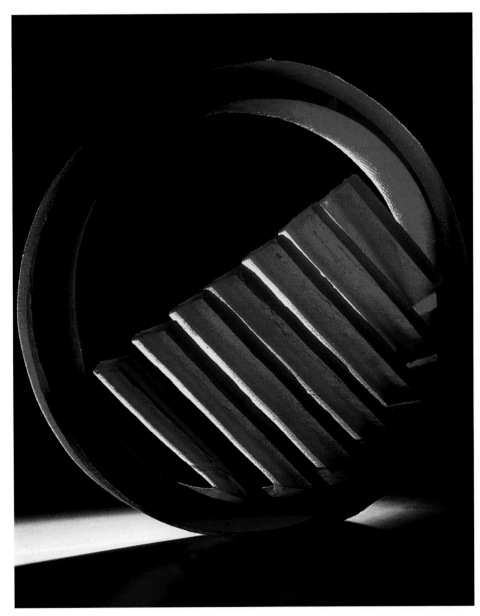

Representing:
Jaroslava Brychtová
Václav Cigler
Bara Krivská
Stanislav Libenský
Štěpán Pala
Zora Palová

Zora Palová, **Bridge Harp**
cast glass, partly polished, 16.5 x 3
photo: Tanya Lyons

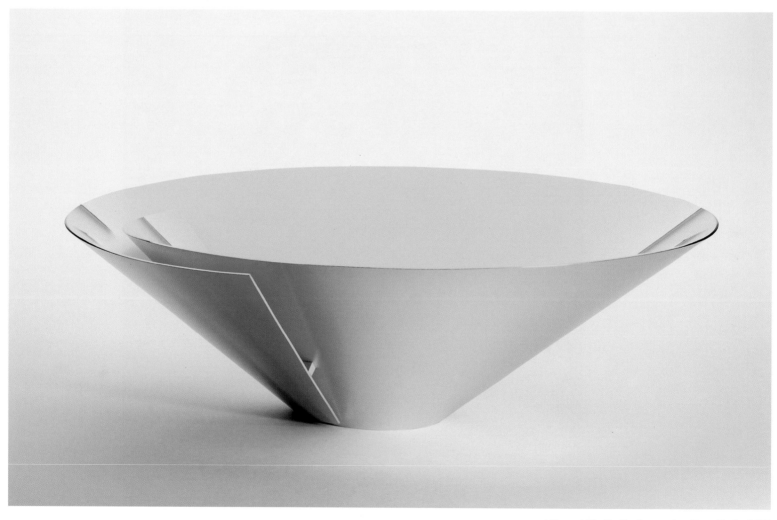

Ulla and Martin Kaufmann, **Aus Dem Kreis,** *2003*
sterling silver, 5 x 15

Galerie Tactus

Hollowware with a touch of jewelry
Staff: Lina and Peter Falkesgaard; Freja Lippmann

Store Regnegade 12, 1
Copenhagen DK 1110
Denmark
voice 45.33.933105
fax 45.33.326001
tactus@galerietactus.com
galerietactus.com

Representing:
Sidsel Dorph-Jensen
Lina Falkesgaard
Seamus Gill
Torben Hardenberg
David Huycke
Martin Kaufmann
Ulla Kaufmann
Puk Lippmann
Lone Løvschal
Hiroshi Suzuki

Lina Falkesgaard, **Garden Ring***, 2005*
18k gold, sapphires, black diamonds
photo: Lars Gundersen

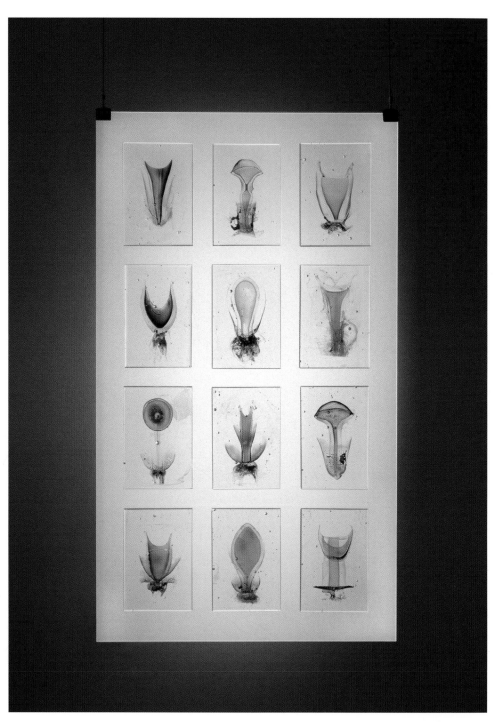

Steffen Dam, **End of My Garden**, *2004*
glass, 21 x 35
photo: Steen Afd. Fem

Galleri Grønlund

Works by three of the most significant glass artists from the Nineties generation in Denmark
Staff: Anne Merete Grønlund, director; Kirstine Grønlund

Birketoften 16a
Værløese 3500
Denmark
voice 45.44.442798
fax 45.44.442798
groenlund@get2net.dk
glassart.dk

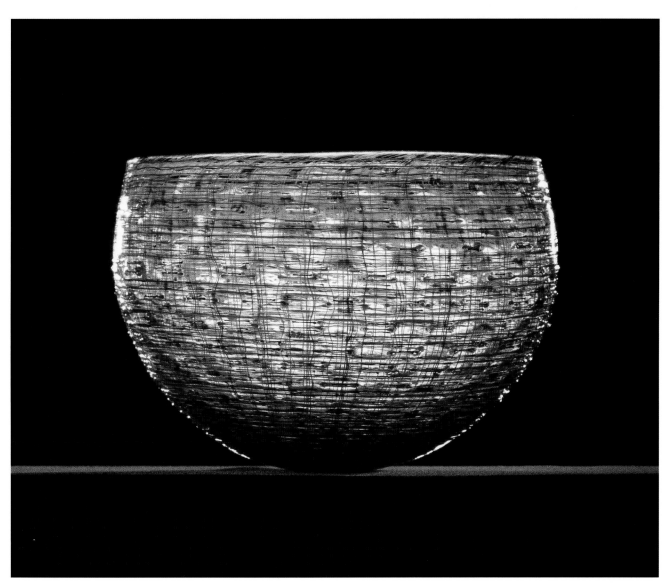

Representing:
Steffen Dam
Tobias Møhl
Stig Persson

Tobias Møhl, **Nest***, 2005*
glass, 5.6d
photo: Poul Ib Henriksen

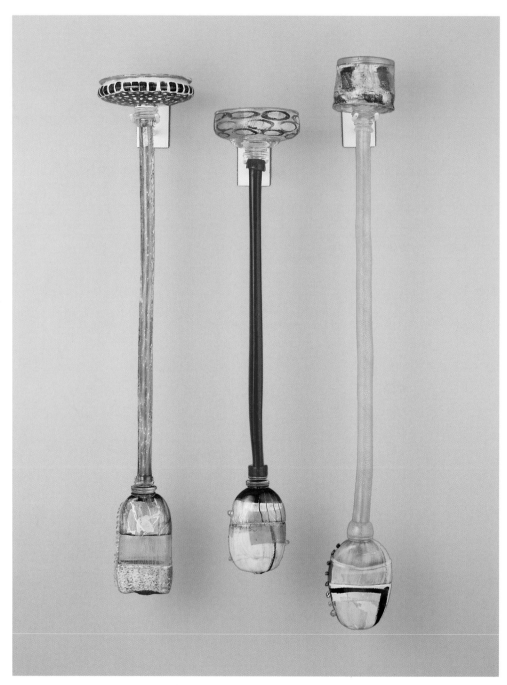

John de Wit, Bahia, Lenor and Geronimo, *2005*
blown glass, etched and painted, various sizes
photo: Rachel Olsson

Gallery 500 Consulting

Promoting excellence and creativity in all media
Staff: Rita Greenfield, owner

3502 Scotts Lane
Philadelphia, PA 19129
voice 215.849.9116
gallery500@hotmail.com
gallery500.com

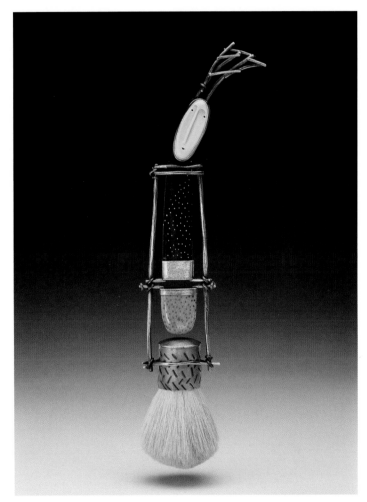

Representing:
Carolyn Morris Bach
Mark Chatterley
John de Wit
Dale Gottlieb
Philip Soosloff

Carolyn Morris Bach, **Deer Brush***, 2005*
fine silver, sterling silver, copper, petrified palm root, ebony, bone, goat hair bristles, 9.5 x 1.75
photo: Hap Sakwa

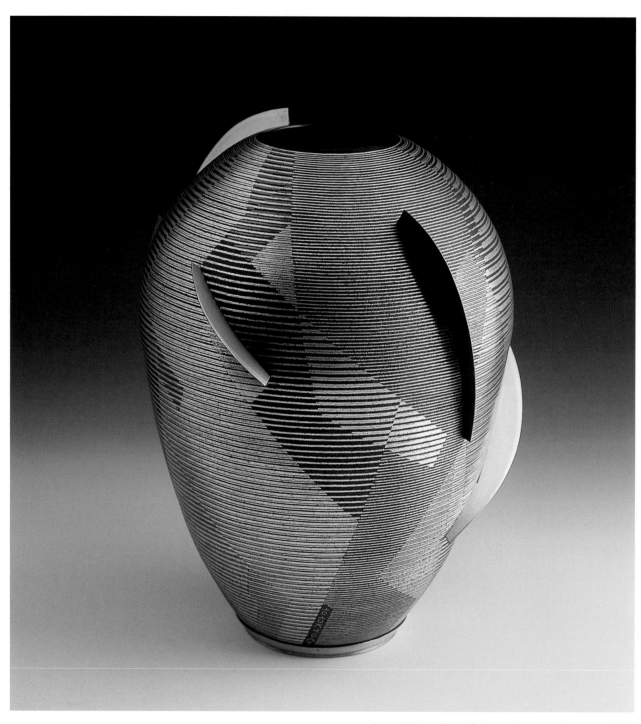

Jung-sil Hong, **Deep Spring of Subconsciousness,** *2003*
silver, gold, copper, steel, lacquer, 12.5 x 9.5 x 9.5

Gallery Gainro

The only gallery in Korea specializing in jewelry and light metal craft
Staff: Hyun-jung Won, director; Song-hee Lee, curator; A-Jung Kim, curator

Gaonix B/D
Sinsa-dong 575
Gangnam-gu, Seoul
Korea
voice 822.541.0647
fax 822.541.0677
gainro@hanmail.net
gainro.com

Representing:
Sung-Hee Ahn
Su-Jung Back
Mun-soo Bae
Ji-Hee Hong
Ji-Sun Hong
Jung-sil Hong
Yeo-ji Hong
Ji-Young Hwangbo
Sun-Young Jang
Ji-Hye Jeon
Jin-Hee Jung
Hye-Rim Kang
Bong-hee Kim
Chong-Ryol Kim
Hee-Kyung Kim
Hong-Young Kim
Hwa-Jin Kim
Jae-Young Kim
Joon-Hee Kim
Ji-Eun Kim
Junh-hoo Kim
Moon-jung Kim
Sun-Jung Kim
Seung-Hee Kim
Joo-Hee Lee
Jung-Eun Lee
Hye-heun Moon
Min-Young Oh
Jin-Young Park
Jung-Eon Park
Su-Ryeon Park
Yun-Joo Park
Hea-Rim Shin
Jung-Hee Shin
Jong-Eun Song
Hyun-jung Won
Hye-Won Youn

Jung-hoo Kim, **The Rain III brooch**, *2003*
silver, lapis lazuli, 3.5 x 3.5

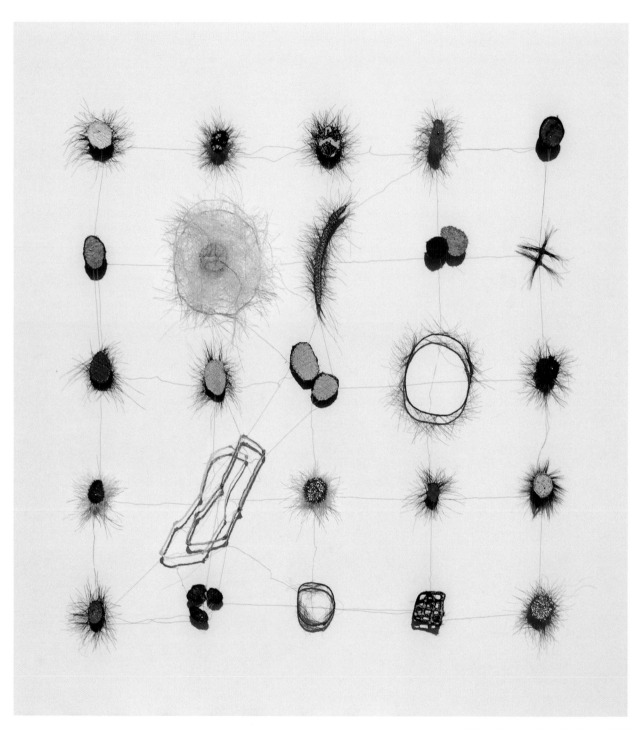

Marian Bijlenga, **Sampler Dots,** *2004*
horsehair, fabric, 26 x 26

Gallery Materia/Cervini Haas Gallery

Two and three-dimensional contemporary fine art in all media
Staff: Wendy Haas, director; Aprille Williams, assistant; Carl Samuels, installer

4222 North Marshall Way
Scottsdale, AZ 85251
voice 480.949.1262
fax 480.949.6050
gallery@cervinihaas.com
gallerymateria.com

Representing:
Roger Asay
Marian Bijlenga
Mark Bressler
David French
Deborah Horrell
Mark Levin
Simon Levy
Kim Rawdin
Carole Ross
Beth Cavener Stichter
Andrea Waxman
Clare Yares

Deborah Horrell, **Two Figures: Alone and Together,** *2005*
pate de verre, found glass, alabaster, 9.75 x 9 x 3
photo: Paul Foster

Rick Dillingham, **Large Globe**, *1987*
raku with glazes, gold leaf, 11 x 16
photo: Mark Freeman

Garth Clark Gallery

Contemporary ceramic art

Staff: Garth Clark; Mark Del Vecchio; Osvaldo Da Silva; Masha Portiansky; Mark Freeman; Claudio Rocha

24 West 57th Street, #305
New York, NY 10019
voice 212.246.2205
fax 212.489.5168
info@garthclark.com
garthclark.com

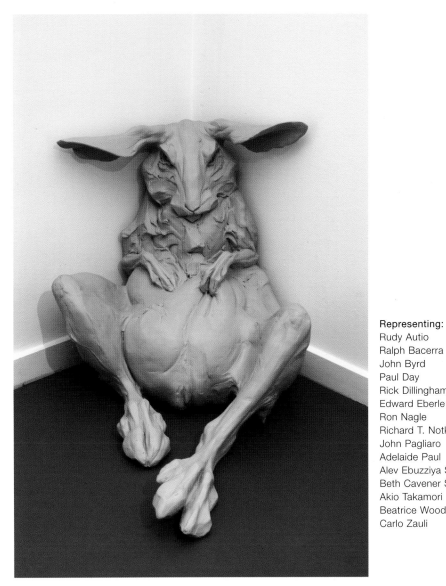

Representing:
Rudy Autio
Ralph Bacerra
John Byrd
Paul Day
Rick Dillingham
Edward Eberle
Ron Nagle
Richard T. Notkin
John Pagliaro
Adelaide Paul
Alev Ebuzziya Siesbye
Beth Cavener Stichter
Akio Takamori
Beatrice Wood
Carlo Zauli

Beth Cavener Stichter, **Strange Attraction,** *2004*
stoneware with porcelain slip, 18 x 22
photo: Noel Allum

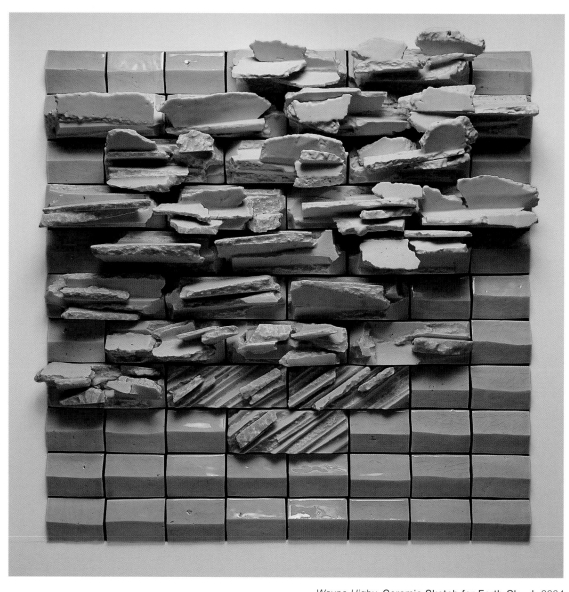

Wayne Higby, **Ceramic Sketch for Earth Cloud,** *2004*
commission, wall piece in progress;
Miller Preforming Arts Center, Alfred University, Alfred, NY
porcelain, 34 x 34 x 6
photo: Brian Oglesbee

Helen Drutt: Philadelphia/Hurong Lou Gallery

Helen Drutt: Philadelphia continues its commitment to the arts and introduces the establishment of the Hurong Lou Gallery in 2005
Staff: Hurong Lou, director, Hurong Lou Gallery; Helen W. Drutt English, founder/director, Helen Drutt: Philadelphia; Martha Flood, archivist; Natalija Mijatovic, assistant

Helen Drutt: Philadelphia
By Appointment Only
Postal Address
2220-22 Rittenhouse Square
Philadelphia, PA 19103-5505
voice 215.735.1625
fax 215.732.1382

Hurong Lou Gallery
320 Race Street
Philadelphia, PA 19106
voice 215.238.8860
fax 215.238.8862
huronglou.com

Representing:
Contemporary Jewelery
Robert Baines
Gijs Bakker
Manfred Bischoff
Pierre Cavalan
Peter Chang
Sharon Church
Georg Dobler
Kyoko Fukuchi
Robin Kranitzky/
 Kim Overstreet
Carlier Makigawa
Bruno Martinazzi
Breon O'Casey
Ritsuko Ogura
Judy Onofrio
Francesco Pavan
Ramon Puig Cuyas
Gerd Rothmann
Deganit Schocken
Helen Shirk
Tore Svensson
Merrily Tompkins
Tone Vigeland
Margaret West
Nancy Worden

Ceramics
Nicholas Arroyave-
 Portela
Jill Bonovitz
Nancy Carman
Anne Currier
William Daley
Andrea Gill
Wayne Higby
Juan Santiago
Rudolf Staffel
Lizbeth Stewart
Robert Turner
Paula Winokur
Robert Winokur
Luo Xiaoping
Sun Koo Yuh

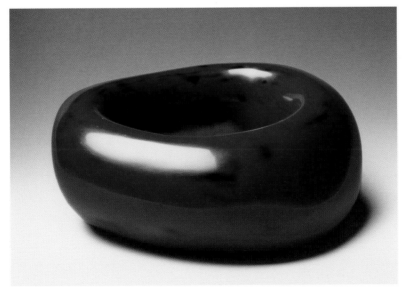

Kyoko Fukuchi, **Bracelet**
lacquer, urushi

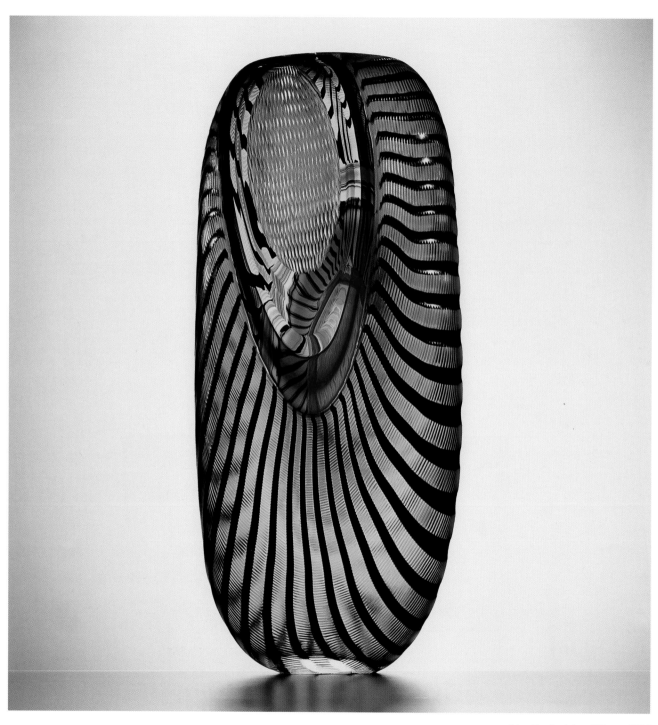

*Lino Tagliapietra, **Bilbao**, 2004*
glass, 25.75 x 11.5 x 4.75
photo: Russell Johnson

Heller Gallery

Exhibiting sculpture using glass as a fine art medium since 1973
Staff: Douglas Heller; Katya Heller; Michael Heller

420 West 14th Street
New York, NY 10014
voice 212.414.4014
fax 212.414.2636
info@hellergallery.com
hellergallery.com

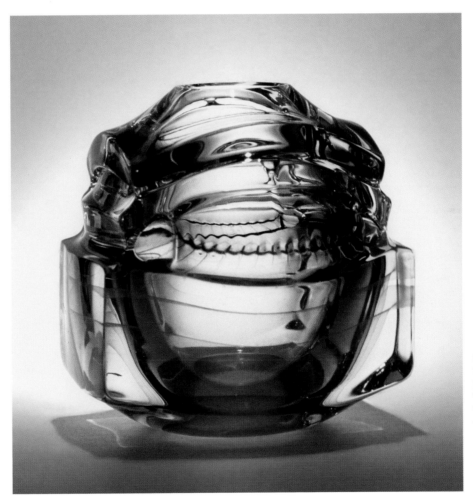

Representing:
Rick Beck
Nicole Chesney
Vladimira Klumpar
Therese Lahaie
Tom Patti
Lino Tagliapietra

Tom Patti, **Solar Airframe**, *1983*
glass, 4 x 4 x 4.25

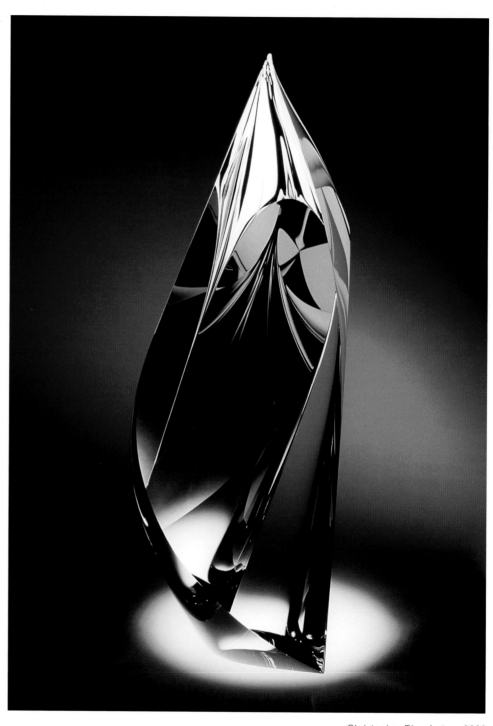

*Christopher Ries, **Lotus**, 2003*
cut and polished optical crystal, 28.75 x 12 x 7
photo: Creative Vision Studio

Holsten Galleries

Contemporary art glass
Staff: Kenn Holsten; Jim Schantz; Mary Childs; Joe Rogers; Stanley Wooley

3 Elm Street
Stockbridge, MA 01262
voice 413.298.3044
fax 413.298.3275
artglass@holstengalleries.com
holstengalleries.com

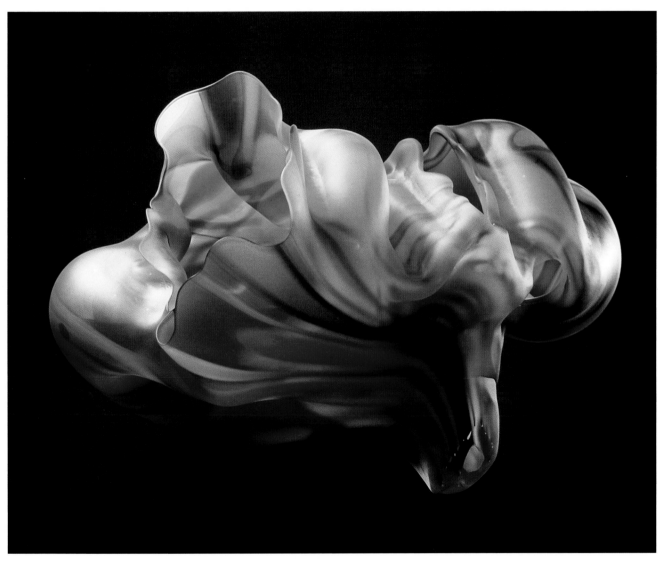

Representing:
Latchezar Boyadjiev
Marvin Lipofsky
Christopher Ries
Martin Rosol

Marvin Lipofsky, **Australian Landscape #3,** *2004*
blown, cut and sandblasted glass, 12 x 19 x 14.5
photo: M. Lee Fatherree

Henriette Schuster, **Medallions Installation,** *2004*
silver, thread, 2 x1.25 x .03125

Jewelers' Werk Galerie

New jewelry from international artists
Staff: Ellen Reiben, director

2000 Pennsylvania Avenue NW
Washington, DC 20006
voice 202.293.0249
fax 202.293.1834
ellenreiben@earthlink.net

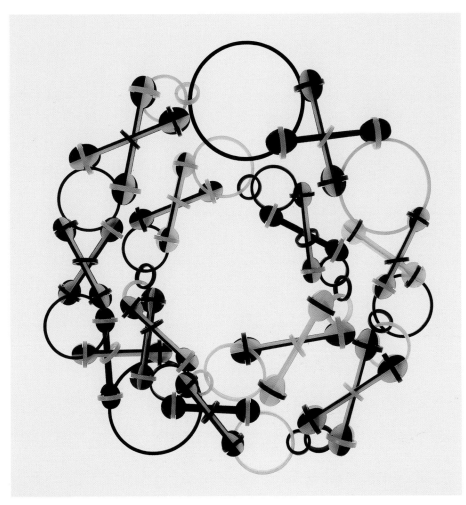

Svenja John, **Necklace X001**
hand-colored polycarbonate, 26L
photo: Silke Mayer

Representing:

Talya Baharal	Otto Künzli
Alexandra Bahlmann	Christa Lühtje
Peter Bauhuis	Sally Marsland
Doris Betz	Darcy Miro
David Bielander	Ruudt Peters
Iris Bodemer	Shari Pierce
Helen Britton	Karen Pontoppidan
Bettina Dittlmann	Mary Preston
Mason Douglas	Dorothea Prühl
Ute Eitzenhöfer	Mah Rana
Sandra Enterline	Axel Russmeyer
Sophia Epp	Dorothea Schippel
Warwick Freeman	Henriette Schuster
Karl Fritsch	Barbara Seidenath
Thomas Gentille	Jiři Šibor
Rebecca Hannon	Vera Siemund
Mielle Harvey	Bettina Speckner
Therese Hilbert	Tore Svensson
Mari Ishikawa	Rachelle Thiewes
John Iversen	Conrad Valett
Michael Jank	Lisa Walker
Svenja John	Andrea Wippermann
Esther Knobel	

Miyashita Zenji, Tall ovoid vase decorated with carved bandings of graduated tones of blue and green colored clay, 2004 stoneware, 18.5 x 12.5 x 7

Joan B. Mirviss, Ltd.

Fine Japanese ceramics by modern masters and contemporary talents
Staff: Joan B. Mirviss, Nadine Welch

PO Box 231095
Ansonia Station
New York, NY 10023
voice 212.799.4021
fax 212.721.5148
joan@mirviss.com
mirviss.com

Representing:
Kishi Eiko
Shoji Hamada
Shoji Kamoda
Masanao Kaneta
Shinobu Kawase
Junko Kitamura
Shoko Koike
Michio Koinuma
Takahiro Kondo
Seiko Minegishi
Zenji Miyashita
Togaku Mori
Taimei Morino
Takuo Nakamura
Kitaoji Rosanjin
Takayuki Sakiyama

*Sakiyama Takayuki, Large vessel with gentle cascading folds and incised linear pattern, 2005
stoneware with ash glaze, 14.75 x 14.25 x 16.5*

119

Elizabeth Fritsch, **Blown Away Firework Vase with Optical Cup and Saucer,** *2004*
hand-built stoneware, colored slips, 21 x 9.5 x 3; 7.5 x 6 x 2.5
photo: Alexander Brattell

Joanna Bird Pottery

Exciting work in clay by leading studio pottery artists and some grass roots makers; focusing on the diversity of created work in clay
Staff: Joanna Bird, owner; Bunny Bird, director; Charlotte Claridge, assistant

By Appointment
19 Grove Park Terrace
London W43QE
England
voice 44.208.995.9960
fax 44.208.742.7752
joanna.bird@ukgateway.net
joannabirdpottery.com

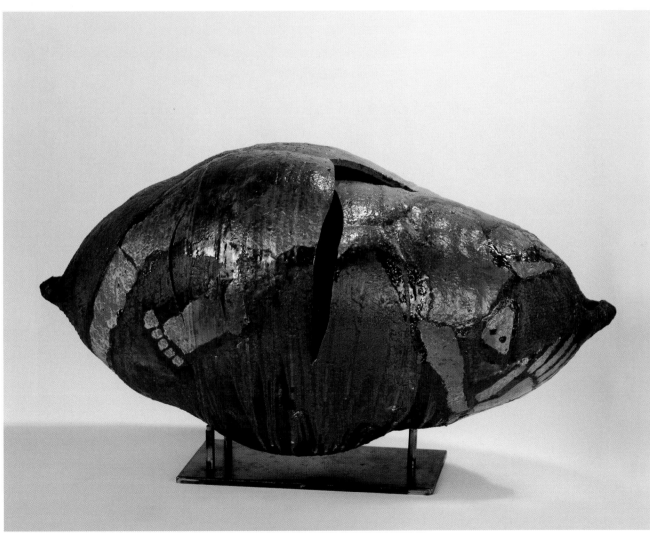

Representing:
Michael Cardew
Thiébaut Chagué
Joanna Constatinidis
Hans Coper
Edmund de Waal
Daniel Fisher
Elizabeth Fritsch
Shoji Hamada
Chris Keenan
Bernard Leach
John Maltby
Heather Park
William Plumptre
Lucie Rie
Julian Stair

Thiébaut Chagué, **Grand Cocon**
thrown stoneware, applied slips and glazes; wood-fired, 24 x 47.5 x 28
photo: Francis Bougner

Ruth Borgenicht, **Cubed Rings II,** *2004*
stoneware, 11 x 16 x 9
photo: Joseph Painter

Lacoste Gallery

Contemporary ceramics relating to the vessel and sculptural form
Staff: Lucy Lacoste; Johanna Gluck; Linda Lofaro

25 Main Street
Concord, MA 01742
voice 978.369.0278
fax 978.369.3375
info@lacostegallery.com
lacostegallery.com

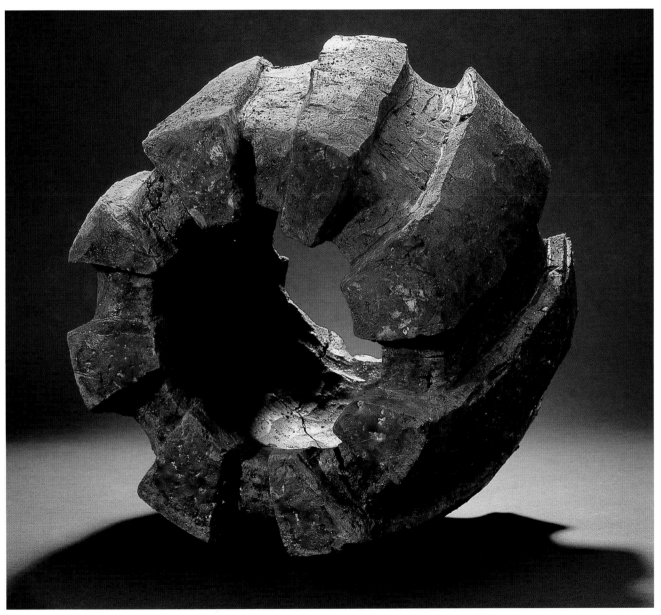

Representing:
Ruth Borgenicht
Paul Chaleff
Ryuichi Kakurezaki
Warren MacKenzie
Jeannie Mah
Mark Pharis
Tim Rowan
Jeff Shapiro
Mark Shapiro

Tim Rowan, **Untitled,** *2004*
wood-fired native clay, 16 x 16 x 16
photo: Bob Barrett

Kubota Shigeo, **Solar Tapestry,** *2004*
hand-woven sisal, 38 x 21 x 3
photo: Nimkin

Lea Sneider

Contemporary fiber art and ceramics from Japan and Korea
Staff: Lea Sneider; Eleanor S. Hyun

211 Central Park West
New York, NY 10024
voice 212.724.6171
fax 212.769.3156
learsneider@aol.com

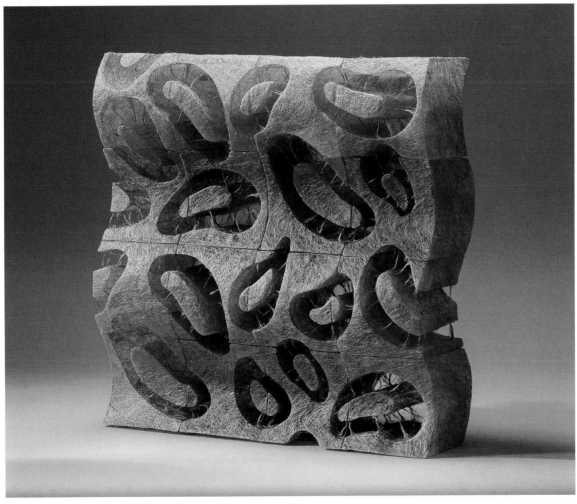

Representing:
Tetsuo Fujimoto
Shoichi Ida
Tsubusa Katoh
Hyun-hee Kim
Shigeo Kubota
Kyoko Kumai
Tetsuo Kusama
Chunghie Lee
Shiro Otani
Junco Sato Pollack
Naoko Serino
Sang Ho Shin
Junko Suzuki
Kazuko Yamanaka
Kwang-Cho Yoon

Naoko Serino, **Generating-5,** *2004*
jute fiber, 16 x 16
photo: Nimkin

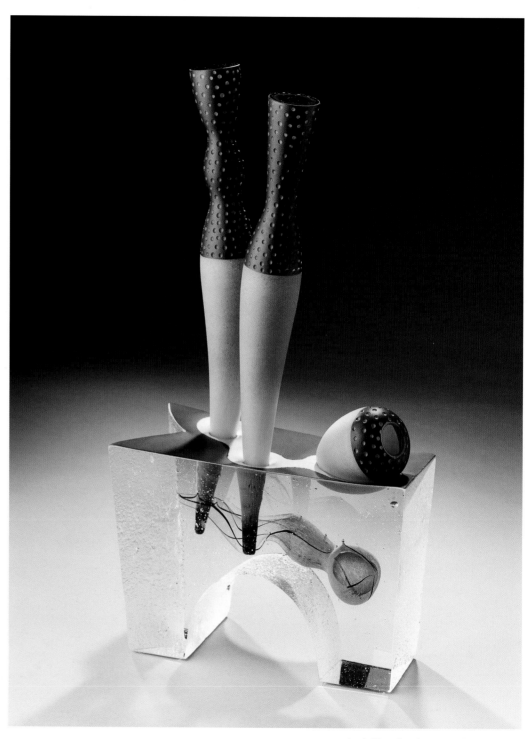

José Chardiet, **Ancestral Tango,** *2005*
glass, gold leaf, 22 x 12 x 6
photo: Martin Doyle

Leo Kaplan Modern

Established artists in contemporary glass sculpture and studio art furniture
Staff: Scott Jacobson; Terry Davidson; Lynn Leff; Courtney Fox

41 East 57th Street
7th floor
New York, NY 10022
voice 212.872.1616
fax 212.872.1617
lkm@lkmodern.com
lkmodern.com

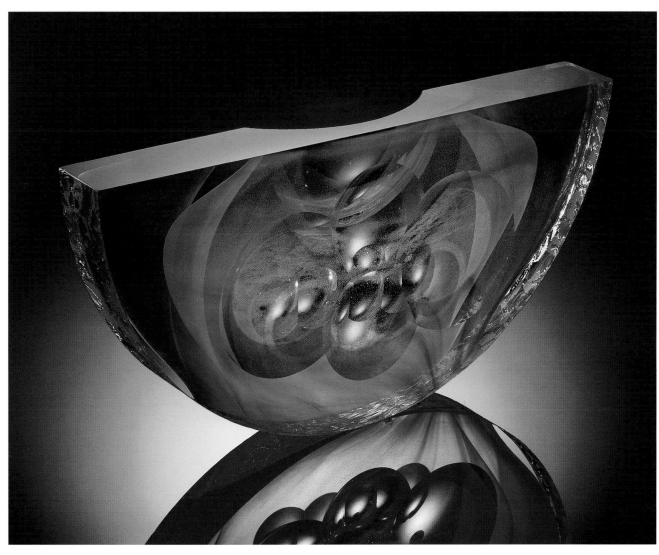

Representing:
Garry Knox Bennett
Greg Bloomfield
Yves Boucard
William Carlson
José Chardiet
Scott Chaseling
KéKé Cribbs
Dan Dailey
David Huchthausen
Richard Jolley
Kreg Kallenberger
John Lewis
Thomas Loeser
Linda MacNeil
Paul Seide
Tommy Simpson
Jay Stanger
Michael Taylor
Cappy Thompson
Gianni Toso
Mary Van Cline
Steven Weinberg
Ed Zucca

Steven Weinberg, **Middle Ground**, *2005*
glass, 12 x 24 x 3

Margie Hughto, **Red Horse,** *2005*
glazed ceramic, 66 x 90

Loveed Fine Arts

Contemporary ceramic works of art

Staff: Edward R. Roberts, president; Daniel Hamparsumyan, Ronald A. Kuchta, Nancy C. Roberts, directors

575 Madison Avenue
Suite 1006
New York, NY 10022
voice 212.605.0591
fax 212.605.0592
loveedfinearts@earthlink.net
loveedfinearts.com

Representing:
Beril Anilanmert
Rudy Autio
Thom Bohnert
Regis Brodie
Susan Budge
Peter Callas
Nino Caruso
Gary Erickson
Tom Folino
Marian Heyerdahl
Margie Hughto
Elena Karina
Yih-Wen Kuo
Pat Lay
Marc Leuthold
Ole Lislerud
Nancy Lovendahl
Louis Mendez
Jeffrey Mongrain
Sylvia Nagy
Gilda Oliver
Alena Ort
Rina Peleg
Charles Plosky
Maria Rudavska
Shin Sang-Ho
Barbara Sorensen
Robert Sperry
Victor Spinski
Dong Hee Suh
Neil Tetkowski
Xavier Toubes
Rouska Valkova
Grace Bakst Wapner
Patti Warashina
Yiannes
Arnold Zimmerman

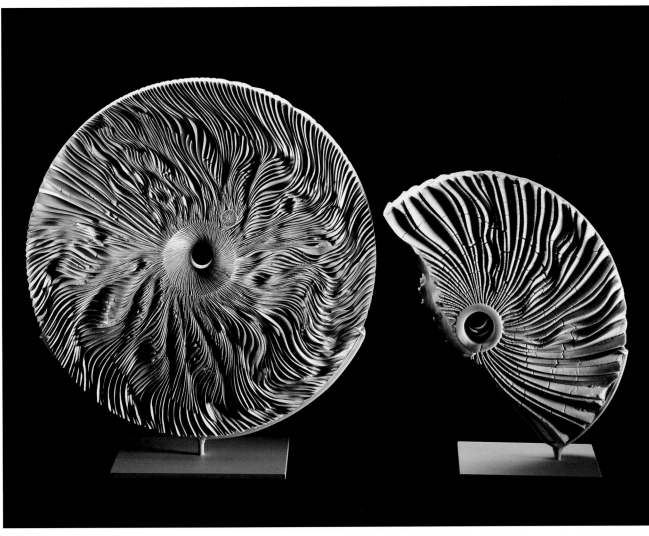

Marc Leuthold, **Us-Nippon Dyad***, 2004*
glazed and unglazed porcelain, 16h
photo: Eva Heyd

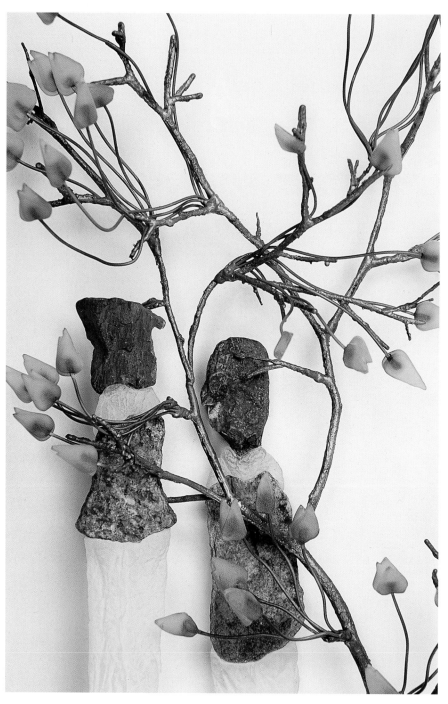

Thomas Scoon, **Entwine***, 2005*
cast crystal, granite, bronze, Bullseye Glass leaves, 29 x 21 x 9

Marx-Saunders Gallery, Ltd.

The most important artists creating artwork form glass
Staff: Bonnie Marx; Ken Saunders; Donna Davies; James Geisen; Dan Miller

230 West Superior Street
Chicago, IL 60610
voice 312.573.1400
fax 312.573.0575
marxsaunders@earthlink.net
marxsaunders.com

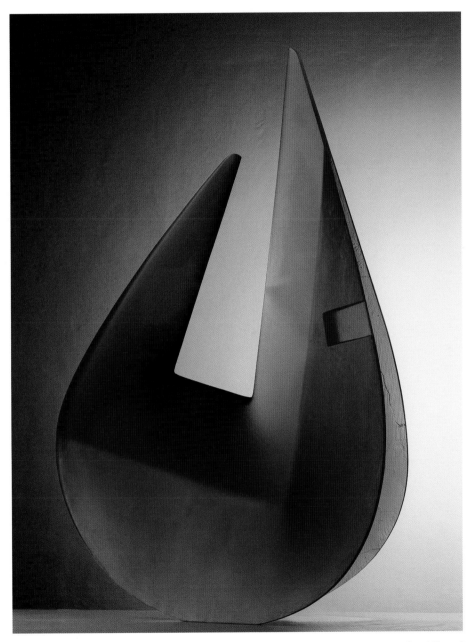

Michael Pavlik and Vladimira Klumpar, **Seed Vessel**
cast glass, 38 x 28 x 18

Representing:
Ken Carder
William Carlson
Sidney Hutter
Vladimira Klumpar
Jon Kuhn
Joel Philip Myers
Michael Pavlik
Thomas Scoon
Paul Stankard

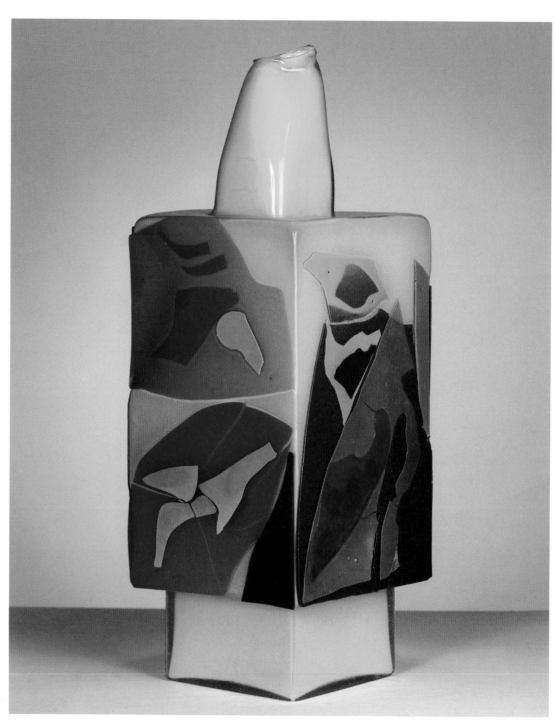

Joel Philip Myers, **Canvas #17,** *2005*
blown glass, 21 x 7.5 x 7.75

Maurine Littleton Gallery

Sculptural work of contemporary masters in glass
Staff: Maurine Littleton, director; Seth Campbell; Zach Vaughn

1667 Wisconsin Avenue NW
Washington, DC 20007
voice 202.333.9307
fax 202.342.2004
littletongallery@aol.com
littletongallery.com

John Littleton and Kate Vogel, **Gyro**, 2004
hot-worked, cut and polished cast glass, 16.75 x 8 x 5.5
photo: John Littleton

Representing:
Harvey K. Littleton
John Littleton
Richard Marquis
Jay Musler
Joel Philip Myers
Colin Reid
Therman Statom
Kate Vogel

*Mariko Kusumoto, **Byobu**, 2004-5*
metal, mixed media, 15 x 30 x 9.5 open; 11 x 17 x 5 closed

Mobilia Gallery

Contemporary decorative arts and studio jewelry
Staff: JoAnne Cooper; Libby Cooper; Susan Cooper; Dwaine Best; Christina Dias

358 Huron Avenue
Cambridge, MA 02138
voice 617.876.2109
fax 617.876.2110
mobiliaart@aol.com
mobilia-gallery.com

Renie Breskin Adams, **Dots Rush in Where Checkers Fear to Thread**, *2004-05*
cotton embroidery, 6.25 x 5.25

Representing:
Linda Behar
Hanne Behrens
Flora Book
Michael Boyd
Renie Breskin Adams
Dorothy Caldwell
Kirsten Clausager
Marilyn Da Silva
Linda Dolack
Dorothy Feibleman
Arline Fisch
Gerda Flockinger, CBE
David Freda
John Garrett
Mary Lee Hu
Mariko Kusumoto
Asagi Maeda
Jennifer Maestre
Tomomi Maruyama
Harold O'Connor
Gugger Petter
Janet Prip
Wendy Ramshaw, OBE RDI
Yuka Saito
Etsuko Sonobe
Jennifer Trask

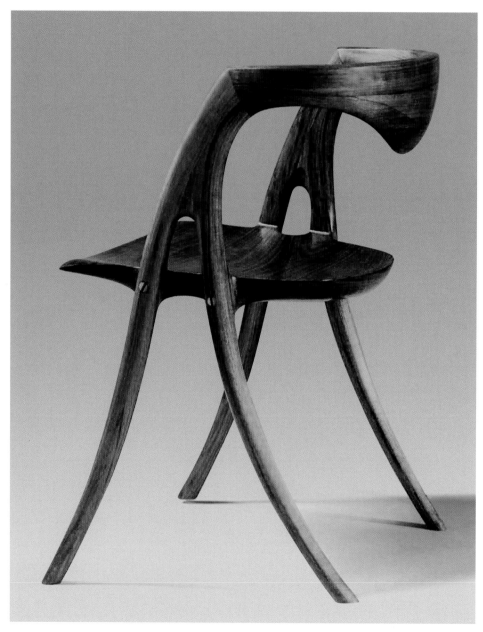

David Ebner, **Side Chair,** *1978*
wood, 30 x 20 x 21
photo: Gill Amiaga

Moderne Gallery

Vintage works from the American Craft Movement, 1920-2000
Staff: Robert Aibel, owner/director; Michael Gruber, designer; Cynthia Tyng, manager

111 North 3rd Street
Philadelphia, PA 19106
voice 215.923.8536
fax 215.923.8435
raibel@aol.com
modernegallery.com

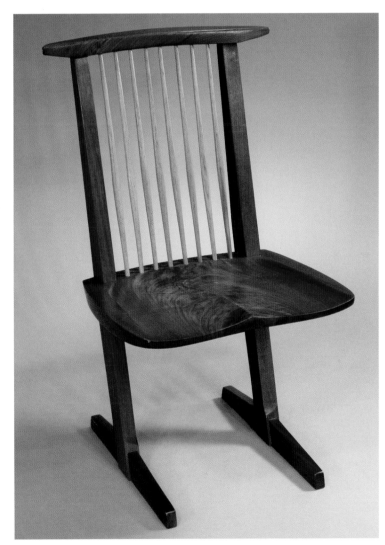

George Nakashima, **Conoid Chair**, 1961
wood, 20 x 16 x 35.5
photo: Michael J. Joniec

Representing:
Wendell Castle
David Ebner
Wharton Esherick
Ken Ferguson
Maija Grotell
Sam Maloof
Emile Milan
George Nakashima
Rude Osolnik
James Prestini
David Roth
Paul Soldner
Bob Stocksdale
Toshiko Takaezu
Peter Voulkos

Christine Barney, **Zig Zag,** *2004*
glass, 17 x 15 x 7
photo: C. Barney

Mostly Glass Gallery

Unique art, technically challenging and aesthetically appealing
Staff: Sami Harawi; Charles Reinhardt; Marcia LePore

34 Hidden Ledge Road
Englewood, NJ 07631
voice 201.816.1222
fax 201.503.9522
info@mostlyglass.com
mostlyglass.com

Representing:
Christine Barney
Antonio Dei Rossi
Mario Dei Rossi
Miriam Di Fiore
Gerry King
Iwao Matsushima
Hermann Mejer
Michael O'Keefe
Madelyn Ricks
Alison Ruzsa

Alison Ruzsa, **When You Least Expect It,** *2005*
glass, painting, 4.5h
photo: Seraphina Tisch

Kim Simonsson, **Spitting Girl,** *2002*
ceramic, glass, 16 x 22 x 38

Nancy Margolis Gallery

Contemporary ceramics and fiber
Staff: Eun Joo Won, assistant to director; Nancy Margolis, director

523 West 25th Street
New York, NY 10001
voice 212.242.3013
fax 212.242.4087
margolisgallery@aol.com
nancymargolisgallery.com

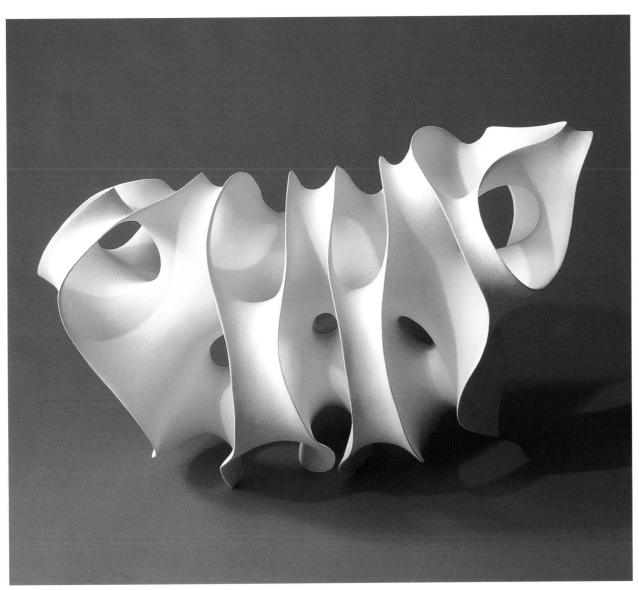

Representing:
Karen Bennicke
Eva Hild
Lissa Hunter
Ferne Jacobs
Ludwika Ogorzelec
Kim Simonsson
Tip Toland

Eva Hild, **Structure,** *2004*
stoneware, 38 x 25 x 23

David Samplonius, **Wall Cabinets,** *2004*
aluminum, bronze, wood, hide

Option Art

Excellence in Canadian contemporary wood, ceramics, jewelry and mixed media sculpture
Staff: Barbara Silverberg, director; Philip Silverberg; Dale Barrett

4216 de Maisonneuve Blvd. West
Suite 302
Montrèal, Quèbec H3Z 1K4
Canada
voice 514.932.3987
fax 514.932.6182
info@option-art.ca
option-art.ca

Sophie DeFrancesca, **Black Strapless**, *2005*
galvanized steel, aluminum, crystals, 53 x 24 x 27

Representing:
Jorge Aguilar
Sophie DeFrancesca
Léopold L. Foulem
Janis Kerman
Richard Milette
Matthias Ostermann
Gilbert Poissant
Susan Rankin
David Samplonius

Janis Kerman, **Brooch Series**, *2004*
sterling silver, 18k gold, turquoise, carnelian, citrine, aquamarine, smoky quartz,
lavender chalcedony, peridot, iolite, amethyst

Léopold L. Foulem, **Yes I Do,** *2003*
ceramic, 12.5 x 9 x 6
photo: Pierre Gauvin

Mari Meszaros, **Frozen in Time,** *2002*
slumped glass, copper wire, stone, 31.5 x 17.75 x 15
photo: Peete van Spankeren

R. Duane Reed Gallery

Contemporary painting, sculpture, ceramics, glass and fiber by internationally recognized artists
Staff: R. Duane Reed; John Elder; Merrill Strauss; Kate Anderson; Glenn Scrivner; Andrea Fares

529 West 20th Street
New York, NY 10011
voice 212.462.2600
fax 212.462.2510
nycreedart@primary.net
rduanereedgallerynyc.com

7513 Forsyth Boulevard
St. Louis, MO 63105
voice 314.862.2333
fax 314.862.8557
reedart@primary.net
rduanereedgallery.com

Luis Montoya and Leslie Ortiz, **David and Goliath,** *2000*
bronze with patina, 20 x 22 x 11

Representing:
Rudy Autio
Sabrina Knowles
Mari Mezaros
Luis Montoya
Leslie Ortiz
Jenny Pohlman
Ross Richmond
Richard Royal

Noam Elyashiv, **ME neckpiece,** *2004*
18k gold
photo: Kevin Sprague

Sienna Gallery

International contemporary jewelry
Staff: Sienna Patti; Raissa Bump

80 Main Street
Box 694
Lenox, MA 01240
voice 413.637.8386
fax 413.637.8387
sienna@siennagallery.com
siennagallery.com

Representing:
Giampaolo Babetto
Jamie Bennett
Melanie Bilenker
Lola Brooks
Raissa Bump
Noam Elyashiv
Esther Knobel
Daniel Kruger
Seung-Hea Lee
Jacqueline Lillie
Mary Preston
Tina Rath
Barbara Seidenath
Sondra Sherman
Johan van Aswegen

Daniel Kruger, **Brooch,** *2004*
silver, lapis lazuli, silk
photo: Udo W. Beier

Jon Eric Riis, **Forest Coat #2**, *2005*
tapestry, 32 x 39

Snyderman-Works Galleries

Contemporary fiber/textile, ceramic, jewelry, studio furniture, glass, sculpture, painting, and architectural installations

Staff: Ruth and Rick Snyderman, owners; Bruce Hoffman, director; Frances Hopson, director, Works; Jen Smith, assistant director, Snyderman; Colleen Barry, assistant director, Works; Leeor Sabbah, associate

303 Cherry Street
Philadelphia, PA 19106
voice 215.238.9576
fax 215.238.9351
bruce@snyderman-works.com
snyderman-works.com

Representing:
Lanny Bergner
Karin Birch
Yvonne Pacanovsky
 Bobrowicz
Mardi Jo Cohen
Joyce Crain
Lisa Cylinder
Scott Cylinder
Robert Ebendorf
Tammy Howell Echols
John Ford
David Forlano
Chris Gustin
Judith Hoyt
Kerry Jamison
Jonathan Kline
Gary Magakis
Amy Orr
Marilyn Pappas
Joh Ricci
Jon Eric Riis
Jonathan Schmuck
Warren Seelig
Karen Shapiro
Barbara Silverstein
Barbara Lee Smith
Emiko Suo
Kiwon Wang
Kathy Wegman
Tom Wegman
Dave Williamson
Roberta Williamson

Lanny Bergner, **Folding Space: Long Tooth,** *2004*
bronze and aluminum screen, 54 x 18

Morigami Jin, **Standing,** *2004*
bamboo, 36 x 15 x 15
photo: Tanaka Yutaka

Tai Gallery/Textile Arts

Japanese bamboo arts and museum quality textiles from Africa, India, Indonesia and Japan
Staff: Robert T. Coffland

616 1/2 Canyon Road
Santa Fe, NM 87501
voice 505.983.9780
fax 505.989.7770
gallery@textilearts.com
textilearts.com

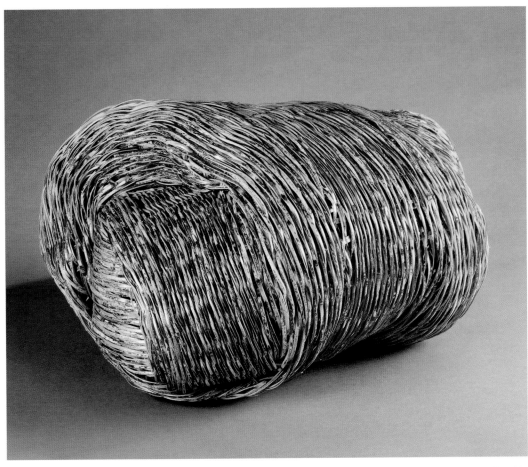

Representing:
Abe Motoshi
Fujinuma Noboru
Hatakeyama Seido
Honda Syoryu
Honma Hideaki
Katsushiro Soho
Kawano Shoko
Kawashima Shigeo
Monden Yuichi
Morigami Jin
Nagakura Kenichi
Sugita Jozan
Tanaka Kyokusho
Torii Ippo
Yamaguchi Ryuun

Tanabe Takeo, **Connection - Water II,** *2004*
bamboo, 12.5 x 21 x 20
photo: Carolyn Wright

153

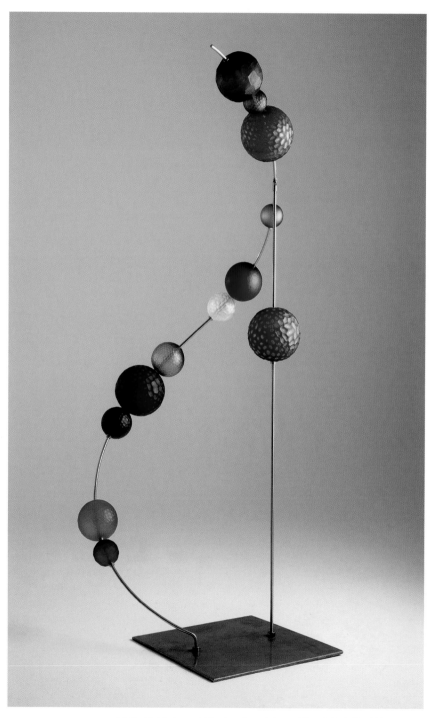

Philip Baldwin and Monica Guggisberg, **The Spiral Sky Wire,** *2004*
glass, metal, 72 x 24 x 32

Thomas R. Riley Galleries

Timeless forms backed by education, service and integrity
Staff: Thomas R. Riley; Cindy L. Riley; Cheri Discenzo

2026 Murray Hill Road
Cleveland, OH 44106
voice 216.421.1445
fax 216.421.1435

642 North High Street
Columbus, OH 43215
voice 614.228.6554
fax 614.228.6550
tom@rileygalleries.com
rileygalleries.com

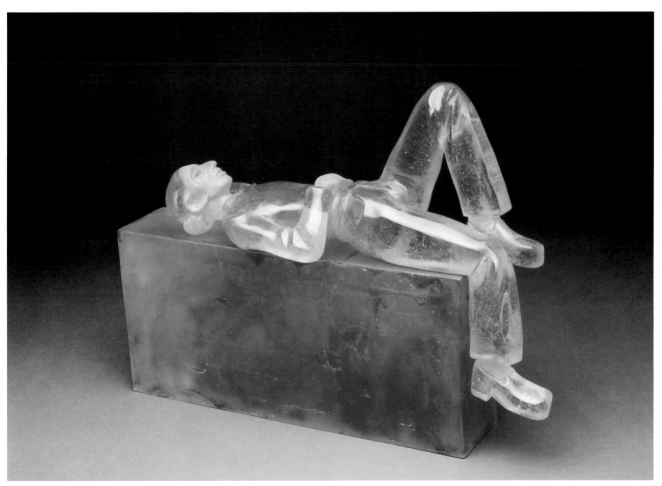

Representing:
Philip Baldwin
Don Charles
Deanna Clayton
Keith Clayton
Matt Eskuche
Kyohei Fujita
Monica Guggisberg
Lucy Lyon
Duncan McClellan
Seth Randal
Mel Rea
David Reekie
Joseph Rossano
Karen Willenbrink
Hiroshi Yamano

Lucy Lyon, **Dreamer**
cast glass, 13.5 x 19 x 5

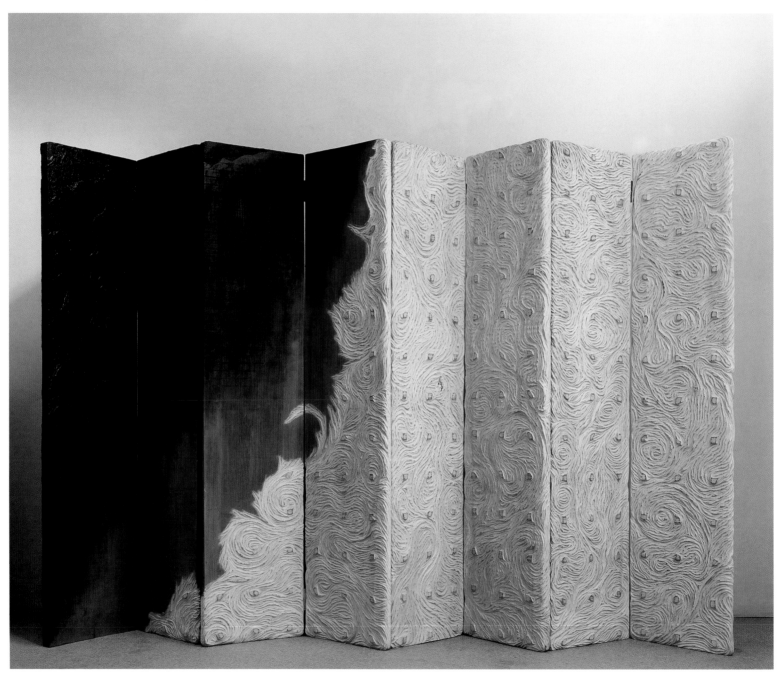

Mitsukuni Takimoto, **Untitled,** *2004*
wooden sculpture, 67 x 122.5 x 1.75
photo: Takao Ōya

Tokyo Art Projects, Inc. / Mika Gallery

Contemporary art: sculptures, ceramics, moving images, painting and photography
Staff: Mika Seki, owner/director; Kiyoka Kaneko, manager; Zachary Carr, assistant director; Misako Kitaoka and Mariko Foster, assistamts

41 East 57th Street
8th floor
New York, NY 10022
voice 212.888.3900
fax 212.888.3906
mg@tokyoartprojects.com
tokyoartprojects.com

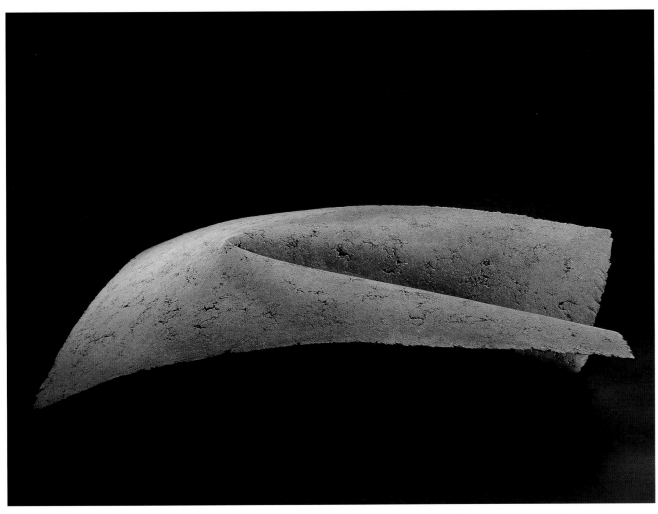

Representing:
Yukiya Izumita
Keiko Kimoto
Mitsukuni Takimoto

Yukiya Izumita, **Kou,** *2002 Grand Prix, Asahi Ceramic Competition*
ceramic, 23.5 x 35 x 7.5
photo: Takao Ōya

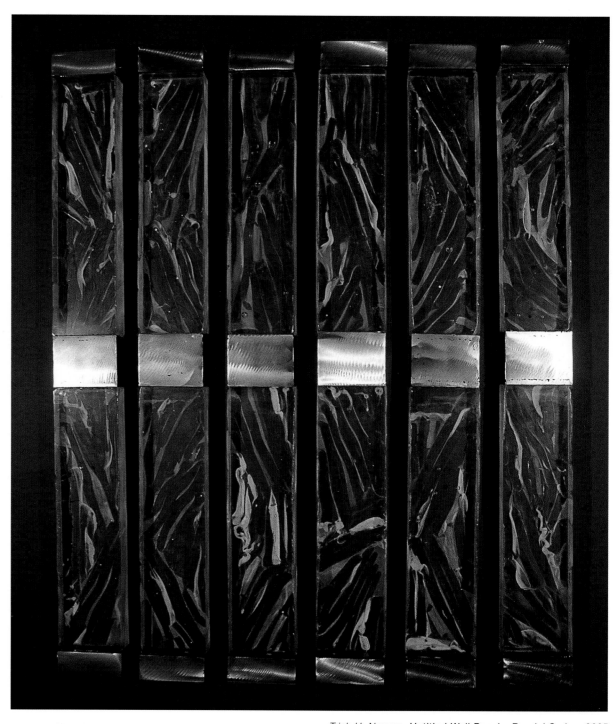

Trinh H. Nguyen, **Untitled Wall Panels, Rondel Series,** *2005*
blown glass, kiln cast, fabricated steel, 36.5 x 4 x 1.75 each; 36.5 x 31.5 x 1.75 overall
photo: Moshe Bursuker

UrbanGlass

An international center for new art made from glass
Staff: Dawn Bennett, executive director; Leanne Ng, development officer; Andrew Page, editor **Glass Quarterly**

647 Fulton Street
Brooklyn, NY 11217-1112
voice 718.625.3685
fax 718.625.3889
info@urbanglass.org
urbanglass.org

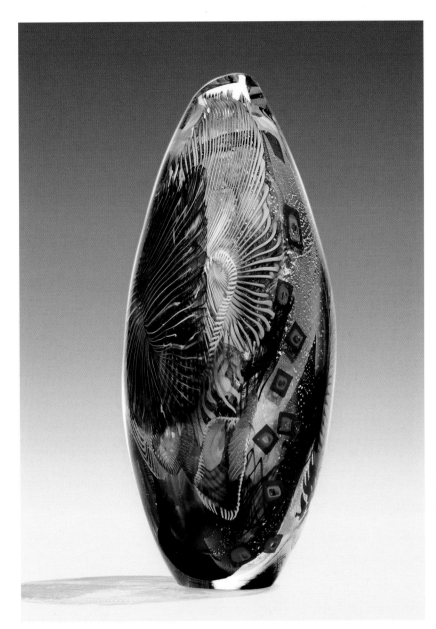

Eric Rubinstein, **Seascape***, 2004*
blown glass, 17 x 8 x 7
photo: Steven Barall

Representing:
Laurie Korowitz-Coutu
Becki Melchione
Trinh Nguyen
Erica Rosenfeld
Eric Rubinstein
Helene Safire
Melanie Ungvarsky

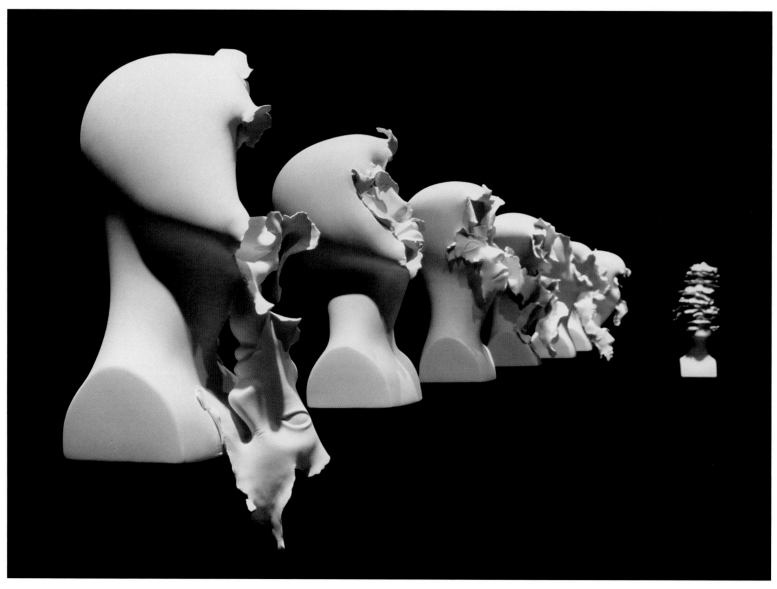

Ivan Albreht, **The Other,** *2004, as installed in WEISSPOLLACK Galleries, 2005*
porcelain, steel, 65 x 12 each
photo: Ivan Albreht

WEISSPOLLACK Galleries

Classic contemporary fine art and sculpture

Staff: David Pollack; Jeffrey Weiss; Rocco Bernardi; Elizabeth Swistock; Maria Wolff

531 West 25th Street, #GR9
New York, NY 10001
voice 212.989.3708
fax 212.989.6392
info@weisspollack.com
weisspollack.com

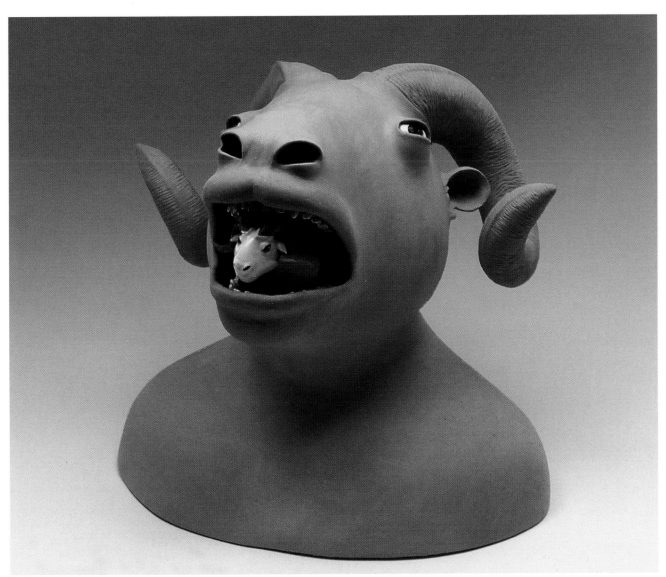

Representing:
Ivan Albreht
Christopher Cantwell
John Carnright
Chuck Connelly
William Couig
Joshua Noah Dopp
Greg Fidler
Gartner/Blade
Tim Harding
Karen Karnes
Kenjiro Kitade
Juanwon Lee
Jim Leedy
James McLeod
Elizabeth Mears
Hideaki Miyamura
Peter Petrochko
Fausto Salvi
Melissa Stern
John Urbain

Kenjiro Kitade, **Craving**, *2003*
coil-built red earthenware, low-fired with glaze and underglaze, 19 x 17 x 18

Shay Lahover, **Ring,** *2004*
22k gold, emeralds, sapphires, invisibly set diamonds, 1 x .75 x .75
photo: R. H. Hensleigh

Yaw Gallery

National and international goldsmiths and silversmiths
Staff: Nancy Yaw, director; Jim Yaw; Edith Robertson

550 North Old Woodward
Birmingham, MI 48009
voice 248.647.5470
fax 248.647.3715
yawgallery@msn.com
yawgallery.com

Representing:
Curtis H. Arima
Lola Brooks
Falk Burger
Harlan Butt
Marilyn Da Silva
Gary Griffin
Amy Haskins
Susan Hoge
Ion Ionesco
John Iversen
Shay Lahover
Barbara Ritter
Cornelia Roethel
Alto Vandian
Saumi Yacouchi

Ion Ionesco, **Ring,** *2004*
pink sapphire, diamonds, platinum, 18k gold, 1 x .75 x .5
photo: R. H. Hensleigh

SOFA 2005

5

Res

Resources

ources

CLAY IN DANISH HANDS

BY DEBORAH KRASNER • PHOTOGRAPHS BY OLE AKHØJ

Living in Denmark for two years in the mid-80s was my opportunity to experience design heaven—it actually took work to find anything ugly or poorly made. Impeccable craftsmanship and quiet confidence in stark form are hallmarks of Danish object making, as they have been for most of the 20th century. These strengths are beautifully on view in "From the Kilns of Denmark," featuring 30 ceramists. The exhibition, curated by Wendy Tarlow Kaplan and Hope Barkan in association with the Danish Museum of Decorative Art, Copenhagen, and the Fitchburg Art Museum, Massachusetts, is touring in the United States before heading back to Europe in 2004."

Those who can't get to the exhibit will still be able to get a good sense of the work from the catalog and the video accompanying it. Although the book format somewhat limits our understanding of the scale of the pieces, their strong forms shine through. The video is a useful adjunct, as it introduces us to the potters and their process, information that was lacking in the exhibition labels.

It's a curious fact of Danish life that Danes, citizens of a tiny country with a total population of around 5.3 million, still feel as if they are at the center of the world. They find it quite unsurprising that they've held a leadership position in the design world for more than 50 years—they know they're that good. For the rest of us, particularly in this country, Danish pots teach us something we've lost touch with: the power of simple form and the seductive beauty of glaze. Training its potters in essentially two major craft schools— the Danish School of Arts and Crafts, Copenhagen, and the School of Arts and Crafts, Kolding—Denmark has created and extended a tradition of thinking analytically and rigorously about shape, and of letting glaze amplify the power of form.

The majority of pots in this exhibition, whether wheel-thrown, hand-built or cast, are based on the cylinder. This shape, the first that potters learn to throw, is akin to learning the alphabet by the letter "A" and then pursuing endless, deep explorations of all that "A" can do. Here, cylinders are quiet moving elegies to the form—as in works by Inger Rokkjær, Bodil Manz, Gertrud Vasegaard—or made rich with texture—as in those by Morten Løbner Espersen and Jane Reumert.

CRAFT
AUG/SEPT 02 $5

AMERICAN
CRAFT

JUNE/JULY 02 $5

QUILT NATIONAL '03

In the 24 years since its inception, the juried biennial exhibition Quilt National has become a distinguished showcase for the art quilt. The 13th edition of this event, "Quilt National '03," opened at the Dairy Barn Southeastern Ohio Cultural Arts Center, Athens, May 24 through September 1, presenting 86 quilts by artists from 27 states and 11 foreign countries. The jurors, quilt artists Liz Axford and Wendy Huhn and Robert Shaw, author of The Art Quilt and other public volumes, drew their selection from 1,152 entries. Their statement in the catalog details the extensive jurying process and the general criteria that applied—good composition and color, a sense of content or theme, a coherent body of work, appropriate size, scale and workmanship. The works pictured here are among the 16 chosen by the jurors to receive awards.

Portions of the exhibition will travel to other venues through 2005. The itinerary and other information can be accessed at www.dairybarn.org. Quilt National 2003: The Best of Contemporary Quilts (Lark Books), 112 pages, introduction by Project Director Hilary Morrow Fletcher. Illustrated, is $24.95 from the Dairy Barn, 740-592-4981 or rachel@dairybarn.org.

CLOCKWISE FROM LUDMILA UFFENHEIMER, New York—Rockings, silk, cotton, hand-painted, wax resist, collage, machine- and hand-quilted, 79 by 58 inches, Award of Excellence, photo/Brian Blauser. DIAN GLOSSIOW, Oregon — Déjà-Vu, hand-dyed and commercial cotton dyed, monoprinted, painted relief printed, machine pieced, appliquéd, quilted, tied, 58 by 67 inches, Cathy Rasmussen Emerging Artist Memorial Award, sponsored by Studio Art Quilt Associates, photo/Brian Blauser. MICHAEL JAMES, Nebraska — A Strange Riddle, cotton printed with digitally developed images using Photoshop, CAD software and a Mimaki textile printer, machine-pieced and -quilted, 57 by 76 inches, Award for Most Innovative Use of the Medium, sponsored by Friends of Fiber Art International. CLAIRE PLUG, New Zealand — Rockface in G, discharge-dyed cotton, machine-quilted, reverse appliquéd, 39 by 74 inches, Lynn Goodwin Borgman Memorial Award for Surface Design, photo/Brian Blauser.

THE ART OF CRAFT

AMERICAN CRAFT is published bimonthly by the American Craft Council, the national organization providing leadership in the craft field since 1943. Annual membership in the Council, including a subscription to the magazine, $40, by contacting www.craftcouncil.org or 1-888-313-5527.

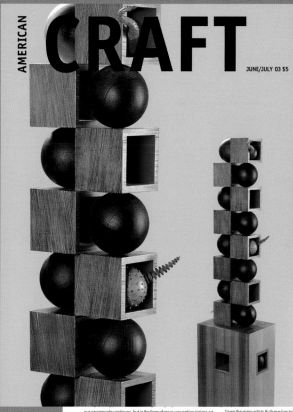

AMERICAN **CRAFT**

JUNE/JULY 03 $5

have many. So in the Bullseye ... Their home is a mixture of what ... " in glass and the art the cou- ...ng with Bullseye's technicians ...cket to be collectors," McGre-

ous promenade continues, but in the form of more conventional glass artworks. Some are delicate, some muscular, but like the driveway and porch, every piece of glass in this collection was in a sense formed by Schwoerer and McGregor, not as artists but as manufacturers of the actual material, at their firm, the Bullseye Glass Company, in Portland, Oregon (which Schwoerer, its current CEO, founded in 1974 with Ray Ahlgren and Boyce Lundstrom).

Bullseye produces some of the most vibrant colored glass in the world and has also been one of the most influential supporters of contemporary glass art through the technologies it has developed to make different glasses compatible (expansion and shrinkage variations being the chief problem in mixing glasses) and for its artist-in-residence programs and resource center/gallery, the Bullseye Connection. The company has grown from a start-up by what Schwoerer quips were "three hippies in a backyard" of a rundown Victorian house to a factory covering nearly two city blocks where that house once stood. With similarly energetic improvisation, they grew their home from an unremarkable 1,500-square-foot ranch-style bungalow bought in 1979 to what is now a 3,900-square-foot villa that Schwoerer calls "a great place to entertain," but which, McGregor unabashedly admits, is also very much "an extension of the business."

"We wanted to make a lab for the uses of the material to see how it can exist in the home beyond the usual method of putting things on shelves," Schwoerer says. "Glass collectors want to see the homes of other glass col-

Given the many artists Bullseye has hosted, the collection is extraordinarily focused on those the couple believe have achieved technical or conceptual advances in the medium. On a wall over a counter, for instance, are a series of shelves lined with the ethereal goblets Dante Marioni blows each holiday season at Bullseye. The collection is a record of a collaboration now in its eighth year between Marioni and the Bullseye technician Sam Andreakos—one McGregor describes as "America's best young glassblower working with America's best glass color chemist."

Marioni requests a type of glass. Andreakos brews a batch. Marioni then uses it to blow goblets—or *Cups*, as he prefers to title them—so delicate they seem spun out of soap bubbles. Year one was clear crystal. Year two, Venetian topaz. Year three, a rare earth mineral called urbinium that results in a color best described as dichroic champagne. And so on, from cobalts to an opaque white to a straw-colored Italian glass known as "pagliesco."

Marioni's so-ah example of blown-glass mastery is the exception in this collection, however. For the most part, Schwoerer and McGregor have turned their home, like their business, into an extended argument for the artistic equality of cast and fused glass, whose creators represent Bullseye's main clientele. In fact, in one prominent case, blown glass actually plays the foil in this collection.

Enter Schwoerer and McGregor's front door and the first piece to be noticed is their Dale Chihuly—a cluster of his *Reeds*—but positioned right next to what is easily their most valued piece, Klaus Moje's *Aperto 96*.

Originally two levels, the house now terraces down the hillside on four levels with a series of decks that fully exploit a 230-degree, four-volcano view.

Material Matters
At Home with
Dan Schwoerer and Lani McGregor

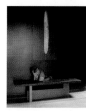

ABOVE: Jun Kaneko's 300-pound, six-feet-long arches of slumped glass create a focal point in the garden. LEFT: Sweden's Bertil Vallien comes every few years to the Bullseye factory to create a body of work in the sand-cast method of which he is a master. *Anoil* is a rare, up-turned wall-mounted piece made in 2000. Annie is poised on a mahogany and steel bench by the late Seattle artist/designer David Gulassa.

THE ART NEWSPAPER

THE 600 ROMAN STATUES HIDDEN IN A BASEMENT FOR 40 YEARS PP.26/27

CHARLES SAATCHI'S BUST-ART SELL-OFF CONTINUES P.43

THE FINANCIAL TRIALS OF THOMAS KRENS'S GLOBAL GUGGENHEIM P.18

Exhibition attendance, 2004

Japanese shows get top visitor numbers

The Hague

Former Yugoslav general sent to jail for shelling Dubrovnik

THE ART NEWSPAPER
WHAT'S ON

MUSEUMS AND GALLERIES • DEALERS' SHOWS • FAIRS • AUCTIONS

MARCH

LONDONMUN
TOKYODÜSSE
VIENNAGR
YORKSEATTE

Books

Venice—only a few decades left?

This is the first comprehensive and accessible scientific analysis of why the city floods and what can be done to stop it

Flooding in Venice since the 13th century, listed before 1917 on historical accounts

Art Market

New York

Privacy at Christie's

The auction house is increasingly relying on private-treaty sales

Christie's

Sale report: Contemporary Art, London

Freud propels Christie's sale to new high

Two paintings by the artist made more than the firm's entire sale last year

Lucian Freud, *Naked portrait 2002*, sold... at Christie's

Gallery offers amnesty to art thieves

the fine art of mo...

CONSTANTINE

Conservation

Lost Bamiyan Buddhas are dated accurately for the first time

Research continues on the colossal sculptures destroyed by the Taliban in 2001

Whatever happened to the Henry Moore in London's Kensington Gardens?

It's cheaper to build a new one

Sculptor's home to open

THE ART NEWSPAPER

No. 83, OCTOBER 1996

A special supplement

ART AND LAW

Rather than a coherent body of rules, systematically recorded in an easy-to-use manual, art law spans many legal disciplines from taxation to copyright. Unfortunately, most of the rules which affect the art market have not been tailored for its use. The market has learnt to live with them, but rising prices and increased litigation have undermined traditional equilibriums and challenged accepted practises. This first Art Newspaper supplement explains why no one can afford to miss these developments

Daniel Shapiro's introductory article exposes the random consequences of using the courts to settle differences in the U.S. He concludes that specialists, more aware of the broader implications for the market as a whole, should be consulted before letting the ball of litigation into the china shop.

Daniel Shapiro

IFAR and the Art Loss Register: practical solutions to potential legal problems

Connie Lowenthal, Executive Director of IFAR

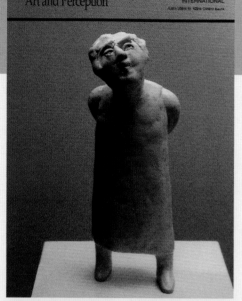

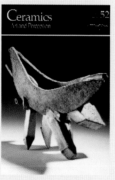

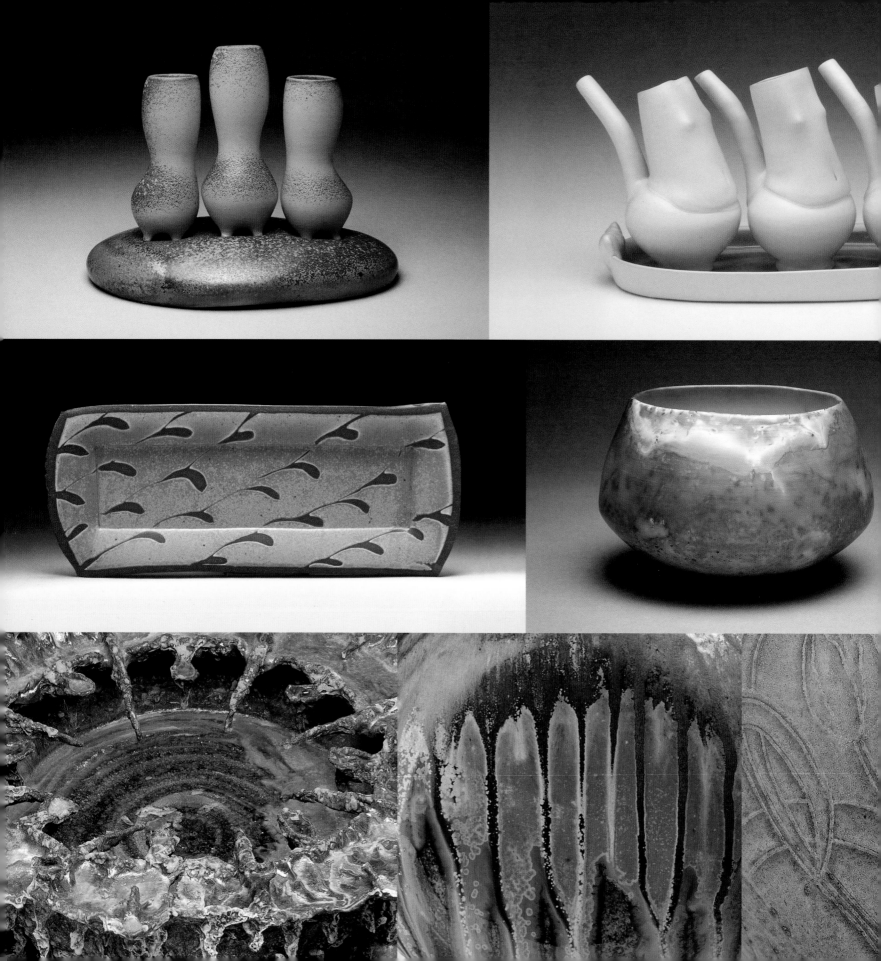

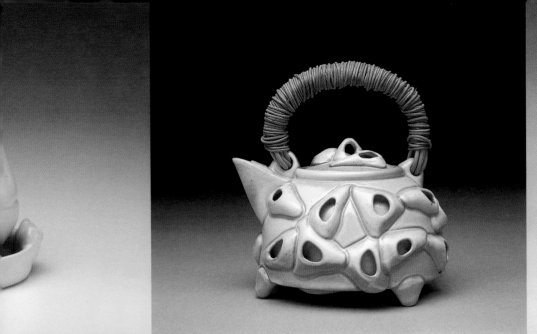
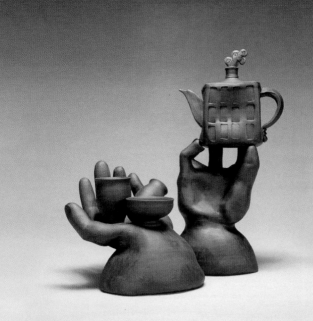
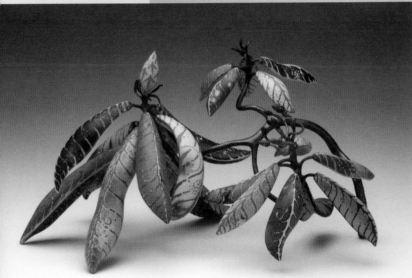

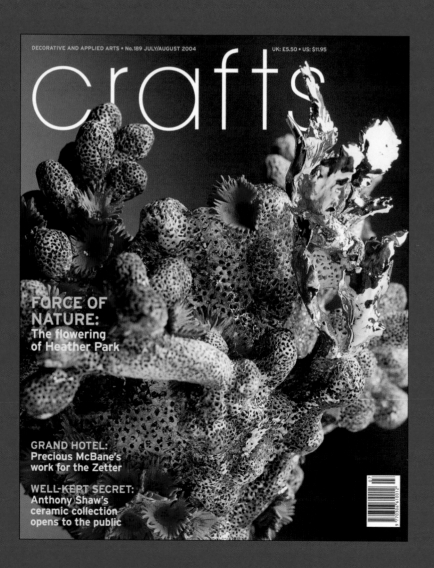

DECORATIVE AND APPLIED ARTS • No.189 JULY/AUGUST 2004 UK: £5.50 • US: $11.95

crafts

FORCE OF NATURE:
The flowering
of Heather Park

GRAND HOTEL:
Precious McBane's
work for the Zetter

WELL-KEPT SECRET:
Anthony Shaw's
ceramic collection
opens to the public

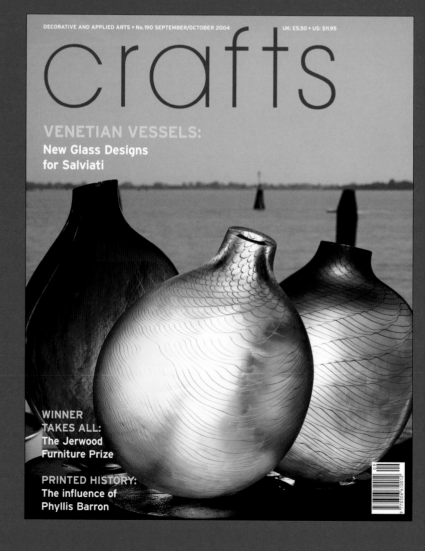

DECORATIVE AND APPLIED ARTS • No.190 SEPTEMBER/OCTOBER 2004 UK: £5.50 • US: $11.95

crafts

VENETIAN VESSELS:
New Glass Designs
for Salviati

**WINNER
TAKES ALL:**
The Jerwood
Furniture Prize

PRINTED HISTORY:
The influence of
Phyllis Barron

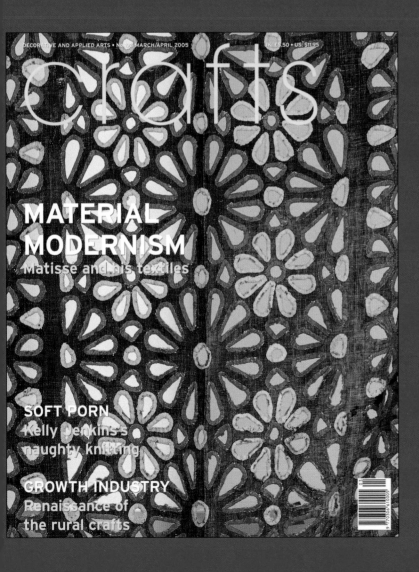

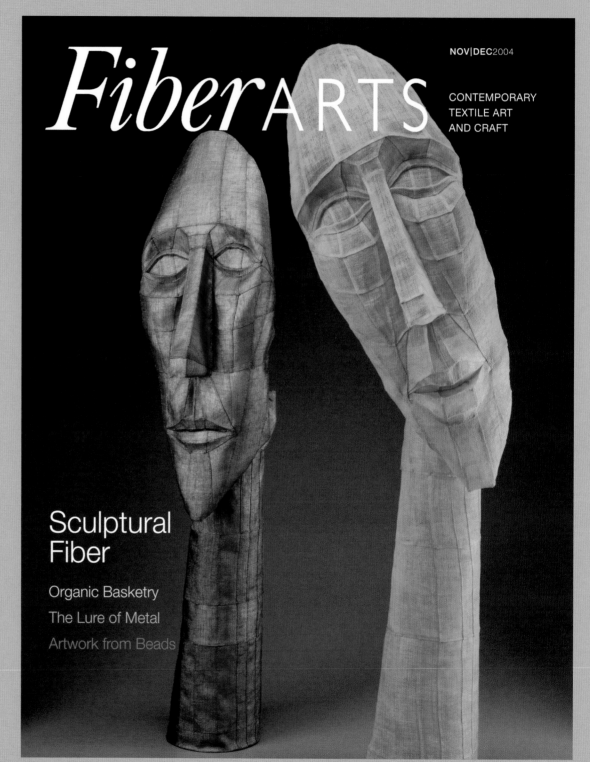

*Fiber*ARTS

NOV|DEC2004

CONTEMPORARY
TEXTILE ART
AND CRAFT

SHOWCASING
FIBER ART
AND ARTISTS

SHARING INSPIRATION
AND INNOVATIONS

PROVIDING RESOURCES
AND INFORMATION

Sculptural
Fiber

Organic Basketry

The Lure of Metal

Artwork from Beads

*Fiber*ARTS

CONTEMPORARY
TEXTILE ART AND
CRAFT

LEFT TO RIGHT, TOP TO BOTTOM: *Janet Kurjan,* Spice Islands; *Emily Richardson,* Came Out of the Sea; *Larissa Brown,* Acrid O; *Ignatius Hats (created by Ignatius Creegan and Rod Givens),* Pagoda; *Karin Birch,* Saint Undelivered; *Banafsheh Moghaddam,* Gilgamesh; *Kathy Weaver,* Cyborg Interface; *Soonran Youn,* Self Container No. 4. All images are details.

ASOFA5

 INTERWEAVE PRESS.

201 E. Fourth Street, Loveland, CO 80537
www.interweave.com

Published 6 times a year

27. Jahrgang · Nr. 1/2005 · Februar/März · € 6,–/sfr 11,– · G 8031 F mit KERAMIKcreativ

KeramikMagazin
CeramicsMagazine

Im Verborgenen. Über Bert Walter
Erstaunliches aus Kiel
Schönheit im Ebenmaß. Gefäße von Thomas Bohle

26. Jahrgang · Nr. 6/2004 · Dezember/Januar · € 6,–/sfr 11,– · G 8031 F mit KERAMIKcreativ

KeramikMagazin
CeramicsMagazine

Gegen die Konvention: Michael Geertsen
Hauptstadtkeramik: Die Sonderschau in Pankow
Sammeln als Wissenschaft: Das Ehepaar Crueger im Gespräch

26. Jahrgang · Nr. 5/2004 · Oktober/November · € 6,–/sfr 11,– · G 8031 F mit KERAMIKcreativ

KeramikMagazin
CeramicsMagazine

Historische Wiederauflage: 11. Westerwaldpreis
Aus einem Guss: Luther-Fischer-Museum eröffnet
Starke Stimme aus der Stille: Nicolas Arroyave-Portela

26. Jahrgang · Nr. 4/2004 · August/September · € 6,–/sfr 11,– · G 8031 F mit KERAMIKcreativ

KeramikMagazin
CeramicsMagazine

Lekker Decadent! Wechselbad der Gefühle in Holland
Hingehauchtes. Keramik von Aino Nebel
Die Puristin. Neues von Judith Rataitz

26. Jahrgang · Nr. 3/2004 · Juni/Juli · € 6,–/sfr 11,– · G 8031 Y

KeramikMagazin
CeramicsMagazine

Nochmal neu! Kannofenbrand in Höhr-Grenzhausen
Immer anders! Im Atelier von Ilse Teipelke
Clay. Eine Ausstellung in der Tate Liverpool

26. Jahrgang · Nr. 2/2004 · April/Mai · € 6,–/sfr 11,– · G 8031 F mit KERAMIKcreativ

KeramikMagazin
CeramicsMagazine

Töpferhände: Helga Gambóa. Ein Porträt
Nordische Blüte. Ein Projekt von Nina Maltrud
Interview: Was ist neu in Frankfurt?

METALSMITH

JEWELRY · DESIGN · METAL ARTS WINTER 2005

25 YEARS

volume 25 number 1
www.snagmetalsmith.org

Poetic Mischief

Tiaras to Tombstones

Miniature Monuments

METALSMITH magazine

A publication of the Society of North American Goldsmiths, the organization for jewelers, designers and metalsmiths.

METALSMITH is the only magazine in America dedicated solely to the metal arts. Published five times a year, and including the acclaimed Exhibition in Print, it documents, analyzes and promotes excellence in jewelry and metalworking, with an emphasis on contemporary ideas, critical issues and relevant historical work.

FOR MORE INFORMATION:
630.778.METL (6385)
Info@snagmetalsmith.org

SUZANNE RAMLJAK, Editor
203.792.5599
fax **203.792.5588**
metalsmitheditor@mindspring.com

JEAN SAVARESE, Advertising Director
413.585.8478
fax **413.585.8430**
advertising@snagmetalsmith.org

DANA SINGER, Executive Director

SIGN UP TODAY!

www.kunstwelt-online.de

We invite you to join the Art Jewelry Forum

and participate with other collectors who share
your enthusiasm for contemporary art jewelry.

Maria Phillips

Amie Plante
2005 Emerging
Artist Winner

Lori Talc

OUR MISSION To promote education, appreciation,
and support for contemporary art jewelry.

OUR GOALS To sponsor educational programs,
panel discussions, and lectures about national and
international art jewelry.

To encourage and support exhibitions, publications,
and programs which feature art jewelry.

To organize trips with visits to private collections,
educational institutions, exhibitions, and artists' studios.

ajf

Join the Art Jewelry Forum today!

E-mail: **info@artjewelryforum.org**

Call: **415.522.2924**

Website: **www.artjewelryforum.org**

Write us at: **Art Jewelry Forum,
P.O. Box 590216, San Francisco, CA
94159-0216**

Cherished Possessions

A NEW ENGLAND LEGACY

EXHIBITION

Closes June 5, 2005

PUBLIC PROGRAM

Calling It Craft - at SOFA

Lecture and guided tour led by design expert Lily Kane

Friday, June 3, 10:15–12:00 noon

Tickets: $35 general; $25 seniors and students
(includes admission to SOFA NYC 2005 and a catalogue)

To register, please call
the Bard Graduate Center Public Programs Department
212-501-3011 or e-mail programs@bgc.bard.edu

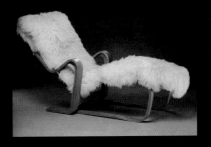

For exhibition information:
212-501-3023
gallery@bgc.bard.edu
www.bgc.bard.edu

Pembroke table, China, ca. 1800, lacquer on wood, gift of the childern of Arthur and Susan cabot Lyman
Various earthenware, probably New England, 1840-1880, earthenware, gift of Betram K. and Nina Fletcher Little
Long chair, Marcel Breuer (1902-1981), London, England, 1936-37, birch, plywood and canvas, bequest of Ise Gropius
Wallpaper, probably Boston, Massachusetts, 1787-1790, stenciled and block-printed wove paper, gift of Mrs. Henry G. Vaughan

Cherished Possessions: A New England Legacy is organized by
the Society for the Preservation of New England Antiquities (SPNEA).

The Bard Graduate Center for Studies in the Decorative Arts, Design, and Culture BGC 18 West 86th Street, New York, NY 10024

Collectors of
Wood
Art

WOOD 2005

Collectors of Wood Art Forum

& **Wood Turning Center
World Turning Conference**

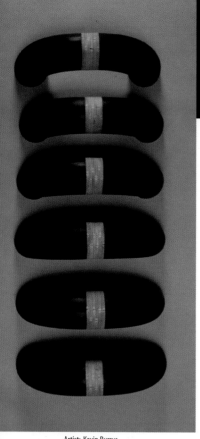

Artist: Kevin Burrus

Collectors of Wood Art *SPECIAL EVENTS*
Held in conjunction with the Wood Turning Center's World Turning Conference in Philadelphia

September 21 – 25, 2005

- **CWA Opening Reception – Exhibits by International Galleries at the Doubletree Hotel Magnificent work on display by established and emerging wood artists**

- **A variety of interesting tours of collectors' homes and artists' studios**

- **US and international artists will join collectorsfor an informal dinner**

- **Special Tours at the Winterthur Museum and the Wharton Esherick Museum**

- **Speakers with a focus on building and displaying your collection**

For information contact the Collectors of Wood Art at 1-888-393-8332 or cwa@nycap.rr.com or
visit our website at www.collectorsofwoodart.org

The Creative Glass Center of America and the
Art Alliance of Contemporary Glass welcome you to

GlassWeekend '05

July 16th & 17th

An International Symposium and
Exhibition of Contemporary Glass at Wheaton Village

Guest Demonstrating Artists

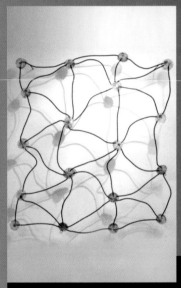

Hank Murta Adams

Shane Fero

José Chardiet

PARTICIPATING GALLERIES:

Bullseye Connection Gallery, Portland, OR
Chappell Gallery, Boston, MA
Elliott Brown Gallery, Seattle, WA
Glass Artists' Gallery, Sydney, Australia
Habatat Galleries, Royal Oak, MI
Hawk Galleries, Columbus, OH
Heller Gallery, New York, NY
L. H. Selman Ltd., Santa Cruz, CA
Leo Kaplan Modern, New York, NY
Marx-Saunders Gallery, Chicago, IL
Maurine Littleton Gallery, Washington DC
Morgan Contemporary Glass Gallery, Pittsburgh, PA
Mostly Glass Gallery, Englewood, NJ
R. Duane Reed Gallery, St. Louis, MO
Sandra Ainsley Gallery, Ontario, Canada
Thomas R. Riley Galleries, Columbus, OH
Snyderman-Works Galleries, Philadelphia, PA
The Glass Gallery, Bethesda, MD
Tobin-Hewett Gallery, Louisville, KY
Wexler Gallery, Philadelphia, PA

SPECIAL OPPORTUNITIES FOR WEEKEND REGISTRANTS:

– Hands-on Experiences (additional fee required)
– Preview Gallery Reception, Friday, July 15
– Saturday Evening Dinner and Auction
– Lectures, Artist Presentations,
 Curator's Tours and Workshops
– Hot Glass Demonstration for Registrants Only

ACCOMMODATIONS:

– Holiday Inn Express 856-293-8888
– Ramada Inn 856-696-3800
– Wingate 856-690-9900
– The Country Inn 856-825-3100

CONTACT CGCA FOR A REGISTRATION FORM

Creative Glass Center of America at Wheaton Village
Phone: 1-800-998-4552
Email: cgca@wheatonvillage.org
Directions: www.wheatonvillage.org

For more information visit:
www.glassweekend.com

Wheaton Village strives to make exhibits, events and programs accessible to all visitors. Funding has been made possible in part by the New Jersey State Council on the Arts/Department of State, a Partner Agency of the National Endowment for the Arts, and the Geraldine R. Dodge Foundation. Wheaton Village received a general operating support grant from the New Jersey Historical Commission, a division of Cultural Affairs in the Department of State

DISPLAY THE NEW COLLECTABLE

DAVID LING ARCHITECT
DAVIDLINGARCHITECT.COM
212.982.7089

Tapestry woven by Jon Eric Riis titled
Icarus No. 1

Sculpture stuffed and quilted by
Margaret Cusack titled *Hands*

Drawing embroidered by B.J. Adams
titled *Hands Drawing Hands*

Sculpture crocheted by
Norma Minkowtiz titled *Sandy G*

WALL WORKS AND SOFT SCULPTURE will complement the glass, clay, metal and wooden objects now adorning your home. Discover the impressive range of works being produced today by a talented bevy of artists who employ countless techniques to construct enviable art works of natural and man-made flexible materials.

SEE PRIVATE COLLECTIONS OF FIBER ART on tours organized by Friends of Fiber Art. Generous collector members show you how handsome fiber art looks in their elegant homes. Many were listed among the "100 Top Collectors in America" published by *Art & Antiques* magazine.

NETWORK WITH THE MOVERS AND SHAKERS who share ideas with the buyers and makers at all programs sponsored by Friends of Fiber Art, the only organization that fosters communication among collectors, curators, critics, dealers and artists.

LEARN WHERE FIBER ART IS ON VIEW by reading the outspoken newsletter for members of Friends of Fiber Art. It notes developments in the museum world and features the achievements of its members.

OUR MISSION is to inform and inspire the art-appreciative public about the "collectability" of contemporary art made of flexible materials.

CONTACT US by phone, fax or mail. Learn about scheduled programs at www.**f**riends**off**iber**a**rt.org our developing Web site.

friends of fiberArt International™

Post Office Box 468
Western Springs, IL 60558
Phone/Fax 708-246-9466

Glass Art Society

The Glass Art Society is an international non-profit organization founded in 1971 whose purpose is to encourage excellence, to advance education, to promote the appreciation and development of the glass arts, and to support the worldwide community of artists who work with glass.

GAS members are artists, students, educators, collectors, gallery and museum personnel, writers, and critics, among others. Membership is open to anyone interested in glass art.

For more information or to join GAS:

Glass Art Society
3131 Western Ave., Suite 414
Seattle, WA 98121

Tel: 206.382.1305
Fax: 206.382.2630
info@glassart.org

www.glassart.org

Glass Gateways: Meet in the Middle
36th Annual Conference
St. Louis, Missouri

GLASS ART
SOCIETY

June 15-17, 2006

Demonstrations, Lectures, Panel Discussions, Exhibitions, Technical Display, Auction, Parties, and more!

CELEBRATE AMERICAN CRAFT ART AND ARTISTS JOIN THE JAMES RENWICK ALLIANCE.

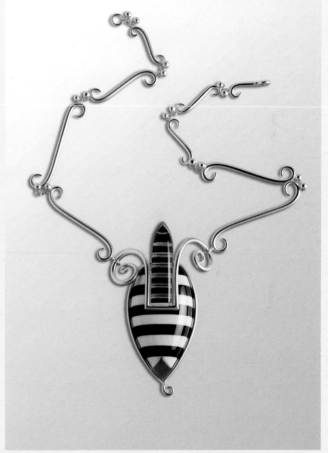

LEARN
about contemporary crafts at our seminars,

SHARE
in the creative vision of craft artists at workshops,

REACH OUT
by supporting our programs for school children,

INCREASE
your skills as a connoisseur,

ENJOY
the comaraderie of fellow craft enthusiasts,

PARTICIPATE
in Craft Weekend including symposium and auction, and

TRAVEL
with fellow members on our craft study tours.

Linda MacNeil "Zebra Flower" Floral Necklace Series, 2003

As a member you will help build our nation's premiere collection of contemporary American craft art at the Renwick Gallery.

The James Renwick Alliance, founded in 1982, is the exclusive support group of the Renwick Gallery of the Smithsonian American Art Museum.

For more information: Call 301-907-3888. Or visit our website: www.jra.org

LongHouse Reserve
Summer 2005

BELLS BY TOSHIKO TAKAEZU

LOUISE NEVELSON

SOL LEWITT

RUTH BORGENICHT

ROY LICHTENSTEIN

WILLEM DE KOONING

GRACE KNOWLTON

PAVEL OPOCENSKY

TAKASHI SOGA

AMY GOLDMAN

SHONNA VALESKA

Wednesdays and Saturdays 2-5pm through September 24

133 Hands Creek Road • East Hampton, NY 11937
TEL. 631.329.3568 FAX 631.329.4299 www.longhouse.org

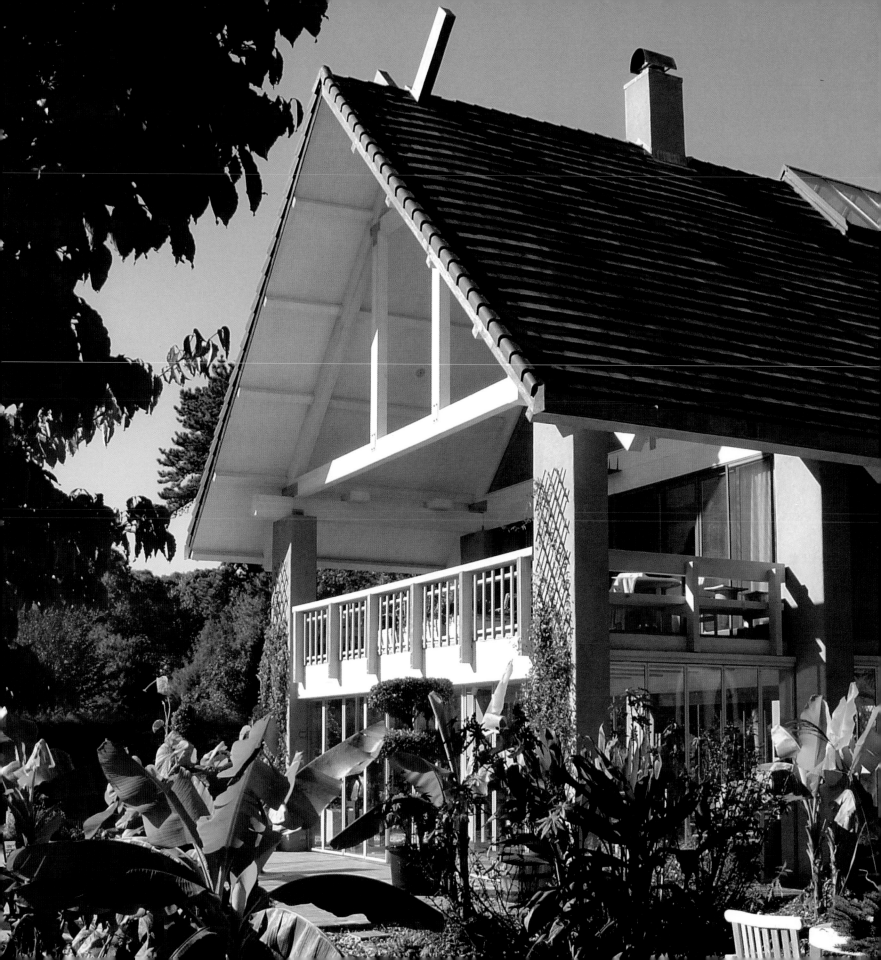

 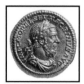
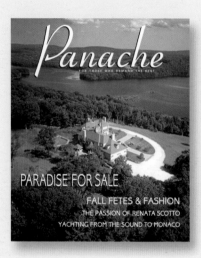 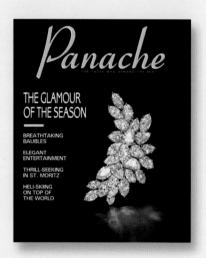 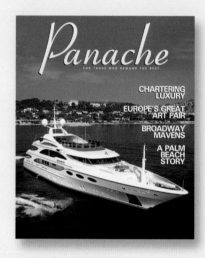

Dual Vision: The Jerome A. & Simona Chazen Collection
May 26—September 11, 2005

Museum of Arts & Design

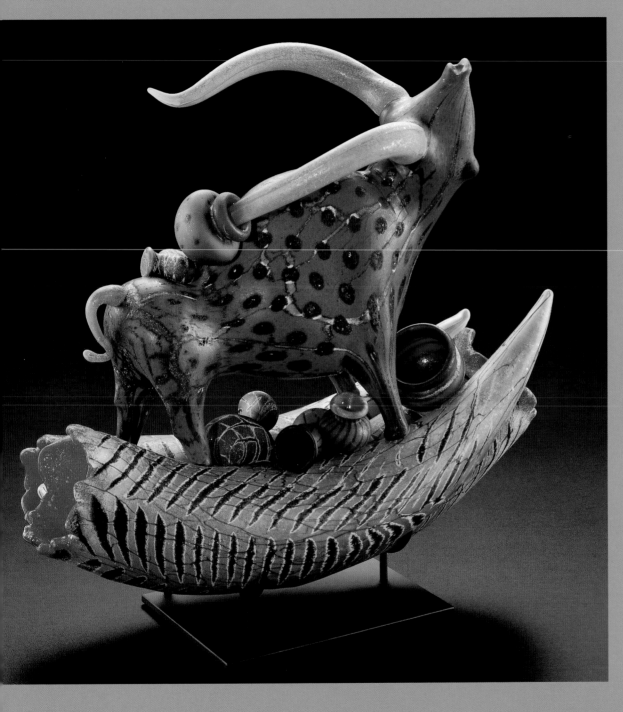

The Museum of Arts & Design
wishes to thank
Jerome A. and Simona Chazen
for their exceptional leadership
and generous gift of works from
their collection, which will be the
cornerstone of the new museum.

While you're at SOFA, please visit
the Museum on 53rd Street.

Museum of Arts & Design Defining Craft of Our Time
40 West 53rd Street
New York, NY 10019
212.956.3535

www.madmuseum.org

William Morris
Raft, 1998
Hand-blown and sculpted glass
18 x 18 x 9"
The Collection of Jerome A.
and Simona Chazen
Photo: Rob Vinnedge

Visit the Sculpture
Objects and Functional Art
website for in-depth
information on SOFA.
View works of art and
enjoy feature articles
on theory, criticism and
practice of contemporary
decorative and fine art.

SOFAEXPO.COM

**Online Exposition
of Sculpture Objects
& Functional Art**

sofaexpo.com

The Archives of American Art thanks Nanette L. Laitman for her gift to the Smithsonian Institution of the

Nanette L. Laitman
Documentation Project for Craft and Decorative Arts

Participants include Glenn Adamson • Neda Al-Hilali • Edgar Anderson • Joyce Anderson • Anneberg Gallery records • Carole Austin • Rudy Autio • Ralph Bacerra • Clayton Bailey • Suzanne Baizerman • Fred Uhl Ball • Dorothy Gill Barnes • James W. Bassler • Garry Knox Bennett • Bill Berkson • Lili Blumenau • J. B. Blunk • Irena Brynner • Joan Falconer Byrd • Candy Store Gallery records • Joyce Marquess Carey • Margaret Carney • Arthur Espenet Carpenter • Chunghi Choo • Fong Chow • Sharon Church • Michael Cohen • Betty Cooke • Edward S. Cooke, Jr. • Nancy Crow • Joanne Cubbs • Val Cushing • William P. Daley • Margaret De Patta • Stephen De Staebler • Dominic Di Mare • Dorothy Weiss Gallery records • Mary Douglas • Fritz Dreisbach • Ruth Duckworth • Robert Ebendorf • Sharon Emmanuelli • Helen Drutt English • Fendrick Gallery records • Fred Fenster • Arline M. Fisch • Oscar Fitzgerald • Donna Forbes • Frank Lloyd Gallery records • Susanne Frantz • Michael Frimkess • Gallery at Workbench records • Donna Gold • Gary Griffin • Trude Guermonprez • Henry Halem • Vicki Halper • Kathleen Hanna • William Harper • Peggie Hartwell • Otto Heino • Lloyd E. Herman • Sheila Hicks • Wayne Higby • Frances Higgins • Ron Ho • Holly Hotchner • Ursula Ilse-Neuman • Michael James • Michael Jerry • Joanne Rapp Gallery/the Hand and the Spirit records • Tom Joyce • Paul J. Karlstrom • Karen Karnes • William Keyser, Jr. • L. Brent Kington • Joey Kirkpatrick • Liza Kirwin • Gerhardt Knodel • Ruth Kohler • Silas Kopf • James Krenov • Earl Krentzin • Gyöngy Laky • Jack Lenor Larsen • Stanley Lechtzin • Rob Levin • Marilyn Levine • Monique Lévi-Strauss • Marvin Lipofsky • Harvey K. Littleton • Frank Lloyd • David Lyon • Flora Mace • Warren MacKenzie • Patricia Malarcher • Sam Maloof • Richard Marquis • John Marshall • Beverly Mayeri • Signe Mayfield • Carolyn Mazloomi • David McFadden • Mary McInnes • Harrison McIntosh • Judy McKie • James Melchert • Margo Mensing • John Paul Miller • Norma Minkowitz • Edward Moulthrop • Richard Mower • Ron Nagle • Tony Natsoulas • Hal Nelson • Walter Nottingham • Jere Osgood • Rudy Osolnik • Carol Owen • Paul and Elmerina Parkman • Alice Parrot • Mark Peiser • John Perreault • Susan Peterson • Sue Pierce • Eugene Pijanowski • Hiroko Sato Pijanowski • Antonio Prieto • Renny Pritikin • Merry Renk • Mija Riedel • Jan Ritter • Richard Ritter • Jean Robertson • John Roloff • Tacey Rosolowski • Edward Rossbach • Jane Sauer • Merryll Saylan • Mary Ann Scherr • Marjorie Schick • Cynthia Schira • Kim Schmahmann • Anita Schnee • Ruth Adler Schnee • June Schwarcz • Kay Sekimachi • Frances Senska • Heikki Seppä • Mary Shaffer • David Shaner • Richard Shaw • Robert Silberman • Philip Simmons • Tommy Simpson • Paul J. Smith • Ramona Solberg • Paul Soldner • Jean and Hilbert Sossin • Robert Sperry • Bob Stocksdale • Susan Cummins Gallery records • Toshiko Takaezu • Akio Takamori • Kenneth Trapp • Bob Trotman • Robert Turner • William Underhill • Stephen H. Van Dyk • James Wallace • Patti Warashina • Richard J. Wattenmaker • Katherine Westphal • Kathyanne White • Gerry Williams • Bob Winston • J. Fred Woell • Betty Woodman • Jan Yager • Cristobal Zañartu

In May 2000, the Archives of American Art, Smithsonian Institution, received a generous gift from Nanette L. Laitman for the creation of the Nanette L. Laitman Documentation Project for Craft and Decorative Arts in America, an important program to document the life and work of America's leading craft artists. During this five-year project the Archives recorded and transcribed 100 oral history interviews with key figures in American craft. The grant also supported a major campaign to collect the papers of prominent artists working in clay, glass, fiber, metal, and wood. This national initiative was realized in association with the Museum of Arts & Design. Visit the Archives of American Art at www.aaa.si.edu

Smithsonian
Archives of American Art

WOOD 2005

&

Collectors of Wood Art Forum

**Wood Turning Center
World Turning Conference**

Creating

Collecting

Critiquing

Wednesday — Sunday,

September 21 — 25, 2005

Philadelphia, PA USA

Wood Turning Center
501 Vine Street
Philadelphia, PA 19106
tel: 215.923.8000
fax: 215.923.4403
turnon@woodturningcenter.org
www.woodturningcenter.org

Hours:
Monday–Friday 10am-5pm
Saturday 12pm-5pm

**Galleries from across the country and abroad
will be presenting work at the CWA Forum at the
Double Tree Hotel.**

Regional Venues participating in WOOD 2005:
(as of February 2005)

- Abington Art Center
- Cheltenham Art Center
- The Clay Studio
- Moderne Gallery
- Nakashima Studio
- Old City Arts Association
- Philadelphia Museum of Art
- Philip & Muriel Berman
 Museum of Art

- Schmidt Dean Gallery
- Snyderman / Works Galle
- Wexler Gallery
- The Wharton Esherick Mu
- Winterthur Museum,
 Library & Gardens
- Wood Turning Center

Wood Turning Center

Wood And Other Lathe-Turned Art

education
preservation
promotion

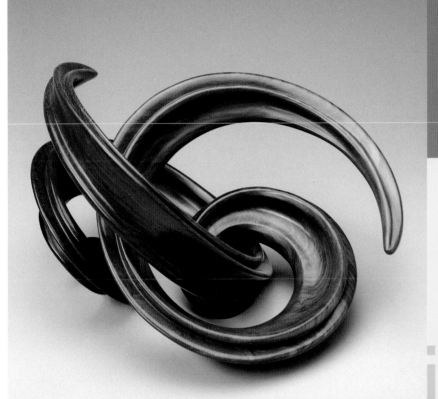

Turning Points includes reviews of exhibitions, conferences and symposia; articles on the art of lathe-turning, from authentic historical reproductions to the most avant-garde; conservation, collector and artist issues. Free one-year subscription with membership.

join us

Wood Turning Center
501 Vine Street, Philadelphia, PA 19106
tel: 215.923.8000
fax: 215.923.4403
turnon@woodturningcenter.org
www.woodturningcenter.org

Hours:
Monday–Friday 10am-5pm
Saturday 12pm-5pm

Members of the Wood Turning Center play a vital role by helping to fulfill its mission of education, preservation and promotion. Because you may share an interest in lathe turning or related arts, we invite you to support WTC with your membership.

Founded in 1986, the Wood Turning Center, a Philadelphia-based not-for-profit arts institution, gallery and resource center, is dedicated to the art and craft of lathe-turned objects. Through its programs, the Center encourages existing and future artists, and cultivates a public appreciation of the field.

Deepen both your knowledge and appreciation of the art of lathe-turning and gain insight into the artists who are expanding the art and craft of wood turning. Contact the Center by phone or visit our web site for details.

Environmental Sculpture by Neil Dawson (NZ)

Painted Wooden Forms by Binh Pho (USA)

Wood by Michael Peterson (USA)

Recognised by *Newsweek* as the "industry favorite"

(Newsweek, 8 March, 2004)

CRAFT ARTS INTERNATIONAL has been recognised by *Newsweek* as the most important "industry favorite", providing essential "international scope" of the variety of contemporary visual and applied arts. According to *Newsweek,* collecting contemporary crafts is now "downright glamourous"; follow the lead of Elle McPherson, Eric Clapton and Donna Karan and begin your own collection with the best information available. Each issue of *Craft Arts International* contains 128 pages, in full colour, with over 400 color images of innovative concepts and new work by leading artists and designer/makers, supported by authoritative and comprehensive texts, essential reading for anyone interested in the contemporary visual and applied arts.

Limited stocks of back issues are available and may be ordered directly from our secure website. Our on-line index includes every article and artist that have appeared in the magazine since it was launched in 1984! And access to this remarkable resource, one of the most comprehensive available on the Internet, is totally free.

Subscriptions: subs@craftarts.com.au Advertising: info@craftarts.com.au

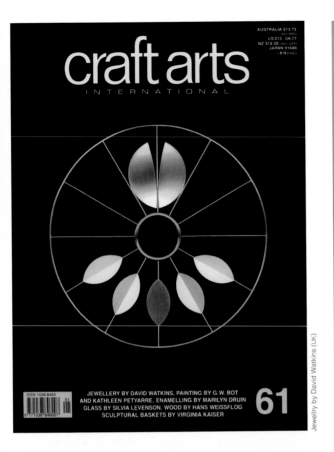

Jewellry by David Watkins (UK)

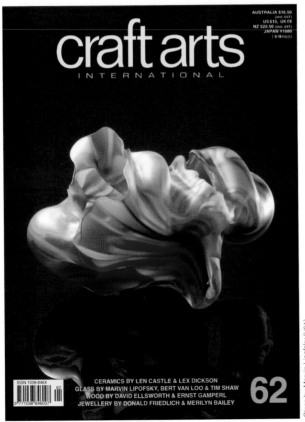

Glass by Marvin Lipofsky (USA)

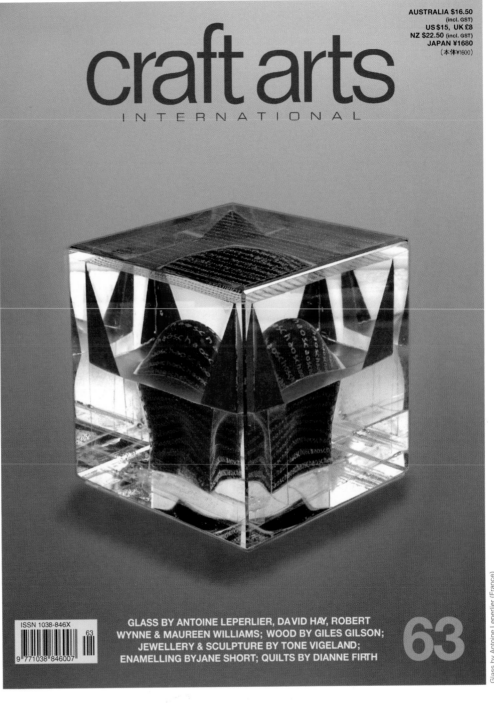

Glass by Antoine Leperlier (France)

Craft Arts International
PO Box 363, Neutral Bay, NSW 2089, Australia
Tel: +61-2 9908 4797, Fax: +61-2 9953 1576

www.craftarts.com.au

SOFA 2005

Advertisements

Ads

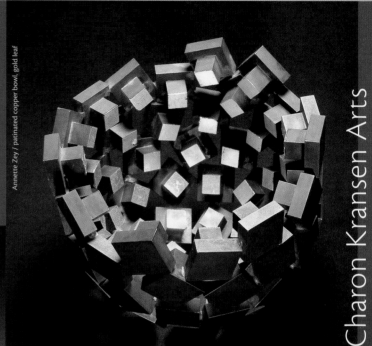

WEXLER
GALLERY

The Wexler Gallery is an internationally recognized
gallery representing the finest in contemporary hand crafted
furniture and decorative arts. We showcase the highest quality of
work in a broad range of styles and techniques. Among the world
renowned artists we represent are Wendell Castle, Dale Chihuly
and Albert Paley.

We serve a wide client base that includes established collectors who
are looking for specific pieces to fill in their collections, as well as
those individuals just beginning to acquire contemporary decorative
art pieces. In addition to our extensive collection and ongoing
shows, the Wexler Gallery features special exhibitions on a
bimonthly basis. We invite you to visit our gallery in Old City
Philadelphia or online at www.wexlergallery.com.

Wexler Gallery 201 N. Third St. Philadelphia, PA 19106 215-923-7030 www.wexlergallery.com

International Expositions
of Sculpture Objects
& Functional Art:

SOFA CHICAGO and
SOFA NEW YORK

1994-2004 catalogues available, surveying
10 years of masterworks bridging the decorative
and fine arts. Featuring essays by leading artists,
scholars and collectors, hundreds of images
of artwork for sale at SOFA expositions and
gallery/speaker/artist indexes. Great references!

visit: www.sofaexpo.com
email: info@sofaexpo.com
call: 800.563.7632

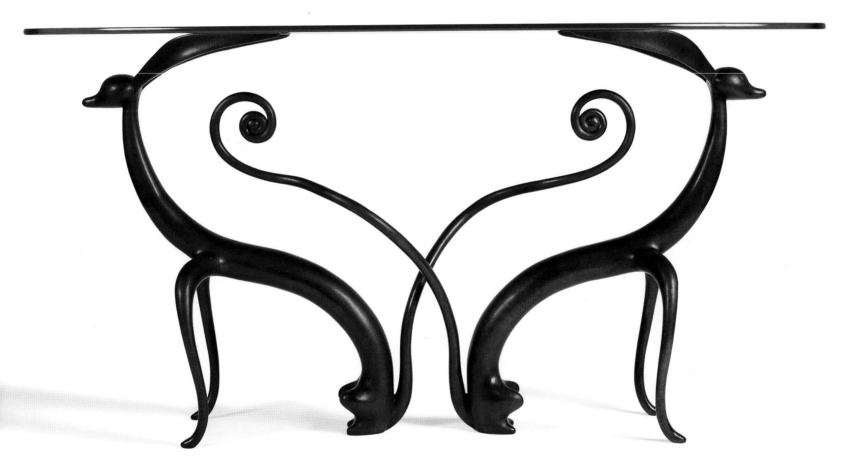

Index of Exhibitors

hibitors

Aaron Faber Gallery
666 Fifth Avenue
New York, NY 10103
212.586.8411
fax 212.582.0205
info@aaronfaber.com
aaronfaber.com

Ann Nathan Gallery
212 West Superior Street
Chicago, IL 60610
312.664.6622
fax 312.664.9392
nathangall@aol.com
annnathangallery.com

Artempresa
San Jeronimo 448
Cordoba 5000
Argentina
54.351.422.1290
fax 54.351.427.1776
artempresa@arnet.com.ar
artempresagallery.org

Barry Friedman Ltd.
32 East 67th Street
New York, NY 10021
212.794.8950
fax 212.794.8889
contact@barryfriedmanltd.com
barryfriedmanltd.com

Bellas Artes/Thea Burger
Bellas Artes
653 Canyon Road
Santa Fe, NM 87501
505.983.2745
fax 505.983.1271
bc@bellasartesgallery.com
bellasartesgallery.com

Thea Burger
39 Fifth Avenue, Suite 3B
New York, NY 10003
802.234.6663
fax 802.234.6903
burgerthea@aol.com

Bentley Projects
215 East Grant Street
Phoenix, AZ 85004
602.340.9200
fax 775.206.9140
information@bentleygallery.com
bentleyprojects.com

Berengo Fine Arts
Glass Studio & Gallery
Fondamenta Vetrai 109/A
Murano, Venice 30141
Italy
39.041.739453
39.041.5276364
fax 39.041.527.6588
adberen@berengo.com
berengo.com

Berengo Collection Gallery
Calle Larga San Marco 412/413
Venice 30124
Italy

Kortestraat 7
Arnhem 6811 EN
The Netherlands
31.26.370.2114
31.61.707.4402
fax 31.26.370.3362
berengo@hetnet.nl

browngrotta arts
Wilton, CT
203.834.0623
fax 203.762.5981
art@browngrotta.com
browngrotta.com

Chappell Gallery
526 West 26th Street
Suite 317
New York, NY 10001
212.414.2673
fax 212.414.2678
amchappell@aol.com
chappellgallery.com

Charon Kransen Arts
By Appointment Only
456 West 25th Street
New York, NY 10001
212.627.5073
fax 212.633.9026
chakran@earthlink.net
charonkransenarts.com

Clay
226 Main Street
Venice, CA 90291
310.399.1416
fax 301.230.9203
info@clayinla.com
clayinla.com

The David Collection
44 Black Spring Road
Pound Ridge, NY 10576
914.764.4674
fax 914.764.5274
jkdavid@optonline.net
thedavidcollection.com

Dean Project
25 Central Park West
Suite 5U
New York, NY 10023
212.252.6840
fax 212.591.6979
info@deanproject.com
deanproject.com

del Mano Gallery
11981 San Vicente Boulevard
Los Angeles, CA 90049
310.476.8508
fax 310.471.0897
gallery@delmano.com
delmano.com

Donna Schneier Fine Arts
By Appointment Only
New York, NY
212.472.9175
fax 212.472.6939
dnnaschneier@mhcable.com

Ferrin Gallery
69 Church Street
Lenox, MA 01240
413.637.4414
fax 914.271.0047
info@ferringallery.com
ferringallery.com

**Galerie Ateliers
d'Art de France**
4 Passage Roux
Paris 75017
France
33.1.4401.0830
fax 33.1.4401.0835
galerie@ateliersdart.com

Galerie Daniel Guidat
142 Rue d'Antibes
Cannes 06400
France
33.4.9394.3333
fax 33.4.9394.3334
albertfeix3@earthlink.net
galeriedanielguidat.com

Galerie Elena Lee
1460 Sherbrooke West
Suite A
Montreal, Quebec H3G 1K4
Canada
514.844.6009
info@galerieelenalee.com
galerieelenalee.com

Galerie Pokorná
Janský Vrsek 15
Prague 1, 11800
Czech Republic
420.222.518635
fax 420.222.518635
office@galeriepokorna.cz
galeriepokorna.cz

Galerie Tactus
Store Regnegade 12, 1
Copenhagen DK 1110
Denmark
45.33.933105
fax 45.33.326001
tactus@galerietactus.com
galerietactus.com

Galleri Grønlund
Birketoften 16a
Værløse 3500
Denmark
45.44.442798
fax 45.44.442798
groenlund@get2net.dk
glassart.dk

Gallery 500 Consulting
3502 Scotts Lane
Philadelphia, PA 19129
215.849.9116
gallery500@hotmail.com
gallery500.com

Gallery Gainro
Gaonix B/D
Sinsa-dong 575
Gangnam-gu, Seoul
Korea
822.541.0647
fax 822.541.0677
gainro@hanmail.net
gainro.com

**Gallery Materia/
Cervini Haas Gallery**
4222 North Marshall Way
Scottsdale, AZ 85251
480.949.1262
fax 480.949.6050
gallery@cervinihaas.com
gallerymateria.com

Garth Clark Gallery
24 West 57th Street, #305
New York, NY 10019
212.246.2205
fax 212.489.5168
info@garthclark.com
garthclark.com

**Helen Drutt: Philadelphia/
Hurong Lou Gallery**
Helen Drutt: Philadelphia
By Appointment Only
Postal Address
2220-22 Rittenhouse Square
Philadelphia, PA 19103-5505
215.735.1625
fax 215.732.1382

Hurong Lou Gallery
320 Race Street
Philadelphia, PA 19106
215.238.8860
fax 215.238.8862

Heller Gallery
420 West 14th Street
New York, NY 10014
212.414.4014
fax 212.414.2636
info@hellergallery.com
hellergallery.com

Holsten Galleries
3 Elm Street
Stockbridge, MA 01262
413.298.3044
fax 413.298.3275
artglass@holstengalleries.com
holstengalleries.com

Jewelers' Werk Galerie
2000 Pennsylvania Avenue NW
Washington, DC 20006
202.293.0249
fax 202.293.1834
ellenreiben@earthlink.net

Joan B. Mirviss, Ltd.
PO Box 231095
Ansonia Station
New York, NY 10023
212.799.4021
fax 212.721.5148
joan@mirviss.com
mirviss.com

Joanna Bird Pottery
By Appointment
19 Grove Park Terrace
London W43QE
England
44.208.995.9960
fax 44.208.742.7752
joanna.bird@ukgateway.net
joannabirdpottery.com

L

Lacoste Gallery
25 Main Street
Concord, MA 01742
978.369.0278
fax 978.369.3375
info@lacostegallery.com
lacostegallery.com

Lea Sneider
211 Central Park West
New York, NY 10024
212.724.6171
fax 212.769.3156
learsneider@aol.com

Leo Kaplan Modern
41 East 57th Street
7th floor
New York, NY 10022
212.872.1616
fax 212.872.1617
lkm@lkmodern.com
lkmodern.com

Loveed Fine Arts
575 Madison Avenue
Suite 1006
New York, NY 10022
212.605.0591
fax 212.605.0592
loveedfinearts@earthlink.net
loveedfinearts.com

M

**Marx-Saunders
Gallery, Ltd.**
230 West Superior Street
Chicago, IL 60610
312.573.1400
fax 312.573.0575
marxsaunders@earthlink.net
marxsaunders.com

Maurine Littleton Gallery
1667 Wisconsin Avenue NW
Washington, DC 20007
202.333.9307
fax 202.342.2004
littletongallery@aol.com
littletongallery.com

Mobilia Gallery
358 Huron Avenue
Cambridge, MA 02138
617.876.2109
fax 617.876.2110
mobiliaart@aol.com
mobilia-gallery.com

Moderne Gallery
111 North 3rd Street
Philadelphia, PA 19106
215.923.8536
fax 215.923.8435
raibel@aol.com
modernegallery.com

Mostly Glass Gallery
34 Hidden Ledge Road
Englewood, NJ 07631
201.816.1222
fax 201.503.9522
info@mostlyglass.com
mostlyglass.com

N

Nancy Margolis Gallery
523 West 25th Street
New York, NY 10001
212.242.3013
fax 212.242.4087
margolisny@aol.com
nancymargolisgallery.com

O

Option Art
4216 de Maisonneuve Blvd. West
Suite 302
Montreal, Quebec H3Z 1K4
Canada
514.932.3987
fax 514.932.6182
info@option-art.ca
option-art.ca

R

R. Duane Reed Gallery
7513 Forsyth Boulevard
St. Louis, MO 63105
314.862.2333
fax 314.862.8557
reedart@primary.net
rduanereedgallery.com

529 West 20th Street
New York, NY 10011
212.462.2600
fax 212.462.2510
nycreedart@primary.net
rduanereedgallerynyc.com

S

Sienna Gallery
80 Main Street
Box 694
Lenox, MA 01240
413.637.8386
fax 413.637.8387
sienna@siennagallery.com
siennagallery.com

Snyderman-Works Galleries
303 Cherry Street
Philadelphia, PA 19106
215.238.9576
fax 215.238.9351
bruce@snyderman-works.com
snyderman-works.com

Tai Gallery/Textile Arts
616 1/2 Canyon Road
Santa Fe, NM 87501
505.983.9780
fax 505.989.7770
gallery@textilearts.com
textilearts.com

Thomas R. Riley Galleries
642 North High Street
Columbus, OH 43215
614.228.6554
fax 614.228.6550
tom@rileygalleries.com
rileygalleries.com

2026 Murray Hill Road
Cleveland, OH 44106
216.421.1445
fax 216.421.1435

Tokyo Art Projects, Inc./ Mika Gallery
41 East 57th Street
8th floor
New York, NY 10022
212.888.3900
fax 212.888.3906
mg@tokyoartprojects.com
tokyoartprojects.com

WEISSPOLLACK Galleries
531 West 25th Street, #GR9
New York, NY 10001
212.989.3708
fax 212.989.6392
info@weisspollack.com
weisspollack.com

Yaw Gallery
550 North Old Woodward
Birmingham, MI 48009
248.647.5470
fax 248.647.3715
yawgallery@msn.com
yawgallery.com

UrbanGlass
647 Fulton Street
Brooklyn, NY 11217-1112
718.625.3685
fax 718.625.3889
info@urbanglass.org
urbanglass.org

Artists

A

Abe, Motoshi
Tai Gallery/Textile Arts

Aguilar, Jorge
Option Art

Ahn, Sung-Hee
Gallery Gainro

Akers, Adela
browngrotta arts

Albert, Sean
Chappell Gallery

Albreht, Ivan
WEISSPOLLACK Galleries

Alepedis, Efharis
Charon Kransen Arts

Anderson, Dona
browngrotta arts

Anderson, Jeanine
browngrotta arts

Angelino, Gianfranco
del Mano Gallery

Anilanmert, Beril
Loveed Fine Arts

Aoki, Mikiko
The David Collection

Arad, Ron
Barry Friedman Ltd.

Arana, Clara Ines
Aaron Faber Gallery

Arentzen, Glenda
Aaron Faber Gallery

Arima, Curtis H.
Aaron Faber Gallery
Yaw Gallery

Arp, Marijke
browngrotta arts

Arroyave-Portela, Nicholas
Helen Drutt: Philadelphia/
 Hurong Lou Gallery

Arteaga, Yordi
Dean Project

Asay, Roger
Gallery Materia/
 Cervini Haas Gallery

Auguste, Catherine
Galerie Ateliers d'Art
 de France

Autio, Rudy
Garth Clark Gallery
Loveed Fine Arts
R. Duane Reed Gallery

Aylieff, Felicity
Clay

Babetto, Giampaolo
Sienna Gallery

Babula, Mary Ann
Chappell Gallery

Bacerra, Ralph
Garth Clark Gallery

Bach, Carolyn Morris
Gallery 500 Consulting

Back, Su-Jung
Gallery Gainro

Bae, Mun-soo
Gallery Gainro

Baharal, Talya
Jewelers' Werk Galerie

Bahlmann, Alexandra
Jewelers' Werk Galerie

Baines, Robert
Helen Drutt: Philadelphia/
 Hurong Lou Gallery

Bakker, Gijs
Helen Drutt: Philadelphia/
 Hurong Lou Gallery

Bakker, Ralph
Charon Kransen Arts

Baldwin, Philip
Thomas R. Riley Galleries

Balsgaard, Jane
browngrotta arts

Barker, Jo
browngrotta arts

Barnaby, Margaret
Aaron Faber Gallery

Barnes, Dorothy Gill
browngrotta arts

Barney, Christine
Mostly Glass Gallery

Bartels, Rike
Charon Kransen Arts

Bartlett, Caroline
browngrotta arts

Basch, Sara
The David Collection

Bauer, Ela
Charon Kransen Arts

Bauhuis, Peter
Jewelers' Werk Galerie

Beck, Rick
Heller Gallery

Becker, Michael
Charon Kransen Arts

Beeler, Anya Kristin
Aaron Faber Gallery

Bégou, Alain
Galerie Daniel Guidat

Bégou, Francis
Galerie Daniel Guidat

Bégou, Marisa
Galerie Daniel Guidat

Behar, Linda
Mobilia Gallery

Behennah, Dail
browngrotta arts

Behrens, Hanne
Mobilia Gallery

Bencomo, Derek
del Mano Gallery

Bennett, Garry Knox
Leo Kaplan Modern

Bennett, Jamie
Sienna Gallery

Bennicke, Karen
Nancy Margolis Gallery

Benzoni, Luigi
Berengo Fine Arts

Berg, Timothy
Dean Project

Bergner, Lanny
Snyderman-Works Galleries

Berman, Harriete Estel
Charon Kransen Arts

Bernstein, Alex Gabriel
Chappell Gallery

Bess, Nancy Moore
browngrotta arts

Bettison, Giles
Barry Friedman Ltd.

Betz, Doris
Jewelers' Werk Galerie

Bezold, Brigitte
Charon Kransen Arts

Bielander, David
Jewelers' Werk Galerie

Bijlenga, Marian
Gallery Materia/
 Cervini Haas Gallery

Bilenker, Melanie
Sienna Gallery

Biles, Russell
Ferrin Gallery

Birch, Karin
Snyderman-Works Galleries

Birkkjaer, Birgit
browngrotta arts

Bischoff, Manfred
Helen Drutt: Philadelphia/
 Hurong Lou Gallery

Blackman, Jane
Clay

Blank, Alexander
The David Collection

Blavarp, Liv
Charon Kransen Arts

Bloomfield, Greg
Leo Kaplan Modern

Blyfield, Julie
Charon Kransen Arts

Bobrowicz, Yvonne Pacanovsky
Snyderman-Works Galleries

Bodemer, Iris
Jewelers' Werk Galerie

Bohnert, Thom
Loveed Fine Arts

Boin, Whitney
Aaron Faber Gallery

Bondanza, Michael
Aaron Faber Gallery

Bonovitz, Jill
Helen Drutt: Philadelphia/
 Hurong Lou Gallery

Book, Flora
Mobilia Gallery

Borgenicht, Ruth
Lacoste Gallery

Borghesi, Marco
Aaron Faber Gallery

Borgman, Mary
Ann Nathan Gallery

Bos, Karin
Dean Project

Boucard, Yves
Leo Kaplan Modern

Boyadjiev, Latchezar
Holsten Galleries

Boyd, Michael
Mobilia Gallery

Braeuer, Antje
Charon Kransen Arts

Bravura, Dusciana
Berengo Fine Arts

Brennan, Sara
browngrotta arts

Breskin Adams, Renie
Mobilia Gallery

Bressler, Mark
Gallery Materia/
 Cervini Haas Gallery

Briddell, Jeremy
Bentley Projects

Brinkmann, Beate
The David Collection

Britton, Helen
Jewelers' Werk Galerie

Brodie, Regis
Loveed Fine Arts

Brooks, Lola
Sienna Gallery
Yaw Gallery

Brown, Christie
Clay

Brychtová, Jaroslava
Barry Friedman Ltd.
Donna Schneier Fine Arts
Galerie Pokorná

Buchert, Wilhelm
Aaron Faber Gallery

Buckman, Jan
browngrotta arts

Budge, Susan
Loveed Fine Arts

Buescher, Sebastian
Charon Kransen Arts

Buge-Buchert, Ute
Aaron Faber Gallery

Bump, Raissa
Sienna Gallery

Burchard, Christian
del Mano Gallery

Burger, Falk
Yaw Gallery

Butt, Harlan
Aaron Faber Gallery
Yaw Gallery

Byrd, John
Garth Clark Gallery

Caldwell, Dorothy
Mobilia Gallery

Caleo, Lyndsay
Chappell Gallery

Callas, Peter
Loveed Fine Arts

Campbell, Pat
browngrotta arts

Cantin, Annie
Galerie Elena Lee

Cantwell, Christopher
WEISSPOLLACK Galleries

Carder, Ken
Marx-Saunders Gallery, Ltd.

Cardew, Michael
Joanna Bird Pottery

Carlin, David
del Mano Gallery

Carlson, William
Leo Kaplan Modern
Marx-Saunders Gallery, Ltd.

Carman, Nancy
Helen Drutt: Philadelphia/
 Hurong Lou Gallery

Carnright, John
WEISSPOLLACK Galleries

Caruso, Nino
Loveed Fine Arts

Castagna, Pino
Berengo Fine Arts

Castle, Wendell
Moderne Gallery

Cavalan, Pierre
Helen Drutt: Philadelphia/
 Hurong Lou Gallery

Cepka, Anton
Charon Kransen Arts

Chabrier, Gilles
Galerie Daniel Guidat

Chagué, Thiébaut
Joanna Bird Pottery

Chaleff, Paul
Lacoste Gallery

Chandler, Gordon
Ann Nathan Gallery

Chang, Peter
Helen Drutt: Philadelphia/
 Hurong Lou Gallery

Chardiet, José
Donna Schneier Fine Arts
Leo Kaplan Modern

Charles, Don
Thomas R. Riley Galleries

Chaseling, Scott
Leo Kaplan Modern

Chatterley, Mark
Gallery 500 Consulting

Chavent, Claude
Aaron Faber Gallery

Chavent, Françoise
Aaron Faber Gallery

Chen, Yu Chun
Charon Kransen Arts

Cheng, Yuyen
Aaron Faber Gallery

Chesney, Nicole
Heller Gallery

Chotard, Cathy
Charon Kransen Arts

Christie, Barbara
The David Collection

Church, Sharon
Aaron Faber Gallery
Helen Drutt: Philadelphia/
 Hurong Lou Gallery

Cigler, Václav
Barry Friedman Ltd.
Galerie Pokorná

Clayton, Deanna
Thomas R. Riley Galleries

Clayton, Keith
Thomas R. Riley Galleries

Clegg, Tessa
Barry Friedman Ltd.

Cohen, Mardi Jo
Snyderman-Works Galleries

Coignard, James
Berengo Fine Arts

Connelly, Chuck
WEISSPOLLACK Galleries

Consentino, Cynthia
Ferrin Gallery

Constatinidis, Joanna
Joanna Bird Pottery

Coper, Hans
Joanna Bird Pottery

Cordova, Cristina
Ann Nathan Gallery

Corvaja, Giovanni
Charon Kransen Arts

Cottrell, Simon
Charon Kransen Arts

Couig, William
WEISSPOLLACK Galleries

Coulson, Valerie Jo
Aaron Faber Gallery

Crain, Joyce
Snyderman-Works Galleries

Cribbs, KéKé
Leo Kaplan Modern

Cucchi, Claudia
Charon Kransen Arts

Curneen, Claire
Clay

Currier, Anne
Helen Drutt: Philadelphia/
 Hurong Lou Gallery

Curtis, Chad
Dean Project

Cylinder, Lisa
Snyderman-Works Galleries

Cylinder, Scott
Snyderman-Works Galleries

Da Silva, Marilyn
Mobilia Gallery
Yaw Gallery

Dailey, Dan
Leo Kaplan Modern

Daley, William
Helen Drutt: Philadelphia/
 Hurong Lou Gallery

Dam, Steffen
Galleri Grønlund

Davy, Woods
Bentley Projects

Dawson, Robert
Clay

Day, Paul
Garth Clark Gallery

de Amaral, Olga
Bellas Artes/Thea Burger

de Santillana, Laura
Barry Friedman Ltd.

de Waal, Edmund
Joanna Bird Pottery

de Wit, John
Gallery 500 Consulting

de Wit, Peter
Charon Kransen Arts

DeAngelis, Laura
Ferrin Gallery

DeFrancesca, Sophie
Option Art

Dei Rossi, Antonio
Mostly Glass Gallery

Dei Rossi, Mario
Mostly Glass Gallery

DeVore, Richard
Bellas Artes/Thea Burger

di Cono, Margot
Aaron Faber Gallery

Di Fiore, Miriam
Mostly Glass Gallery

Dick, Jeff
Bentley Projects

Dietz, Gundi
Ferrin Gallery

Dillingham, Rick
Donna Schneier Fine Arts
Garth Clark Gallery

Dittlmann, Bettina
Jewelers' Werk Galerie

Dixon, Stephen
Clay

Dobler, Georg
Helen Drutt: Philadelphia/
 Hurong Lou Gallery

Dolack, Linda
Mobilia Gallery

Dombrowski, Joachim
The David Collection

Donat, Ingrid
Barry Friedman Ltd.

Dopp, Joshua Noah
WEISSPOLLACK Galleries

Dorph-Jensen, Sidsel
Galerie Tactus

Douglas, Mason
Jewelers' Werk Galerie

Droog
Barry Friedman Ltd.

Drury, Chris
browngrotta arts

Dubois, Valerie
The David Collection

Duckworth, Ruth
Bellas Artes/Thea Burger

Duong, Sam Tho
Charon Kransen Arts

Ebendorf, Robert
Aaron Faber Gallery
Snyderman-Works Galleries

Eberle, Edward
Garth Clark Gallery

Ebner, David
Moderne Gallery

Echols, Tammy Howell
Snyderman-Works Galleries

Ehmck, Nina
The David Collection

Eisch, Erwin
Barry Friedman Ltd.
Donna Schneier Fine Arts

Eitzenhöfer, Ute
Jewelers' Werk Galerie

Ellsworth, David
del Mano Gallery

Elyashiv, Noam
Sienna Gallery

Enterline, Sandra
Jewelers' Werk Galerie

Epp, Sophia
Jewelers' Werk Galerie

Erickson, Gary
Loveed Fine Arts

Eriksson, Petronella
The David Collection

Esherick, Wharton
Moderne Gallery

Eskuche, Matt
Thomas R. Riley Galleries

Faba
Artempresa

Fabrega, Miky
Dean Project

Falkesgaard, Lina
Galerie Tactus

Fanourakis, Lina
Aaron Faber Gallery

Farey, Lizzie
browngrotta arts

Feibleman, Dorothy
Mobilia Gallery

Fein, Harvey
del Mano Gallery

Feller, Lucy
Ferrin Gallery

Fennell, J. Paul
del Mano Gallery

Ferguson, Ken
Moderne Gallery

Ferrari, Gerard
Ann Nathan Gallery

Fidler, Greg
WEISSPOLLACK Galleries

Firmager, Melvyn
del Mano Gallery

Fisch, Arline
Mobilia Gallery

Fisher, Daniel
Joanna Bird Pottery

Fleming, Ron
del Mano Gallery

Flockinger, CBE, Gerda
Mobilia Gallery

Flynn, Michael
Clay

Flynn, Pat
Aaron Faber Gallery

Folino, Tom
Loveed Fine Arts

Ford, John
Snyderman-Works Galleries

Forlano, David
Snyderman-Works Galleries

Foulem, Léopold L.
Option Art

Frank, Peter
Charon Kransen Arts

Freda, David
Mobilia Gallery

Freeman, Warwick
Jewelers' Werk Galerie

French, David
Gallery Materia/
 Cervini Haas Gallery

Frève, Carole
Galerie Elena Lee

Frey, Viola
Donna Schneier Fine Arts

Fritsch, Elizabeth
Joanna Bird Pottery

Fritsch, Karl
Jewelers' Werk Galerie

Fujii, Keitaro
Bentley Projects

Fujimoto, Tetsuo
Lea Sneider

Fujinuma, Noboru
Tai Gallery/Textile Arts

Fujita, Kyohei
Thomas R. Riley Galleries

Fukuchi, Kyoko
The David Collection
Helen Drutt: Philadelphia/
 Hurong Lou Gallery

Fukumoto, Shihoko
Bellas Artes/Thea Burger

Gallas, Tania
The David Collection

Galloway-Whitehead, Gill
The David Collection

Garrett, John
Mobilia Gallery

Gartner/Blade
WEISSPOLLACK Galleries

Gavotti, Elizabeth
Artempresa

Gentille, Thomas
Helen Drutt: Philadelphia/
 Hurong Lou Gallery
Jewelers' Werk Galerie

Georgieva, Ceca
browngrotta arts

Giles, Mary
browngrotta arts

Gill, Seamus
Galerie Tactus

Glancy, Michael
Barry Friedman Ltd.

Glendinning, John
Galerie Elena Lee

Gnaedinger, Ursula
Charon Kransen Arts
The David Collection

Good, Michael
The David Collection

Gottlieb, Dale
Gallery 500 Consulting

Goudji
Galerie Daniel Guidat

Greboníčková, Stanislava
Chappell Gallery

Grecco, Krista
Ann Nathan Gallery

Green, Linda
browngrotta arts

Griffin, Gary
Yaw Gallery

Gross, Michael
Ann Nathan Gallery

Grossen, Françoise
browngrotta arts

Grotell, Maija
Moderne Gallery

Guggisberg, Monica
Thomas R. Riley Galleries

Gustin, Chris
Snyderman-Works Galleries

Hafermalz-Wheeler, Christine
Aaron Faber Gallery

Hamada, Shoji
Joan B. Mirviss, Ltd.
Joanna Bird Pottery

Hamm, Ulrike
The David Collection

Hamma, Michael
The David Collection

Hanagarth, Sophie
Charon Kransen Arts

Hannon, Rebecca
Jewelers' Werk Galerie

Hardenberg, Torben
Galerie Tactus

Harding, Tim
WEISSPOLLACK Galleries

Harvey, Mielle
Jewelers' Werk Galerie

Haskins, Amy
Yaw Gallery

Hatakeyama, Seido
Tai Gallery/Textile Arts

Hatekayama, Norie
browngrotta arts

Hayashibe, Masako
The David Collection

Heath, Barbara
Aaron Faber Gallery

Hector, Valerie
Charon Kransen Arts

Heilig, Marion
The David Collection

Heindl, Anna
Charon Kransen Arts

Heinrich, Barbara
Aaron Faber Gallery

Henricksen, Ane
browngrotta arts

Henton, Maggie
browngrotta arts

Hernmarck, Helena
browngrotta arts

Heskett-Brem, Luci
Aaron Faber Gallery

Heyd, Eva
Chappell Gallery

Heyerdahl, Marian
Loveed Fine Arts

Hibbert, Louise
del Mano Gallery

Hicks, Sheila
browngrotta arts

Higby, Wayne
Helen Drutt: Philadelphia/
 Hurong Lou Gallery

Hilbert, Therese
Jewelers' Werk Galerie

Hild, Eva
Nancy Margolis Gallery

Hildebrandt, Marion
browngrotta arts

Hill, Chris
Ann Nathan Gallery

Hiller, Mirjam
Charon Kransen Arts

Hiramatsu, Yasuki
Charon Kransen Arts

Hirte, Lydia
The David Collection

Hobin, Agneta
browngrotta arts

Hoge, Susan
Yaw Gallery

Holmes, Kathleen
Chappell Gallery

Honda, Syoryu
Tai Gallery/Textile Arts

Hong, Ji-Hee
Gallery Gainro

Hong, Ji-Sun
Gallery Gainro

Hong, Jung-sil
Gallery Gainro

Hong, Yeo-ji
Gallery Gainro

Honma, Hideaki
Tai Gallery/Textile Arts

Honma, Kazue
browngrotta arts

Horn, Robyn
del Mano Gallery

Horrell, Deborah
Gallery Materia/
 Cervini Haas Gallery

Howard-Kicinski, Jennifer
Aaron Faber Gallery

Hoyt, Judith
Snyderman-Works Galleries

Hromek, Peter
del Mano Gallery

Hu, Mary Lee
Mobilia Gallery

Huchthausen, David
Leo Kaplan Modern

Huff, Melissa
Aaron Faber Gallery

Hughto, Margie
Loveed Fine Arts

Hunt, Kate
browngrotta arts

Hunter, Lissa
Nancy Margolis Gallery

Hunter, William
Barry Friedman Ltd.

Hutter, Sidney
Marx-Saunders Gallery, Ltd.

Huycke, David
Galerie Tactus

Hwang, Jeannie
Aaron Faber Gallery

Hwangbo, Ji-Young
Gallery Gainro

Ida, Shoichi
Bellas Artes/Thea Burger
Lea Sneider

Iezumi, Toshio
Chappell Gallery

Ionesco, Ion
Yaw Gallery

Ishida, Meiri
Charon Kransen Arts

Ishikawa, Mari
The David Collection
Jewelers' Werk Galerie

Ishiyama, Reiko
Charon Kransen Arts

Isupov, Sergei
Ferrin Gallery

Iversen, John
Jewelers' Werk Galerie
Yaw Gallery

Iwata, Hiroki
Charon Kransen Arts

Izawa, Yoko
The David Collection

Izumita, Yukiya
Tokyo Art Projects, Inc./
 Mika Gallery

J

Jacobs, Ferne
Nancy Margolis Gallery

Jamison, Kerry
Snyderman-Works Galleries

Jang, Sun-Young
Gallery Gainro

Janich, Hilde
Charon Kransen Arts

Jank, Michael
Jewelers' Werk Galerie

Jensen, Mette
Charon Kransen Arts

Jeon, Ji-Hye
Gallery Gainro

Johansson, Karin
Charon Kransen Arts

John, Svenja
Jewelers' Werk Galerie

Jolley, Richard
Leo Kaplan Modern

Jónsdóttir, Kristin
browngrotta arts

Jordan, John
del Mano Gallery

Joy, Christine
browngrotta arts

Juenger, Ike
Charon Kransen Arts

Jung, Jin-Hee
Gallery Gainro

Kakurezaki, Ryuichi
Lacoste Gallery

Kallenberger, Kreg
Leo Kaplan Modern

Kamoda, Shoji
Joan B. Mirviss, Ltd.

Kaneko, Jun
Bentley Projects

Kaneta, Masanao
Joan B. Mirviss, Ltd.

Kang, Hye-Rim
Gallery Gainro

Kang, Yeonmi
Charon Kransen Arts

Karina, Elena
Loveed Fine Arts

Karnes, Karen
WEISSPOLLACK Galleries

Katoh, Tsubusa
Lea Sneider

Katsushiro, Soho
Tai Gallery/Textile Arts

Kaufman, Glen
browngrotta arts

Kaufmann, Martin
Charon Kransen Arts
Galerie Tactus

Kaufmann, Ruth
browngrotta arts

Kaufmann, Ulla
Charon Kransen Arts
Galerie Tactus

Kawano, Shoko
Tai Gallery/Textile Arts

Kawase, Shinobu
Joan B. Mirviss, Ltd.

Kawashima, Shigeo
Tai Gallery/Textile Arts

Kawata, Tamiko
browngrotta arts

Kazoun, Marya
Berengo Fine Arts

Keenan, Chris
Joanna Bird Pottery

Kent, Ron
del Mano Gallery

Kerman, Janis
Aaron Faber Gallery
Option Art

Kim, Bong-hee
Gallery Gainro

Kim, Chong-Ryol
Gallery Gainro

Kim, Hee-Kyung
Gallery Gainro

Kim, Hong-Young
Gallery Gainro

Kim, Hyun-hee
Lea Sneider

Kim, Jae-Young
Gallery Gainro

Kim, Ji-Eun
Gallery Gainro

Kim, Joon-Hee
Gallery Gainro

Kim, Junh-hoo
Gallery Gainro

Kim, Kyung Shin
The David Collection

Kim, Moon-jung
Gallery Gainro

Kim, Seung-Hee
Gallery Gainro

Kim, Sun-Jung
Gallery Gainro

Kimelman, Nora
Artempresa

Kimoto, Keiko
Tokyo Art Projects, Inc./
 Mika Gallery

Kindelmann, Heide
The David Collection

King, Gerry
Mostly Glass Gallery

Kinghorn, Judith
Aaron Faber Gallery

Kirkpatrick, Joey
Donna Schneier Fine Arts

Kitade, Kenjiro
WEISSPOLLACK Galleries

Kitamura, Junko
Joan B. Mirviss, Ltd.

Klancic, Anda
browngrotta arts

Kline, Jonathan
Snyderman-Works Galleries

Klumpar, Vladimira
Heller Gallery
Marx-Saunders Gallery, Ltd.

Knauss, Lewis
browngrotta arts

Knobel, Esther
Jewelers' Werk Galerie
Sienna Gallery

Knowles, Sabrina
R. Duane Reed Gallery

Kobayashi, Mazakazu
browngrotta arts

Kobayashi, Naomi
browngrotta arts

Koch, Gabriele
Clay

Koenigsberg, Nancy
browngrotta arts

Kogelnik, Kiki
Berengo Fine Arts

Kohyama, Yasuhisa
browngrotta arts

Koike, Shoko
Joan B. Mirviss, Ltd.

Koinuma, Michio
Joan B. Mirviss, Ltd.

Kolb, Giselle
Aaron Faber Gallery

Kolesnikova, Irina
browngrotta arts

Kondo, Takahiro
Joan B. Mirviss, Ltd.

Korowitz-Coutu, Laurie
UrbanGlass

Kosonen, Markku
browngrotta arts

Krakowski, Yael
Charon Kransen Arts

Kranitzky, Robin
Helen Drutt: Philadelphia/
 Hurong Lou Gallery

Kretchmer, Steven
Aaron Faber Gallery

Krivská, Bara
Galerie Pokorná

Kruger, Daniel
Sienna Gallery

Krupenia, Deborah
Charon Kransen Arts

Kubota, Shigeo
Lea Sneider

Kuhn, Jon
Marx-Saunders Gallery, Ltd.

Kukec, Sinisa
Dean Project

Kumai, Kyoko
browngrotta arts
Lea Sneider

Künzli, Otto
Jewelers' Werk Galerie

Kuo, Yih-Wen
Loveed Fine Arts

Kuramoto, Yoko
Chappell Gallery

Kusama, Tetsuo
Lea Sneider

Kushner, Robert
Bellas Artes/Thea Burger

Kusumoto, Mariko
Mobilia Gallery

Kyriacou, Kostas
The David Collection

L

Lacoursiere, Leon
del Mano Gallery

Lahaie, Therese
Heller Gallery

Lahover, Shay
Yaw Gallery

Lake, Pipaluk
Chappell Gallery

Laky, Gyöngy
browngrotta arts

Larsen, Merete
del Mano Gallery

Larssen, Ingrid
The David Collection

Latven, Bud
del Mano Gallery

Lay, Pat
Loveed Fine Arts

Layport, Ron
del Mano Gallery

Leach, Bernard
Joanna Bird Pottery

Lee, Chunghie
Lea Sneider

Lee, Dongchun
Charon Kransen Arts

Lee, Joo-Hee
Gallery Gainro

Lee, Juanwon
WEISSPOLLACK Galleries

Lee, Jung-Eun
Gallery Gainro

Lee, Seung-Hea
Sienna Gallery

Leedy, Jim
WEISSPOLLACK Galleries

Lenzo, Peter
Ferrin Gallery

Leuthold, Marc
Loveed Fine Arts

Levin, Mark
Gallery Materia/
 Cervini Haas Gallery

Levy, Simon
Gallery Materia/
 Cervini Haas Gallery

Lewis, John
Leo Kaplan Modern

Libenský, Stanislav
Barry Friedman Ltd.
Donna Schneier Fine Arts
Galerie Pokorná

Lillie, Jacqueline
Sienna Gallery

Lippe, Jennifer
Aaron Faber Gallery

Lindqvist, Inge
browngrotta arts

Lipofsky, Marvin
Holsten Galleries

Lippmann, Puk
Galerie Tactus

Lislerud, Ole
Loveed Fine Arts

Littleton, Harvey K.
Maurine Littleton Gallery

Littleton, John
Maurine Littleton Gallery

Ljones, Åse
browngrotta arts

Lockau, Kevin
Galerie Elena Lee

Loeser, Thomas
Leo Kaplan Modern

Louiselio
Galerie Ateliers d'Art
 de France

Løvaas, Astrid
browngrotta arts

Lovendahl, Nancy
Loveed Fine Arts

Løvschal, Lone
Galerie Tactus

Lucero, Michael
Donna Schneier Fine Arts

Lühtje, Christa
Jewelers' Werk Galerie

Lynch, Sydney
Aaron Faber Gallery

Lyon, Lucy
Thomas R. Riley Galleries

Lyons, Tanya
Galerie Elena Lee

Mace, Flora
Donna Schneier Fine Arts

Machata, Peter
Charon Kransen Arts

Mackellar, Christine
Aaron Faber Gallery

MacKenzie, Warren
Lacoste Gallery

MacNeil, Linda
Leo Kaplan Modern

MacNutt, Dawn
browngrotta arts

Maeda, Asagi
Mobilia Gallery

Maestre, Jennifer
Mobilia Gallery

Magakis, Gary
Snyderman-Works Galleries

Mah, Jeannie
Lacoste Gallery

Mailland, Alain
del Mano Gallery

Majoral, Enric
Aaron Faber Gallery

Makigawa, Carlier
Helen Drutt: Philadelphia/
 Hurong Lou Gallery

Malinowski, Ruth
browngrotta arts

Maloof, Sam
Moderne Gallery

Maltby, John
Joanna Bird Pottery

Mandel, Jan
Aaron Faber Gallery

Marchetti, Stefano
Charon Kransen Arts

Marco del Pont, Celia
Artempresa

Marquis, Richard
Maurine Littleton Gallery

Marsh, Bert
del Mano Gallery

Marsland, Sally
Jewelers' Werk Galerie

Martinazzi, Bruno
Helen Drutt: Philadelphia/
 Hurong Lou Gallery

Maruyama, Tomomi
Mobilia Gallery

Matoušková, Anna
Chappell Gallery

Matsushima, Iwao
Mostly Glass Gallery

Mattar, Wilhelm Tasso
Aaron Faber Gallery
The David Collection

Matthias, Christine
Charon Kransen Arts

McClellan, Duncan
Thomas R. Riley Galleries

McDevitt, Elisabeth
Charon Kransen Arts

McLeod, James
WEISSPOLLACK Galleries

Mears, Elizabeth
WEISSPOLLACK Galleries

Mejer, Hermann
Mostly Glass Gallery

Melchione, Becki
UrbanGlass

Mendez, Louis
Loveed Fine Arts

Merkel-Hess, Mary
browngrotta arts

Metcalf, Bruce
Charon Kransen Arts

Mezaros, Mari
R. Duane Reed Gallery

Micheluzzi, Massimo
Barry Friedman Ltd.

Miguel
Charon Kransen Arts

Milan, Emile
Moderne Gallery

Milette, Richard
Option Art

Minegishi, Seiko
Joan B. Mirviss, Ltd.

Minkowitz, Norma
Bellas Artes/Thea Burger

Miro, Darcy
Jewelers' Werk Galerie

Miyamura, Hideaki
WEISSPOLLACK Galleries

Miyashita, Zenji
Joan B. Mirviss, Ltd.

Møhl, Tobias
Galleri Grønlund

Monden, Yuichi
Tai Gallery/Textile Arts

Mongrain, Jeffrey
Loveed Fine Arts

Montoya, Luis
R. Duane Reed Gallery

Moon, Hye-heun
Gallery Gainro

Moore, William
del Mano Gallery

Mori, Togaku
Joan B. Mirviss, Ltd.

Morigami, Jin
Tai Gallery/Textile Arts

Morino, Taimei
Joan B. Mirviss, Ltd.

Moty, Eleanor
Aaron Faber Gallery

Moulthrop, Matt
Bentley Projects
del Mano Gallery

Moulthrop, Philip
Bentley Projects
del Mano Gallery

Mühlfellner, Martina
The David Collection

Mulford, Judy
browngrotta arts

Munsteiner, Bernd
Aaron Faber Gallery

Munsteiner, Jutta
Aaron Faber Gallery

Munsteiner, Tom
Aaron Faber Gallery

Musler, Jay
Maurine Littleton Gallery

Myers, Joel Philip
Barry Friedman Ltd.
Marx-Saunders Gallery, Ltd.
Maurine Littleton Gallery

N

Nagakura, Kenichi
Tai Gallery/Textile Arts

Nagle, Ron
Garth Clark Gallery

Nagy, Sylvia
Loveed Fine Arts

Nakamura, Naoka
Charon Kransen Arts

Nakamura, Takuo
Joan B. Mirviss, Ltd.

Nakashima, George
Moderne Gallery

Nancey, Christophe
Galerie Ateliers d'Art
 de France

Nègre, Suzanne Otwell
The David Collection

Nelson, John
Bentley Projects

Nguyen, Trinh
UrbanGlass

Niehues, Leon
browngrotta arts

Nijland, Evert
Charon Kransen Arts

Nio, Keiji
browngrotta arts

Nittman, David
del Mano Gallery

Notkin, Richard T.
Garth Clark Gallery

Nuñez, Cristina
Artempresa

O'Casey, Breon
Helen Drutt: Philadelphia/
 Hurong Lou Gallery

O'Connor, Harold
Aaron Faber Gallery
Mobilia Gallery

Ogorzelec, Ludwika
Nancy Margolis Gallery

Ogura, Ritsuko
Helen Drutt: Philadelphia/
 Hurong Lou Gallery

Oh, Min-Young
Gallery Gainro

Ohira, Yoichi
Barry Friedman Ltd.

O'Keefe, Michael
Mostly Glass Gallery

Oliver, Gilda
Loveed Fine Arts

Olson, Lena
The David Collection

Onofrio, Judy
Helen Drutt: Philadelphia/
 Hurong Lou Gallery

Orr, Amy
Snyderman-Works Galleries

Ort, Alena
Loveed Fine Arts

Ortiz, Leslie
R. Duane Reed Gallery

Osolnik, Rude
Moderne Gallery

Ossipov, Nikolai
del Mano Gallery

Ostermann, Matthias
Option Art

Otani, Shiro
Lea Sneider

Ott, Helge
The David Collection

Ouellette, Caroline
Galerie Elena Lee

Overstreet, Kim
Helen Drutt: Philadelphia/
Hurong Lou Gallery

Oyatani, Shigeru
Bentley Projects

Paganin, Barbara
Charon Kransen Arts

Pagliaro, John
Garth Clark Gallery

Pala, Štěpán
Galerie Pokorná

Palová, Zora
Galerie Pokorná

Papesch, Gundula
Charon Kransen Arts

Pappas, Marilyn
Snyderman-Works Galleries

Pardon, Earl
Aaron Faber Gallery

Pardon, Tod
Aaron Faber Gallery

Park, Heather
Joanna Bird Pottery

Park, Jin-Young
Gallery Gainro

Park, Jung-Eon
Gallery Gainro

Park, Su-Ryeon
Gallery Gainro

Park, Yun-Joo
Gallery Gainro

Parker-Eaton, Sarah
del Mano Gallery

Parmentier, Silvia
Artempresa

Patti, Tom
Heller Gallery

Paul, Adelaide
Garth Clark Gallery

Pavan, Francesco
Helen Drutt: Philadelphia/
Hurong Lou Gallery

Pavlik, Michael
Marx-Saunders Gallery, Ltd.

Peiser, Mark
Donna Schneier Fine Arts

Peleg, Rina
Loveed Fine Arts

Perez, Jesus Curia
Ann Nathan Gallery

Perkins, Flo
Donna Schneier Fine Arts

Perkins, Sarah
Aaron Faber Gallery

Persson, Stig
Galleri Grønlund

Peters, Ruudt
Jewelers' Werk Galerie

Peterson, Michael
del Mano Gallery

Petrochko, Peter
WEISSPOLLACK Galleries

Petter, Gugger
Mobilia Gallery

Pfaff, Judy
Bellas Artes/Thea Burger

Pharis, Mark
Lacoste Gallery

Pheulpin, Simone
browngrotta arts

Phillips, Maria
The David Collection

Pho, Binh
del Mano Gallery

Pierce, Shari
Jewelers' Werk Galerie

Pimental, Alexandra
The David Collection

Pinchuk, Anya
Charon Kransen Arts

Pinchuk, Natalya
Charon Kransen Arts

Plosky, Charles
Loveed Fine Arts

Plumptre, William
Joanna Bird Pottery

Pohlman, Jenny
R. Duane Reed Gallery

Poissant, Gilbert
Option Art

Pollack, Junco Sato
Lea Sneider

Pontoppidan, Karen
Jewelers' Werk Galerie

Portaleo, Karen
Ferrin Gallery

Powell, Stephen Rolfe
Donna Schneier Fine Arts

Powning, Peter
Galerie Elena Lee

Pragnell, Valerie
browngrotta arts

Prestini, James
Moderne Gallery

Preston, Mary
Jewelers' Werk Galerie
Sienna Gallery

Priddle, Graeme
del Mano Gallery

Priest, Frances
Clay

Priest, Linda Kindler
Aaron Faber Gallery

Prip, Janet
Mobilia Gallery

Prühl, Dorothea
Jewelers' Werk Galerie

Psuty, Ingrid
Aaron Faber Gallery

Puig Cuyas, Ramon
Helen Drutt: Philadelphia/
Hurong Lou Gallery

Quigley, Robin
Aaron Faber Gallery

Racz, Simone
Artempresa

Ramshaw, OBE RDI, Wendy
Mobilia Gallery

Rana, Mah
Jewelers' Werk Galerie

Randal, Seth
Thomas R. Riley Galleries

Rankin, Susan
Option Art

Rannik, Kaire
Charon Kransen Arts

Rath, Tina
Sienna Gallery

Rawdin, Kim
Gallery Materia/
	Cervini Haas Gallery

Rea, Mel
Thomas R. Riley Galleries

Reekie, David
Thomas R. Riley Galleries

Reichert, Sabine
The David Collection

Reid, Colin
Maurine Littleton Gallery

Reymann, Julia
The David Collection

Reynolds, Nancy Sansom
Bentley Projects

Rezzonico, Irene
Berengo Fine Arts

Rhoads, Kait
Chappell Gallery

Ricci, Joh
Snyderman-Works Galleries

Richmond, Ross
R. Duane Reed Gallery

Richmond, Vaughn
del Mano Gallery

Ricks, Madelyn
Mostly Glass Gallery

Rie, Lucie
Joanna Bird Pottery

Ries, Christopher
Holsten Galleries

Riis, Jon Eric
Snyderman-Works Galleries

Ripollés, Juan
Berengo Fine Arts

Ritter, Barbara
Yaw Gallery

Roberts, David
Clay

Roethel, Cornelia
Yaw Gallery

Rosanjin, Kitaôji
Joan B. Mirviss, Ltd.

Rose, Jim
Ann Nathan Gallery

Rose, John
Bentley Projects

Rosenfeld, Erica
UrbanGlass

Rosol, Martin
Holsten Galleries

Ross, Carole
Gallery Materia/
	Cervini Haas Gallery

Rossano, Joseph
Thomas R. Riley Galleries

Rossbach, Ed
browngrotta arts

Roth, David
Moderne Gallery

Rothmann, Gerd
Helen Drutt: Philadelphia/
	Hurong Lou Gallery

Rothstein, Scott
browngrotta arts

Rousseau-Vermette, Mariette
browngrotta arts

Rowan, Tim
Lacoste Gallery

Royal, Richard
R. Duane Reed Gallery

Rubinstein, Eric
UrbanGlass

Rudavska, Maria
Loveed Fine Arts

Russmeyer, Axel
Jewelers' Werk Galerie

Ruzsa, Alison
Mostly Glass Gallery

Ryan, Jackie
Charon Kransen Arts

S

Sachs, Debra
browngrotta arts

Safire, Helene
UrbanGlass

Saito, Kayo
The David Collection

Saito, Yuka
Mobilia Gallery

Sakiyama, Takayuki
Joan B. Mirviss, Ltd.

Salvi, Fausto
WEISSPOLLACK Galleries

Sammartino, Marianna
Aaron Faber Gallery

Samplonius, David
Option Art

Sang-Ho, Shin
Loveed Fine Arts

Sanguino, Reinaldo
Dean Project

Sano, Takeshi
Chappell Gallery

Sano, Youko
Chappell Gallery

Santiago, Juan
Helen Drutt: Philadelphia/
	Hurong Lou Gallery

Sarneel, Lucy
Charon Kransen Arts

Saunders, Gayle
Aaron Faber Gallery

Sawyer, George
Aaron Faber Gallery

Schippel, Dorothea
Jewelers' Werk Galerie

Schmid, Renate
Charon Kransen Arts

Schmitz, Claude
Charon Kransen Arts

Schmuck, Jonathan
Snyderman-Works Galleries

Schocken, Deganit
Helen Drutt: Philadelphia/
	Hurong Lou Gallery

Schuster, Henriette
Jewelers' Werk Galerie

Schutz, Biba
Charon Kransen Arts

Schwarcz, June
Donna Schneier Fine Arts

Scobie, Neil
del Mano Gallery

Scoon, Thomas
Marx-Saunders Gallery, Ltd.

Seelig, Warren
Snyderman-Works Galleries

Seid, Carrie
Bentley Projects

Seide, Paul
Leo Kaplan Modern

Seidenath, Barbara
Jewelers' Werk Galerie
Sienna Gallery

Sekiji, Toshio
browngrotta arts

Sekijimá, Hisako
browngrotta arts

Sekimachi, Kay
browngrotta arts

Selva, Margarita
Artempresa

Semecká, Lada
Chappell Gallery

Serino, Naoko
Lea Sneider

Shaffer, Mary
Donna Schneier Fine Arts

Shapiro, Jeff
Lacoste Gallery

Shapiro, Karen
Snyderman-Works Galleries

Shapiro, Mark
Lacoste Gallery

Shaw, Sam
Aaron Faber Gallery

Shaw-Sutton, Carol
browngrotta arts

Sheng, Shan Shan
Berengo Fine Arts

Sherman, Sondra
Sienna Gallery

Shin, Hea-Rim
Gallery Gainro

Shin, Jung-Hee
Gallery Gainro

Shin, Sang Ho
Lea Sneider

Shindo, Hiroyuki
browngrotta arts

Shioya, Naomi
Chappell Gallery

Shirk, Helen
Helen Drutt: Philadelphia/
 Hurong Lou Gallery

Shuler, Michael
del Mano Gallery

Šibor, Jiří
Jewelers' Werk Galerie

Siemund, Vera
Jewelers' Werk Galerie

Siesbye, Alev Ebuzziya
Garth Clark Gallery

Silverman, Bobby
Bentley Projects

Silverstein, Barbara
Snyderman-Works Galleries

Simon, Marjorie
Charon Kransen Arts

Simonsson, Kim
Nancy Margolis Gallery

Simpson, Tommy
Leo Kaplan Modern

Sinner, Steve
del Mano Gallery

Sisson, Karyl
browngrotta arts

Skubic, Peter
Helen Drutt: Philadelphia/
 Hurong Lou Gallery

Sloan, Susan Kasson
Aaron Faber Gallery

Smelvær, Britt
browngrotta arts

Smith, Barbara Lee
Snyderman-Works Galleries

Smith, Fraser
del Mano Gallery

Smith, Hayley
del Mano Gallery

Smuts, Butch
del Mano Gallery

So, Jin-Sook
browngrotta arts

Soldner, Paul
Moderne Gallery

Song, Jay
Aaron Faber Gallery

Song, Jong-Eun
Gallery Gainro

Sonobe, Etsuko
Mobilia Gallery

Soosloff, Philip
Gallery 500 Consulting

Sorensen, Barbara
Loveed Fine Arts

Sørenson, Grethe
browngrotta arts

Spano, Elena
Charon Kransen Arts

Speckner, Bettina
Jewelers' Werk Galerie

Sperry, Robert
Loveed Fine Arts

Spinski, Victor
Loveed Fine Arts

Spira, Rupert
Clay

Staffel, Rudolf
Helen Drutt: Philadelphia/
 Hurong Lou Gallery

Stair, Julian
Clay
Joanna Bird Pottery

Stanger, Jay
Leo Kaplan Modern

Stankard, Paul
Marx-Saunders Gallery, Ltd.

Statom, Therman
Maurine Littleton Gallery

Stebler, Claudia
Charon Kransen Arts

Stern, Ethan
Chappell Gallery

Stern, Melissa
WEISSPOLLACK Galleries

Stiansen, Kari
browngrotta arts

Stichter, Beth Cavener
Gallery Materia/
 Cervini Haas Gallery
Garth Clark Gallery

Stocksdale, Bob
Moderne Gallery

Striffler, Dorothee
Charon Kransen Arts

Strokowsky, Cathy
Galerie Elena Lee

Stutman, Barbara
Charon Kransen Arts

Sugawara, Noriko
Aaron Faber Gallery

Sugita, Jozan
Tai Gallery/Textile Arts

Suh, Dong Hee
Loveed Fine Arts

Suh, Hye-Young
Charon Kransen Arts

Suo, Emiko
Snyderman-Works Galleries

Superior, Mara
Ferrin Gallery

Suzuki, Hiroshi
Galerie Tactus

Suzuki, Junko
Lea Sneider

Svensson, Tore
Helen Drutt: Philadelphia/
 Hurong Lou Gallery
Jewelers' Werk Galerie

Syvanoja, Janna
Charon Kransen Arts

Tagliapietra, Lino
Heller Gallery

Takaezu, Toshiko
Moderne Gallery

Takamiya, Noriko
browngrotta arts

Takamori, Akio
Garth Clark Gallery

Takimoto, Mitsukuni
Tokyo Art Projects, Inc./
Mika Gallery

Tanaka, Chiyoko
browngrotta arts

Tanaka, Hideho
browngrotta arts

Tanaka, Kyokusho
Tai Gallery/Textile Arts

Tanikawa, Tsuroko
browngrotta arts

Tate, Blair
browngrotta arts

Tawney, Lenore
browngrotta arts

Taylor, Michael
Leo Kaplan Modern

Tetkowski, Neil
Loveed Fine Arts

Thakker, Salima
Charon Kransen Arts

Thiewes, Rachelle
Jewelers' Werk Galerie

Thompson, Cappy
Leo Kaplan Modern

Tiitsar, Ketli
Charon Kransen Arts

Toland, Tip
Nancy Margolis Gallery

Tolosa, Maria Alejandra
Artempresa

Tolvanen, Terhi
Charon Kransen Arts

Tomita, Jun
browngrotta arts

Tompkins, Merrily
Helen Drutt: Philadelphia/
Hurong Lou Gallery

Torii, Ippo
Tai Gallery/Textile Arts

Tornheim, Holly
del Mano Gallery

Toro, Elias
Artempresa

Toso, Gianni
Leo Kaplan Modern

Toubes, Xavier
Loveed Fine Arts

Trask, Jennifer
Mobilia Gallery

Trekel, Silke
Charon Kransen Arts

Truman, Catherine
Charon Kransen Arts

Tuberty, Tom
Bentley Projects

Tuccillo, John
Ann Nathan Gallery

Turner, Robert
Helen Drutt: Philadelphia/
Hurong Lou Gallery

Ueno, Yumi
Aaron Faber Gallery

Ungvarsky, Melanie
UrbanGlass

Urbain, John
WEISSPOLLACK Galleries

Urbschat, Erik
Charon Kransen Arts

Vagi, Flora
Charon Kransen Arts

Valett, Conrad
Jewelers' Werk Galerie

Valkova, Rouska
Loveed Fine Arts

Vallien, Bertil
Donna Schneier Fine Arts

Valoma, Deborah
browngrotta arts

van Aswegen, Johan
Sienna Gallery

Van Cline, Mary
Leo Kaplan Modern

van der Leest, Felieke
Charon Kransen Arts

Van Stom, Feyona
Artempresa

Vandian, Alto
Yaw Gallery

Vermandere, Peter
Charon Kransen Arts

Vermette, Claude
browngrotta arts

Vesery, Jacques
del Mano Gallery

Vigeland, Tone
Helen Drutt: Philadelphia/
Hurong Lou Gallery

Vigliaturo, Silvio
Berengo Fine Arts

Vikman, Ulla-Maija
browngrotta arts

Vilhena, Manuel
Charon Kransen Arts

Virden, Jerilyn
Ann Nathan Gallery

Vízner, František
Barry Friedman Ltd.
Donna Schneier Fine Arts

Vogel, Kate
Maurine Littleton Gallery

Voulkos, Peter
Moderne Gallery

W

Wagle, Kristen
browngrotta arts

Wagner, Karin
Charon Kransen Arts

Wahl, Wendy
browngrotta arts

Walker, Lisa
Jewelers' Werk Galerie

Wallström, Mona
The David Collection

Wang, Kiwon
Snyderman-Works Galleries

Wapner, Grace Bakst
Loveed Fine Arts

Warashina, Patti
Loveed Fine Arts

Watkins, Alexandra
Aaron Faber Gallery

Waxman, Andrea
Gallery Materia/
 Cervini Haas Gallery

Wegman, Kathy
Snyderman-Works Galleries

Wegman, Tom
Snyderman-Works Galleries

Weinberg, Steven
Leo Kaplan Modern

Weiss, Beate
The David Collection

Weissflog, Hans
del Mano Gallery

Weldon-Sandlin, Red
Ferrin Gallery

West, Margaret
Helen Drutt: Philadelphia/
 Hurong Lou Gallery

Westermark, Hedvig
The David Collection

Westphal, Katherine
browngrotta arts

Willenbrink, Karen
Thomas R. Riley Galleries

Williamson, Dave
Snyderman-Works Galleries

Williamson, Roberta
Snyderman-Works Galleries

Winokur, Paula
Helen Drutt: Philadelphia/
 Hurong Lou Gallery

Winokur, Robert
Helen Drutt: Philadelphia/
 Hurong Lou Gallery

Wippermann, Andrea
Jewelers' Werk Galerie

Wise, Jeff
Aaron Faber Gallery

Wise, Susan
Aaron Faber Gallery

Won, Hyun-jung
Gallery Gainro

Wood, Beatrice
Donna Schneier Fine Arts
Garth Clark Gallery

Woodman, Betty
Donna Schneier Fine Arts

Worden, Nancy
Helen Drutt: Philadelphia/
 Hurong Lou Gallery

Xiaoping, Luo
Helen Drutt: Philadelphia/
 Hurong Lou Gallery

Yacouchi, Saumi
Yaw Gallery

Yamaguchi, Ryuun
Tai Gallery/Textile Arts

Yamanaka, Kazuko
Lea Sneider

Yamano, Hiroshi
Thomas R. Riley Galleries

Yares, Clare
Gallery Materia/
 Cervini Haas Gallery

Yiannes
Loveed Fine Arts

Yonezawa, Jiro
browngrotta arts

Yoon, Kwang-Cho
Lea Sneider

Yoshida, Masako
browngrotta arts

Youn, Hye-Won
Gallery Gainro

Young, Cybèle
Bentley Projects

Yuh, Sun Koo
Helen Drutt: Philadelphia/
 Hurong Lou Gallery

Zanella, Annamaria
Charon Kransen Arts

Zauli, Carlo
Garth Clark Gallery

Zembok, Udo
Galerie Ateliers d'Art
 de France

Zhitneva, Sasha
Chappell Gallery

Zimmerman, Arnold
Loveed Fine Arts

Zobel, Michael
Aaron Faber Gallery

Zoritchak, Yan
Galerie Daniel Guidat

Zuber, Czeslaw
Galerie Daniel Guidat

Zucca, Ed
Leo Kaplan Modern

Zulalian, Lia
Ferrin Gallery

Zynsky, Toots
Barry Friedman Ltd.